LOOK AWAY

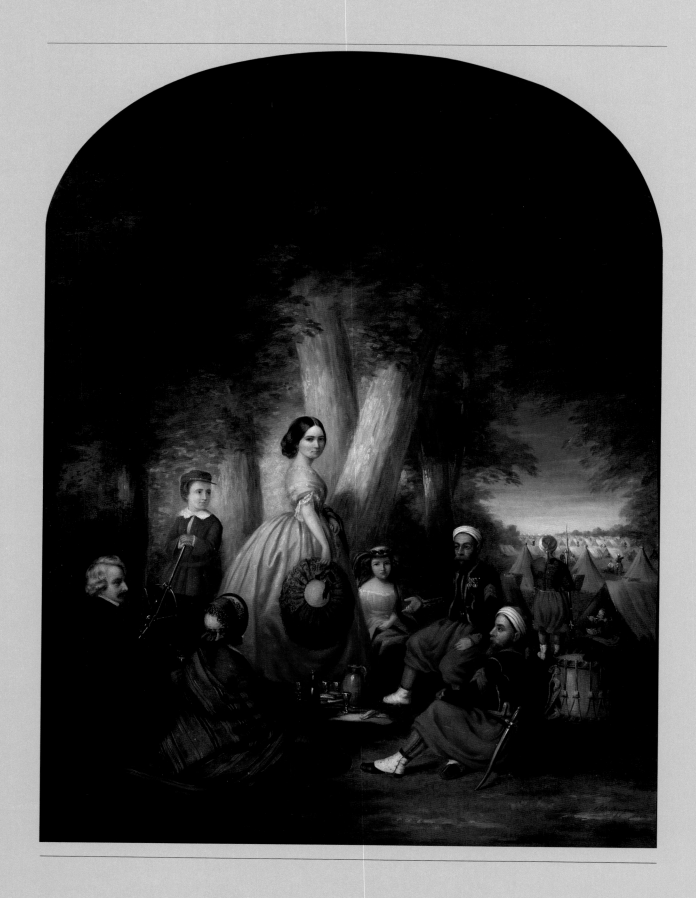

LOOK AWAY

Reality and Sentiment in Southern Art

ESTILL CURTIS PENNINGTON

A
Saraland
Press
Book

PEACHTREE

PUBLISHERS

LTD.

SARALAND
PRESS

Frontispiece: James Hamilton Shegogue (1806-1872), *The Zouave-'qui vivé*, oil on canvas, 51 x 38¼ inches, 1860, the collection of Jay P. Altmayer.

Historically, there were about 10 Zouave regiments of both Union and Confederate militia units who modeled themselves on the original Zouaves of the French colonial armies (c. 1830). These light infantry troops were famous for their drills and characteristic uniforms of bright colored baggy trousers, gaiters and turban, which gave Zouave regiments a distinctive and brilliant appearance.

The artist, born in Charleston, South Carolina, was a landscapist and genre painter of Huguenot descent. The French expression "Qui Vive" which Shegogue added to the title of the painting, describes his feelings about the Zouaves "who are enjoying life." This work was displayed at the National Academy of Design in 1861.

FOR THE
CAYWOOD-WAGNER-PENNINGTON
FAMILIES

A Saraland Press Book
509 East Saint John Street
Spartanburg, South Carolina 29302

*published in collaboration with
and distributed by*
Peachtree Publishers, Ltd.
494 Armour Circle, NE
Atlanta, Georgia 30324

Manufactured in the United States of America by Arcata Graphics

10 9 8 7 6 5 4 3 2 1

Design by Anne Morgan Jones

This project developed and produced by Robert M. Hicklin, Jr.

Cover painting: *Bayou Plaquemines* by Joseph Rusling Meeker

LIBRARY OF CONGRESS
CATALOGING-IN-PUBLICATION DATA
Pennington, Estill Curtis.
 Look Away: reality and sentiment in Southern art/Estill Curtis Pennington.
 p. cm.
 "A Saraland Press book."
 Bibliography: p.
 Includes index.
 ISBN 0-934601-92-5
 1. Painting. American—Southern States. 2. Southern States in art. 3. Regionalism in art—Southern States. I. Title.
ND220.P46 1989
759. 15'09'034—dc20 89-8731
 CIP

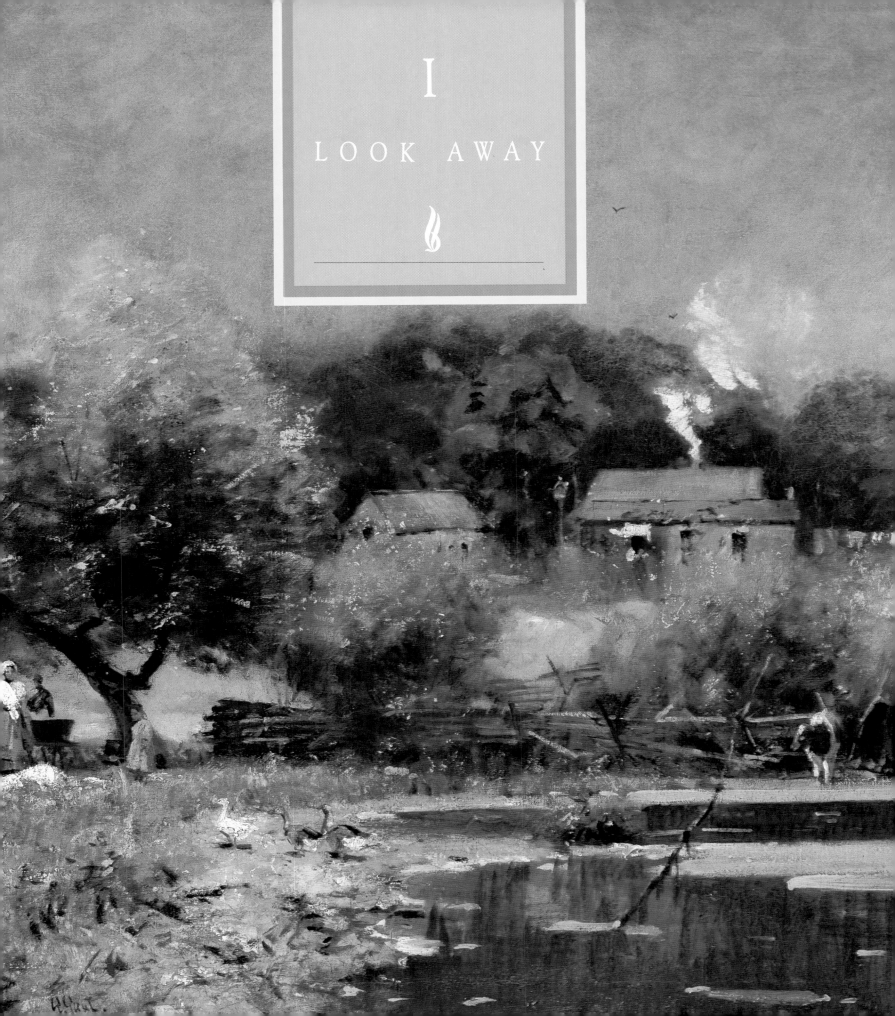

I

LOOK AWAY

I wish I was
in the land of cotton,
old times there
are not forgotten.
Look away, look away,
look away, Dixieland.

I

LOOK AWAY

C entral to the lyrics of the old minstrel song "Dixie" is the passionate longing for old times not forgotten. Without regard to what those times may have meant or what they still may mean to each individual, these lyrics sound the central theme of all things Southern: the past continues to exert a strong influence upon the present, because Southerners do not forget. Indeed, they yearn to remember, to recall, to reflect.

The South's central theme of remembrance and nostalgia proceeds from ancient notions in Western culture about reality and sentiment—about the sharp division between things as they really were and things as we now imagine them to have been. In the South this split is expressed in highly evocative ideas about Southern life that have persisted through American history. Even at this juncture in the history of the South, when the great changes of the last twenty-five years have brought so many new road signs on the cultural terrain, the South is still imagined as a place where there is a near-religious love of the land and the families who have inhabited it, and where a densely tangled, complex relationship between black and white has yielded richer language and custom.

These ideas form the extended metaphors upon which Southern artists enact their visions of reality and sentiment. Consider, for the purposes of this walk through Southern art of the last two hundred years, that these

metaphors are the guideposts, and the path we shall tread between each individual post is another effort to chart the cultural terrain of the land of cotton. This terrain has been explored in a substantial body of Southern historical and literary study, but the study of Southern art involves making a bridge between ideas and things—reconciling enduring literary-historical notions about the character of the South with actual art objects.

To locate these objects—to find a body of Southern art—involves far more than a mere study of place. The study of art is balanced between an interest in locale as an inspiration for subject matter and meaning and as the actual site of an artist's life. An artist may or may not have been influenced by his natal associations. In this respect, the question of indigenous Southern art is more extensive than the issue of indigenous Southern literature.

Non-southern writers of note have rarely used the South as material or setting. But several artists who were not native Southerners have had a great impact upon the region. This may be seen in the presence of itinerant portrait artists and resident internationals in sites as varied as Richmond, Charleston, and New Orleans during the nineteenth century. It may also be seen in the works of established Northern artists painting in Florida or Louisiana during their escape from harsh winter to temperate spring.

Within the study of American art, it is assumed that any work produced upon this continent by an artist from any background is subject to consideration. Within the realm of Southern art as a more specific, subjective study, this is not so. Thus, locating a body of Southern art is a complex matter, made more complex by the fact that a mere cataloging of objects does not constitute a study of Southern art. Once found, these objects must be interpreted within the body of prevailing thought; it is necessary to seek Southern themes in Southern art objects, which must be subjected to the same scrutiny that has been applied to other aspects of Southern studies.

Perhaps the most extensively indulged notion in the popular imagination is the idea that art communicates very specific information about the place from which it came. With this idea in mind, art is both a commodity and a virtue which we associate with a tribe or locale. Or, to use a nineteenth-century metaphor, art becomes an illuminating lamp upon the cultural terrain, enabling us to see not only the way in which the past was furnished, but how it was decorated. So deeply do we imagine past cultures to be precisely

what their art suggests, that we identify them with art historical labels. The ancient Greeks become the "classics," imbued with a tasteful restraint that echoes down the corridors of neo-classicism appearing with the ordered columns of a Doric temple built at the end of each century.

Inevitably in every culture there appears a longing to define what is specifically indigenous. Books have been written on what is English about English art and what is Italian about Italian art, and these have had to compete in broad cultural terms with books written about what is Western about the art of the Western world and what is Oriental about the art of the East. Perhaps these approaches are unfair to the merits of an individual effort or an individual product, but it cannot be denied that they enrich our understanding of persons and places, giving a colorful resonance which far transcends the written catalog of what they spent and what they got.

The English art historian, Nicholas Pevsner, has questioned the very validity of stressing "a national point of view...in appreciating works of art...." His volume, *The Englishness of English Art,* is a useful study of a familiar phenomenon. Yet, his pursuit of English themes in English art reveals, to his mind, certain trends and "meanings" that satisfy the need of the social historian for deeper insight into the basic human motivation to create, to make. While not entirely parallel, his approach to English art is a suitable beginning for exploration of what is "Southern" about the art of the South.

Comparisons between English and Southern culture reveal several similarities of superficial note, with far-reaching implications. White Southerners have traditionally indulged themselves in certain English affectations concerning cultural orientation. Artists and writers in both cultures during the nineteenth century expressively concerned themselves with the importance of revering ancestors, cherishing the minutiae of the local landscape, and articulating the emotions of human interaction in a manner which we have come to describe as sentimental. This summation may say more about our culture than theirs.

However, in both cultures a deceptively simple sense of rightness disguises a deeper social malaise. In England this was manifest in a rigid hierarchy of wealth, privilege, and class, which flattered some and held others hostage. In the South a provincial version of this caste system ex-

isted. It lacked the luster of a titled nobility but acted out many of its more flagrant aspirations. The arrangement of servant and master in England, which left much to be desired, was free from the taint of human bondage that lent an air of fatalism to the Southern character. Social tension of this type is precisely what Pevsner finds to be essential to a climate of taste and artistic expression.

In both the Southern and English cultures a lengthy and substantial literary tradition initially overshadowed indigenous expression in the plastic arts such as painting and sculpture. As in England, the Southern world reveals patterns of development that color artistic growth from the colonial period through the nineteenth century. Southerners did develop a strong interest in portraiture for the middle classes. The body of this portraiture was created, initially, by foreign itinerants who made a lasting impression upon the colonials.

An interesting point of parallelism in the uses of costume and pose in portraiture may be seen by examining the art of Anthony van Dyck in the Court of the Stuarts and its later uses in the British portraiture styles of the late eighteenth century. Van Dyck's initial popularity at the Court of Charles I rested in his ability to capture the imagined grandeur of the sitter with all the high-style flourish of the continental Baroque spirit. While van Dyck invested his sitters with a certain attitude and posed them in a slightly contorted manner so as to heighten the drama of the scene, he did not dress them in a manner that was inconsistent with the age.

Not surprisingly, the vast majority of his sitters were supporters of the King during the English Civil War, a position which gained them the name "cavaliers" for the brilliance of their costume, so different from the somber Puritan garb, and the glamour of their cause. One only has to look at the portrait of the King's cousin, James Stuart, Duke of Richmond and Lennox, standing with easy confidence, attended by his loyal dog, and dressed as a knight of the realm, to ascertain his sympathies.

Cavalier pose, if not cavalier attitudes, continued to be a stylistic factor in English portraiture throughout the eighteenth century. As late as 1770, we can see Thomas Gainsborough, in his most famous portrait, *Blue Boy,* attiring the son of a successful ironmonger in court dress and propelling him into eternity as the very essence of boyish nobility. The appealing

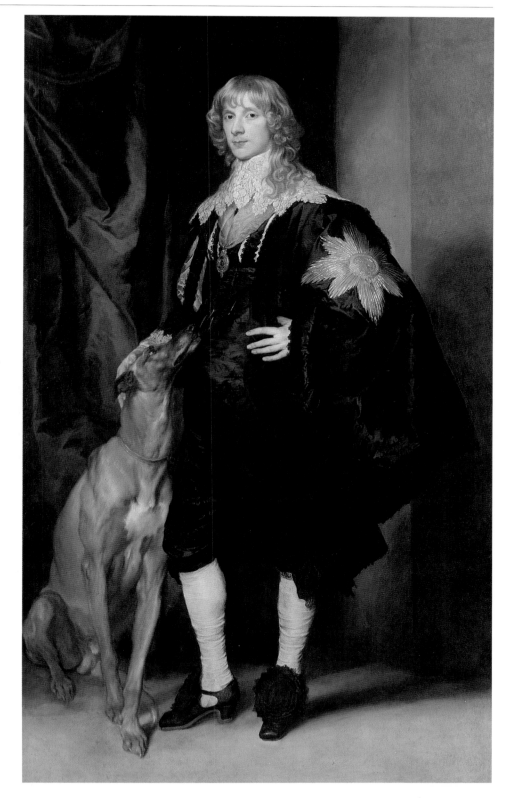

ANTHONY VAN DYCK (1599–1641), *James Stuart (1612–1655), Duke of Richmond and Lennox,* oil on canvas, 85 x 50¼ inches, undated, The Metropolitan Museum of Art, Gift of Henry G. Marquand, 1889, Marquand Collection, (89.15.16).

relaxed attitude of the subject in Gainsborough's work has become one of the most widely copied stances in the history of art, a stance we see in subsequent works by Southern artists.

Interestingly enough, in the same year when Gainsborough painted and exhibited his work at the Royal Academy, Benjamin West painted a portrait of Thomas Middleton of South Carolina in very much the same pose and attitude. Thomas Middleton was the youngest son of Henry Middleton of Middleton Place in South Carolina and had been sent back to England to be educated, in the tradition of many successful colonial English families.

By continuing the tie with England, the myth of the cavalier beginnings of the South was given greater credence. After the War Between the States when many Southern writers were looking for distinct cultural identity, this myth of cavalier association became an important selling point in their works. The echo of the lost cause of the Stuarts in the lost cause of the Confederacy lent new glamour and romance to pulp fiction and glossy illustration.

The appeal of cavalier poses and costume was surpassed in much of the work of colonial Southern itinerant artists by their use of the poses in certain English high-style portraits of the day. Charles Bridges, John Wollaston, and Jeremiah Theus all seem to have had copies of various court portraits which they followed when posing their provincial sitters. While giving their sitters an air of authority, these artists also affirmed the importance of external artistic vision, perhaps at the expense of local talent and native design.

This reliance by a prosperous and socially ambitious colonial culture on the high styles of the mother country is a manifestation of the same cultural inferiority complex which Pevsner finds so deeply engraved in the English imagination. "None of the other nations of Europe has so abject an inferiority complex about its own aesthetic capabilities as England," Pevsner writes. Until quite recently that same attitude of inferiority has been a part of the Southern attitude towards its own art.

Two powerful cultural circumstances have conspired to obscure Southern art from Southern eyes: the structure of wealth and the phenomenon of taste. As to wealth, art flourishes best in established urban centers with a free flow of capital and a worldly sense of style. These elements allow a

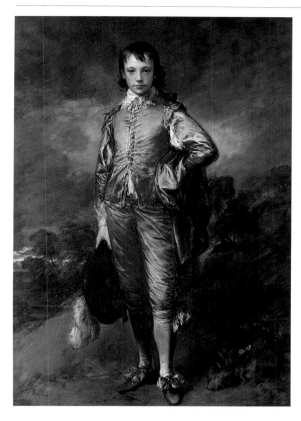

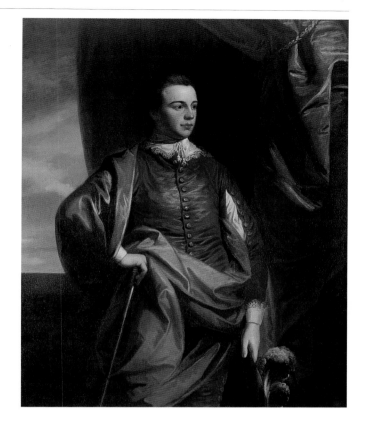

THOMAS GAINSBOROUGH
(1727–1788), *Blue Boy,* oil on canvas,
70 x 48 inches, c. 1770, Henry E.
Huntington Library and Art Gallery.

BENJAMIN WEST (1738–1820),
Thomas Middleton (1753–1797), oil on
canvas, 49½ x 39 inches, 1770, The
Gibbes Museum of Art/Carolina Art
Association. Recent cleaning of this por-
trait has revealed West's signature and
the date 1770, which makes the Middle-
ton portrait a contemporary of Gains-
borough's *Blue Boy* and raises a rather
fascinating issue of who influenced
whom in terms of costume and composi-
tion in the close-knit art world of London
in 1770. Visual comparisons and connec-
tions between the works have not previ-
ously been made. (For a complete
discussion of the painting, and other ex-
amples of West's work from this period,
see Helmut von Erffa and Arthur Staley,
The Paintings of Benjamin West, New
Haven: Yale University Press, 1986.)

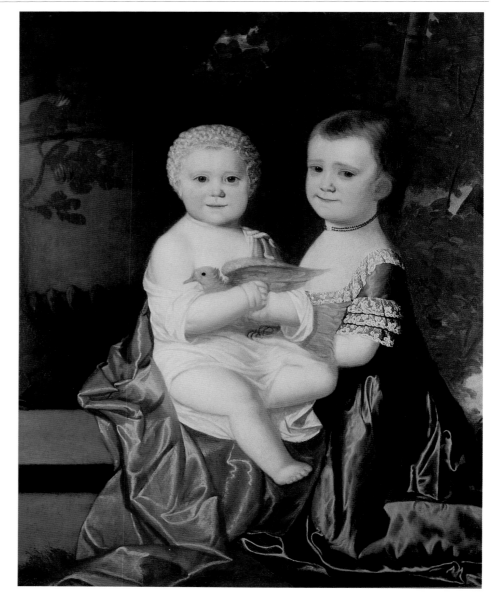

HENRY BENBRIDGE (1743-1812), *The Gatling Children*, oil on canvas, 40 x 35 inches, pre-1790, collection of Mr. and Mrs. Cleve G. Harris. It seems likely that the children of James and Mary Cowper Gatling of Hertford County, North Carolina were painted during Benbridge's late itinerancy in the Carolinas at the end of the eighteenth century. Jordan Gatling is the small child on the right, supporting an infant sibling. He was the father of Richard Jordan Gatling, with whom he invented machines for sowing cotton seeds. Richard Gatling was the inventor of the rapid-firing Gatling gun. (See Robert Gordon Stewart, *Henry Benbridge (1743–1812), American Portrait Painter,* Washington, D.C.: Smithsonian Institution Press, 1971.)

market to solidify and movements to emerge from healthy interaction between artists. Wealth and larger art communities were absent throughout much of the colonial and nineteenth-century South, except in New Orleans where a substantial visual arts tradition emerged in that non-English culture in the aftermath of the Louisiana Purchase.

In terms of taste, Southern art has occupied an extremely low profile within the national canon. However, the issues and events of Southern history have been far more damaging to the rise of a recognizable Southern art aesthetic than the simple absence of a central urban center in the region.

War, severe loss of property, disruption of life, defeat, and the concomitant psychological strain are all ingredients of the Southern psyche which have been explored with tremendous sensitivity by social and intellectual historians. Curiously enough, these same factors, which created the tensions that have resulted in the highly admired body of Southern writing, have not been examined as a background to output in the plastic arts. Southern culture, so clearly defined in the writings of the Fugitive/Agrarian movement, and so intricately detailed in the scholarship of authors like Bertram Wyatt-Brown and Clement Eaton, seems to be a suitable field for discoursing at length upon human interaction, while ignoring a wealth of information in the form of artistic material.

In part this may be explained by the lack of clarity Southern culture achieves when viewed in the context of the larger nation. The South is most often described in terms of a popular culture with romantic implications. This "romanticism" involves certain tiresome notions of moonlight and magnolias. Though trite and overplayed, this taste for Southern romance cannot be ignored, for it reflects a longing on the part of popular culture to create an intriguing avenue of escape.

A longing for an ideal pastoral world, inhabited by heroic individuals, is a very valid and worthy notion. The pastoral life is at the core of any search for what may be defined as uniquely American or particularly Southern. As a nation, we have tended to place great emphasis on the heroic worth of the individual, struggling against awesome odds to achieve a personal goal. This heroic individual is a cornerstone of Southern culture, although the individual almost always is someone from the past, rather than the present.

Southern culture does have an additional aspect which departs from the laissez-faire mentality of commercial American thought. During the turbulent debates of the ante-bellum period, upon the stage where the drama of master and slave was acted out, there was a deeply-held belief that Southern culture was less concerned with material gain, and possessed of far greater spiritual value. This is the strongest voice from that far-off land of cotton to be heard, and one that still deserves an audience. We Southerners are still unresolved, fortunately, as to whether our greatest cultural imperative is to make a buck or to make a better world.

Despite this rather enticing combination of the pursuit of happiness and

the elevation of etiquette and good form to a transcendental level, the contradictions of Southern life are glaring in the extreme. To "see" Southern art, one must pursue the old Southern dichotomy of fantasy and fact, displayed with varying skill upon an itinerant canvas. Reality, in the guise of objective historical accounting for goods and people, collides with the extensively evolved, and very sentimental, lens through which the South has viewed itself. This lens has been used most often to peer into a kaleidoscopic melange rather than to focus upon a particular place at microscopic range.

If we set about to define art in terms of the character of place, then the qualities of a Southern place must be defined and Southern art held up to them. The reality and sentiment of Southern art mirrors the dualities of personal impulse and cultural history that we have already been discussing. There is the old South and the new. There is the great complexity of race, black and white; a handy and allegorical division, given the old implications of light and shadow, and one which conveniently allows both sides to ignore the presence of other races and other cultures, even in a nation which is proud to call itself a melting pot.

Since the days of Reconstruction a duality has emerged between the rural South and the urban South personified by the rise of Southern cities, the growth of Southern industry, and the demise of Southern farms and small towns. It has been given additional flavor by the intriguing issues of labor exploitation by Northern manufacturing concerns looking for cheap help and the absence of unions.

The South has faced the integration of its own blacks and whites while absorbing a great influx of new citizens moving South in search of jobs in the "Sunbelt." In a humorous aside it might be held that paranoia is a worthy ingredient of the truly Southern personality. It is, after all, part of the popular notion of Southern culture that there is a great suspicion of outsiders. There is no more appropriate outlet for that prejudice than the press who have seen fit to lump the identifiable body of Southern life and culture together with that of the Southwest with whom the South shares almost nothing in common except a moderate temperature during the winter months.

Compounding this question of what is Southern art is the value attached to works of art by the market. While dealers, historians, and museums were

finding and displaying with great seriousness American painting of the last century, Southern art from the same era was relegated to the backs of antique shops or treated with antiquarian interest by book dealers and print shop owners.

The bifocal lens of scholarship looks at once with the eye of the antiquarian and the eye of the connoisseur. The antiquarian is delighted that any object has survived the damages of passing through time and several hands. The connoisseur shares that delight but would also like to know more about the intrinsic value of the object, how it measures up against other objects of its sort, and in what condition it has remained. The antiquarian precedes the connoisseur in most instances, excavating, documenting, and cataloging. The connoisseur tidies up and offers the last word in that exquisite market game: *value*.

In the study of art we have consigned greater value, and greater academic interest, to painting and sculpture than we have to the graphic and decorative arts. A punch bowl of the sort which survives from the Andrew Jackson White House tells us a great deal about how such goods were made and decorated in the period of manufacture, but we are not tempted to think that any great cultural revelations are to be found in a happy female face painted in bright pink upon a white ground and trimmed with gold.

Andrew Jackson Punch Bowl, Punch Bowl from the Presidential service of Andrew Jackson (Term of office: 1829–1837), hard paste porcelain, 7½ inches high x 12 inches in diameter, French origin, inscribed on Eagle illustrations: W. A. Barnet del., Robert M. Hicklin Jr., Inc., Spartanburg, South Carolina.

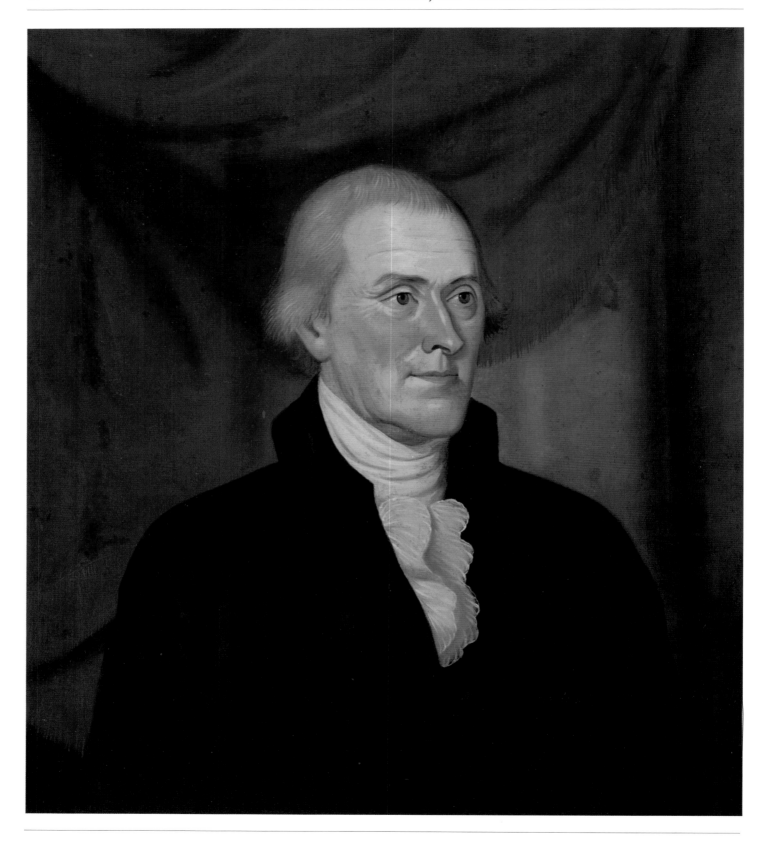

The same observation cannot be made of painting and sculpture. Art is a symbolic expression often rendering a highly personal reality. Portraiture, for example, prompts the viewer to consider the accuracy of likeness and, in the case of depicting subjects of historical note, the extent to which the character of the individual has been captured as well.

Charles Peale Polk's portrait of Thomas Jefferson, painted from life at Monticello in early November, 1799, is a work which seems to be most at one with the spirit and philosophy of the farmer-politician. More than any other Southern figure of the nineteenth century, Jefferson was responsible for creating a body of thought concerning the relationship of the individual to the land upon which he lived and farmed which would nourish the agrarian fantasies of the secession movement.

Here we see Jefferson vigorous and robust at the age of fifty-six, ruddy of complexion, and looking out from the picture plane with a clear, enthusiastic gaze. While the more formal state portraits of Jefferson by Trumbull may capture the statesmanlike quality of this complex Virginia gentleman, in Polk's work we have a sense of the man who could articulate with great vigor a message of intellectual romanticism, a "love of the land."

If a self-projected myth of the importance of owning and working upon the land can be seen as a central theme in Southern life, then Jefferson is at the core of that myth. In his most idealistic moments he looked for a generation of noble farmers to rise up in the South and lead the Republic.

The virtue which these farmers would need for this purpose would come from their natural relationship to the land. "Those who labour in the earth are the chosen people of God," Jefferson wrote in his *Notes on the State of Virginia.* He argued most persuasively against the rise of an industrial class, whom he regarded as a "canker which soon eats to the heart of its laws and constitution." Affirming his belief in non-material values, the sage of Monticello writes that it is "the manners and spirit of a people which preserve a republic in vigor."

The sentiment of these ideas is profound indeed and certainly of a piece with prevailing thought in the Western world during a period in which the encumbering vestigial remains of feudalism were being thrown off and a renewed interest in the "rights of man" was fomenting revolution and reform. From this time emerged our own Republic, the bloody demise of the

CHARLES PEALE POLK (1767–1822), *Thomas Jefferson,* oil on canvas, 27¼ x 24 inches, 1799, Robert M. Hicklin Jr., Inc., Spartanburg, South Carolina. (For an account of the sitting and Polk's life, see Linda Crocker Simmons, *Charles Peale Polk, 1767-1822, A Limner and His Likenesses,* Washington, D.C.: Corcoran Gallery of Art, 1981.)

ancien regime in France, and important changes in the English constitution.

Jefferson's impulse was to affirm the rights of man through establishing a natural aristocracy, an aristocracy of worth, not means. He came to represent an ideal sentiment whose reality was far less compassionate. Jefferson's appeal to the ante-bellum Southern mentality springs from his aristocratic beliefs, expressed in writing, but also lived out in debt-encumbered grace upon his little mountain. The manners and spirit of the ante-bellum Southerner were aristocratic in intention, but paranoid in reality. As national and international movements increased the pressure to end slavery everywhere on the planet, Southerners began a dangerous retreat behind an apologetic and self-deluding defense of a most peculiar institution.

The strains of evangelicalism present in the abolitionist movements in England and America had a counterpart in this Southern defense. Many Southerners knew slavery to be a great wrong, but defended it on the basis of Biblical justification. As the strength of the Bible is a deliberate vagueness, it is not surprising that both sides found ample text to support their views. This tendency to a self-righteousness has not vanished from the Southern character, and indeed continues to be one of the most consistent strains in a culture whose noble aristocracy of the soil has come to devote itself to demagogues and televangelists.

Concerning the issue of slavery, the mind of the South also found political justifications which were far sounder than the erstwhile Biblical arguments. One of the greatest tragedies in Southern life, apart from the existence of slavery, was its insistence of the rights of states to determine the course of action for its citizenry. By binding that belief to the issue of slavery, the ante-bellum South guaranteed the decline of local decision-making and unwittingly played into the hands of those who favored big government and a constraining bureaucracy.

A conflict between a worthy idealistic code of honor, decency, justice and the degrading circumstances of slavery created within the Southern mind a deep wellspring of irony. Rarely do reality and sentiment concur. These are the ironies which the writers of the early part of the twentieth century found so appealing about the mind of the South.

From this perspective what seems so startling about this mind is the extent to which piety and idealism could be combined to such a disastrous

end. Charles Colcock Jones, Jr., whose family letters, *The Children of Pride,* affords one of the most satisfyingly intensive looks into the life of a family in the old South, could write to his parents that the slave trader was "the lowest form of occupation in which a moral man can engage, and the effect is a complete perversion of all that is just, kind, honorable, and of good report among men." Yet none of this disapproval of slavery kept him from becoming one of the first of the enthusiastic gentlemen to enlist in the cause to fight for Southern independence.

This simultaneous hatred of slavery and willingness to enlist in the cause of Southern nationalism is nowhere more ironically apparent than in the life and career of the Kentucky artist Thomas Satterwhite Noble. Kentucky experienced the full range of emotional involvement in the issues of North and South. A slave state with a strong abolitionist movement, it was also the site of the most active slave market in the South in the Bluegrass city of Lexington.

Noble was a native of Lexington where his father operated a hemp factory, converting the local agricultural commodity into the baling twine that would secure the loads of cotton in the Deep South. From childhood Noble had been at odds with his father on his choice of career as well as matters of public policy and private morality. Noble had determined to become an artist and he was an opponent of slavery. Yet when the war broke out, the ties of family and friendship and a belief in the importance of states' rights moved Noble to enlist in the Southern army. After four years of service during which time he put his knowledge of rope-making to use by operating a rope bridge in the Louisiana theatre of action, he surrendered at New Orleans.

Following the war Noble began to paint a series of pictures depicting the horrors of the slave trade which he had always despised. With vivid memories of the dramatic moments on the block beside the old Courthouse in Lexington he painted canvases infused with outrage at humanity humiliated, families separated, and mothers forced to murder their children to free them from further bondage.

As powerful as these pictures are, they lack the commanding, eerie quality of Noble's masterpiece, *The Price of Blood, A Planter Selling His Son.* Before us Noble has set a planter, seated in the comfortable circumstances

of his study, negotiating the sale of his son to the slave dealer who stands, a mute witness behind the scene. The son, a pale mulatto replica of his father, stands to the left in a grand-manner pose borrowed directly from Gainsborough's ubiquitous *Blue Boy*.

Knowledge of the title of the work compounds the disturbing psychological undercurrent. A certain objective disdain might be the most predictable response to the scene were it not for the unsettling fact that the slave being sold is the product of an illicit liaison between the slaveholder and one of his servants. The most powerful member of this scene is the one who is missing. Of the young man's mother's identity and being we have no image. We can only surmise that her invisible, anonymous existence is part of the tragic circumstances at hand.

In the literature surrounding this painting much has been made of the fact that the son is the product of a racially-mixed relationship between master and slave. Fear of miscegenation is an aspect of paranoia carried into the rantings of the far right in our own day. But miscegenation seems far less threatening to the spirit of man than other troubles apparent in the work. The strongest issue which remains is the issue which has been made most clear by the composition of the work: whatever the circumstance of birth, the parent is abandoning his child to a harsh fate; and ultimately abandonment is far more cruel than mixed parentage.

The irony of the circumstance is further compounded by the vague presence of the print in the background above the father's head. One can just barely discern Abraham in the process of offering his son Isaac as a sacrifice to Yahweh. That parable is well-known and often commented upon. Far less familiar is Abraham's own act of abandoning a son born of a miscegenetic relationship, his offspring Ishmael, son of his faithful servant Hagar. Abraham expelled both Ishmael and Hagar into the desert after Sarah gave birth to Isaac.

The Price of Blood cannot be seen by our more informed eye as a one-act Victorian melodrama. The most unsettling aspect of the entire painting is the look which Noble has given the father. While Noble borrowed the visage of Confederate General Pike as the source for this image, the pose is his own exciting invention. There is no remorse in those eyes, rather a look of defiance and disdain at the viewer who is clearly an intruder upon the scene.

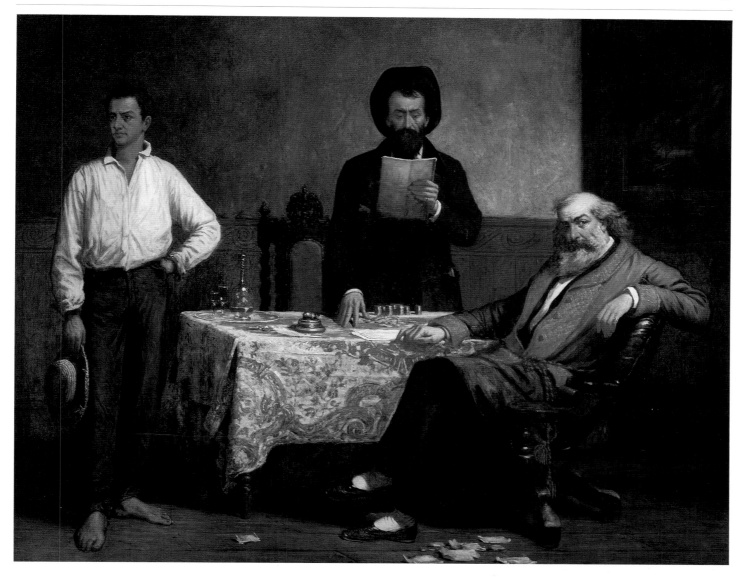

THOMAS SATTERWHITE NOBLE
(1835–1907), *The Price of Blood, A
Planter Selling His Son,* oil on canvas,
39¼ x 49½ inches, 1868, The Morris
Museum of Art, Augusta, Georgia.

EYRE CROWE (1824-1910), *Richmond Slave Market Auction,* oil on canvas, 13 x 21 inches, c. 1855, the collection of Jay P. Altmayer. Crowe is thought to have accompanied William Makepeace Thackeray on his trip to America in 1852 when the noted British novelist was in the South, writing a series of articles on slavery for the London journals.

Garbing the master in a comfortable dressing gown is an unsettling reference to his freedom to seduce at will.

The grand and cavalier attitude of the son seems to be an immediate reference to his indigenous nobility and savage grace even in the instance of his most humiliating moment. The sense of detachment between father and son is most fully realized by the fact that neither looks at the other.

Noble's attitude towards the slave dealer is also worth noting. He has no visual contact with the viewer but remains a solitary standing figure, hovering over his mass of coins and reading the contract in his hand. If guilt is to be assigned, or emotional complexity inferred, it is between the father and the son, as they interact with the viewer, rather than with the slaver who is seen by Noble, in keeping with prevailing Southern attitudes, as simply doing his dirty job.

In at least two other examples of art depicting the more tragic aspects of slavery, the artist takes a far more detached or melodramatic view. Two British artists, Eyre Crowe and John Adam Houston, painted slave scenes during visits to the United States in the ante-bellum period. Crowe's work is a curiously analytical, almost clinical, view of a slave auction in Richmond. In that work, the well-dressed female slaves look more like eligible young girls awaiting the attentions of a suitor than chattel being dispersed into an unwanted bondage. The grinning and leering faces of the male crowd provide a most disturbing undercurrent which, while more shallow than that of Noble, still conveys the proper point.

Houston's *Fugitive Slave* is a painting of great intensity, but one in which the treatment of light and shadow proves more visually attractive than the plight of the slave, who seems to serve only as a prop in the vast drama of flight and pursuit. As a symbol this slave could be interchangeable with any subjugated person in the course of Western world history.

Though it is a relatively unknown work, one cannot help but see *The Price of Blood* as the single most important image concerning the issue of slavery and its far-ranging implications to be produced by a Southerner and concerning a Southern subject. Painted after the war, it is neither an apologist work of simple didactic meaning nor a pandering work of high melodrama. It is a work of substance transcending reality and sentiment to encapsulate the horrors that led to war and the collapse of an ambitious

society.

Once those conflicts had been resolved by a costly and bloody civil war, a defeated and impoverished people faced the task of reconstructing a coherent self-image for the new South. Two schools of thought, neither in competition nor complimentary, emerged to create the image of the South which has endured until this time. Writers and public figures like Henry Watterson, Henry Grady, and Robert E. Lee encouraged the South to move beyond its sorrows and accept defeat with grace, while seeking new forms of economic growth and expansion and greatly improved educational systems.

On the other hand, the moonlight-and-magnolia school of writers, including Thomas Nelson Page, became involved in creating a South which, in defeat, was even grander than it had been in reality. Page propelled the agrarian idealism of Jefferson into the Reconstruction era with the conviction that "there is something potent in the Southern soil, which drew to it all who once rested in its bosom, without reference to race, or class, or station." With a strident call, he asked for a generation of historians to arise to articulate the life of the South.

Page issues his call at the moment when the full sentiment of the high Victorian culture has seeped into every antimacassar-hung corner of the American imagination. The valiant knight of the medieval era and the pure maiden of the field become the popular icons of the day. Prints of chivalrous General Lee, especially the engraving of *The Last Meeting of Lee and Jackson* by Halpin, proliferated into Southern homes.

These popular prints derived from paintings which were the most significant expression of the new South feeling and none is better known than *The Burial of Latane*. Painted by William D. Washington in 1864, it attracted large crowds when it was first exhibited in Richmond in the final days of the war. However, after it was engraved by A.G. Campbell in 1868, it became one of the icons of the Lost Cause.

Without disparaging the depth of feeling apparent in Washington's work, it does make for an interesting comparison with *The Price of Blood*. Where *The Price of Blood* is a compelling work of psychological intensity, *The Burial of Latane* is an example of Victorian sentimentalism at its most flagrant.

The stage has been set for a scene of heart-rending emotion. A young

JOHN ADAM HOUSTON (1813–
1884), *The Fugitive Slave*, oil on canvas,
33 x 66 inches, 1853, the collection of Jay
P. Altmayer. James L. Caw, in his history
of *Scottish Painting Past and Present,
1620–1908*, published in Edinburgh in
1908, notes that Houston "was more in-
terested in the picturesque and romantic
than in the antiquarian element in his-
tory" and "painted some landscapes
which show considerable feeling for the
sparkle and play of light." That sparkle
of light in this work serves to heighten
both the sense of danger, as the slave
hides by night, and the sense of hope,
seen in the bright star shining overhead.

doctor, Captain William Latane, is the only Confederate officer to be killed in Jeb Stuart's daring cavalry raid on McClellan's forces around the Chickahominy River in June 1862. Latane's brother John had found his body and taken it to Westwood Plantation in Hanover County with the hope of giving the young officer a proper burial. There he found the entirely female household of Catherine Brockenbrough who dispatched John Latane back to the front with the promise that his brother would be given a proper burial. The women were unable to obtain the services of the local Episcopal priest and so the order of burial from the Book of Common Prayer was read by Mrs. Brockenbrough's sister, Mrs. William B. Newton, as the children and slaves of the plantation watched, and mourned, and wept.

Unlike *The Price of Blood,* there are no startling undercurrents in this work, and the uses which have been made of European compositional sources are neither profound nor evocative. The presiding female figure stands in an attitude of devotion borrowed directly from the doe-eyed madonnas of French salon artists William Adolphe Bouguereau and Paul Delaroche. The children and slaves are arranged in a theatrical manner, segregated by the grave between the blacks on the left and the white female chorus on the right.

This theatrical arrangement is heightened by the presence of the small girl bearing a floral wreath which we assume she is about to drop upon the coffin. The blacks maintain an air of quiet respect. The only possible suggestion of deeper meaning could be found in the presence of the black servants. In several works from this period, notably the art of Gilbert Gaul, there is the suggestion that many Southern blacks supported the Southern war effort and sought out their fallen masters upon the battlefield in an attempt to bring them home for burial.

With these two works representing the range of emotion caught up in the seminal movement in Southern history, we can affirm the polarities of reality and sentiment so imaginatively displayed upon both these powerful, moving canvases. Where Noble has captured a profound sense of the reality of slavery and sexual exploitation, Washington has evoked the sentiment of simple devotion and loss.

Southern thought in the late nineteenth century was not just caught up in fanciful sentimentalizing about the noble proponents of a lost cause.

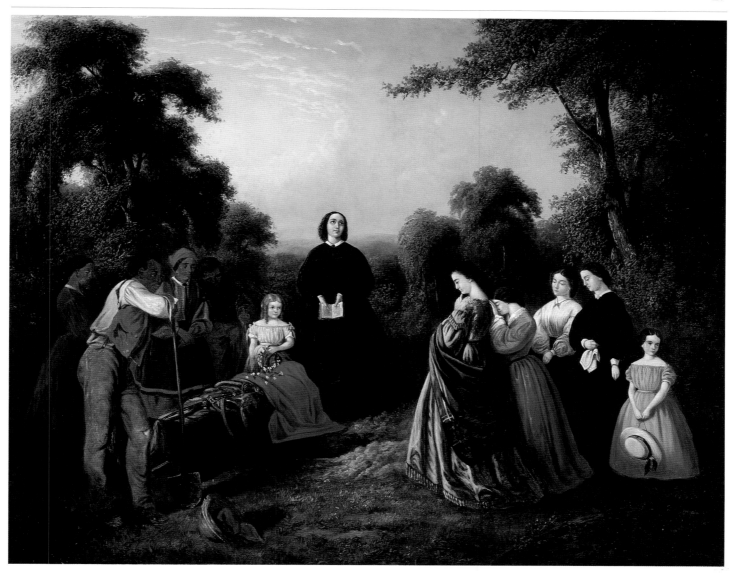

WILLIAM D. WASHINGTON
(1833–1870), *The Burial of Latane*, oil
on canvas, 36⅛ x 46⅛ inches, 1864,
from the collection of Judge John E.
DeHardit, Gloucester, Virginia.

Solidly-grounded Southern historians began to create a revisionist theory of "life and labor in the old South," to use the expression of Ulrich Bonnell Phillips, which defied the didactic theorists of the Reconstruction era. These authors made a quiet and subtle return to certain apologetic and self-justifying rationales for the inequities in ante-bellum Southern life.

Where emotion and Biblical justification once held the day, statistics and carefully recorded interviews created a benign image of a complex social system. Northern politicians and thinkers were far too occupied with the problems of immigration and emerging urban blight to pay any heed to new Southern philosophy. It is almost as if, the war over and slavery at an end, the rest of America was content to allow the South to drift back into its own way of dealing with things.

The very Northern politicians who had championed emancipation now sanctioned the slow erosion of the franchise from the black population. History began to swing from liberal views on the state of man to far more conservative notions about the importance of laissez-faire capitalism and the danger of one man/one vote. In the midst of robber barons and social reformers fighting for the mind of the new industrial state, the South began to reshape its own mythology, forging from nostalgia a dreamlike world which was entirely compatible with the fantasies of the symbolist painters working at the end of the century.

It was at this time that Southern writers of note found their voice, just as Southern painters in greater numbers began to take up the brush. Writers such as Ellen Glasgow and James Branch Cabell had begun to examine the nostalgic image of the South with a fierce, yet loving, scrutiny. The late nineteenth century saw the rise of a truly Southern school of landscape painting in Louisiana. The same pastoral mood which characterizes European art of the Barbizon period seeps into the landscapes of swamps and bayous, and takes human form in the heroes and heroines struggling to keep their land.

Amid the more predictable landscapes of the Louisiana School, Gilbert Gaul's highly impressionistic Tennessee landscape is an inspiring vision of things to come. Without the tinge of nostalgia or the subliminal suggestion of the heavy hand of the cult of the scenic South, Gaul's work is refreshing, delicate, and a sensitive statement on the picturesque values of place, an

GILBERT GAUL (1855–1919), *Van Buren, Tennessee,* oil on canvas, 30 x 44 inches, c. 1881, Robert M. Hicklin Jr., Inc., Spartanburg, South Carolina. Although Gaul was born in New Jersey, his close affinity with the Southern landscape and the tales of the Civil War began when he was a boy. In 1881 he inherited a farm in Van Buren, Tennessee and spent the next thirty years of his life there and in Nashville where he taught art. His series of paintings based on the war was highly regarded, but his landscapes, very much in the Barbizon mood, warmly colored and loosely composed, represent his best work.

often missing sensitivity in the late nineteenth century.

Sensitivity to the issues of race and the potential of black culture as subject matter for literature and art would become very apparent in Southern art of the first half of the twentieth century. The black characters of William Faulkner and Du Bose Heyward display a tenacity of character enviable for strength. The role of the black expands from simple allegory to full dramatic intent.

Artists in this same period begin to discover blacks as subject matter. Painters of ability as varied as the modestly talented Marie Hull of Mississippi or the perceptive John McCrady of Louisiana use blacks as a vehicle for expressing the conflicts of the modern age. McCrady is especially sensitive to the mythology of the black experience. In one group of paintings he captures the power of the black religious experience and connects these works with the surging compositions of the regionalist school of American art.

Swing Low, Sweet Chariot is a reminder of the central importance of religion in the black Southern experience. Representing the eternal struggle between good and evil, heightened by a compelling, Baroque sense of light and shadow, it depicts the efforts of goodness to secure the soul of a departing black from the designs of the devil. While based on the stereotypes of black life that would soon become obsolete, it was a far greater object of progress than the despicable caricatures of the late nineteenth century.

The existence of cultural polarities is to be expected in any culture. Pevsner has written "the history of styles as well as the cultural geography of nations can only be successful...that is approach truth...if it is conducted in terms of polarities, that is in pairs of apparently contradictory qualities." For Pevsner, and for English art as he sees it, those contradictions were poised between the logical and the illogical, between a truth to nature and a truth to personal style.

Within the context of Southern culture, we must consider whether those same polarities exist between the frightening extremes of a seemingly nourishing nostalgic longing for a charming romantic past, and a darkly mirrored grotesque existence played out in decadent ruin.

Between these extremes we may see three forms of Southern art in their most basic categories. Portraiture, naturalistic art, and city views offer a

JOHN MCCRADY (1911-1968), *Swing Low, Sweet Chariot,* multi-stage on canvas, 37 x 50¼ inches, 1937, The Saint Louis Art Museum, Purchase: Eliza McMillan Fund.

verifiable vision of the reality of the Southern scene. Genre painting represents the other polarity, suggesting with colorful passion the mysterious world of the imagination, where incident and behavior are frozen in a suggestive instance. Landscape art often combines both these elements, securing the necessary view of the land, preserving the essential spirit of place.

Reality and sentiment are as intertwined in the Southern soul as the honeysuckle vine wound around the wire fence in the bottom of the garden. To untangle the fence is to cut away an encumbering and destructive force of nature, growing upon the works of man and pulling it back into the ground.

Witnessing that cycle, one cannot help hearing the echoes of the Nashville Agrarians. The twelve Southerners who wrote *I'll Take My Stand* were out of step with their own time as they sought a poetic resolution to the final triumph of the industrial age. They feared that a slow erosion of the traditions of Southern life and culture would render the South indistinguishable from the rest of the country, indeed the rest of a soulless anonymous world.

To take up the scattered remnants of Southern art is to continue the affirmation of the value of Southern culture. Many demands are still made upon the former cotton kingdom. As a laboratory for social change and racial reconciliation, the South is well known. It is also the warm and beating heart of a vapid nation, a fanciful vision in color, played out to a black and white world.

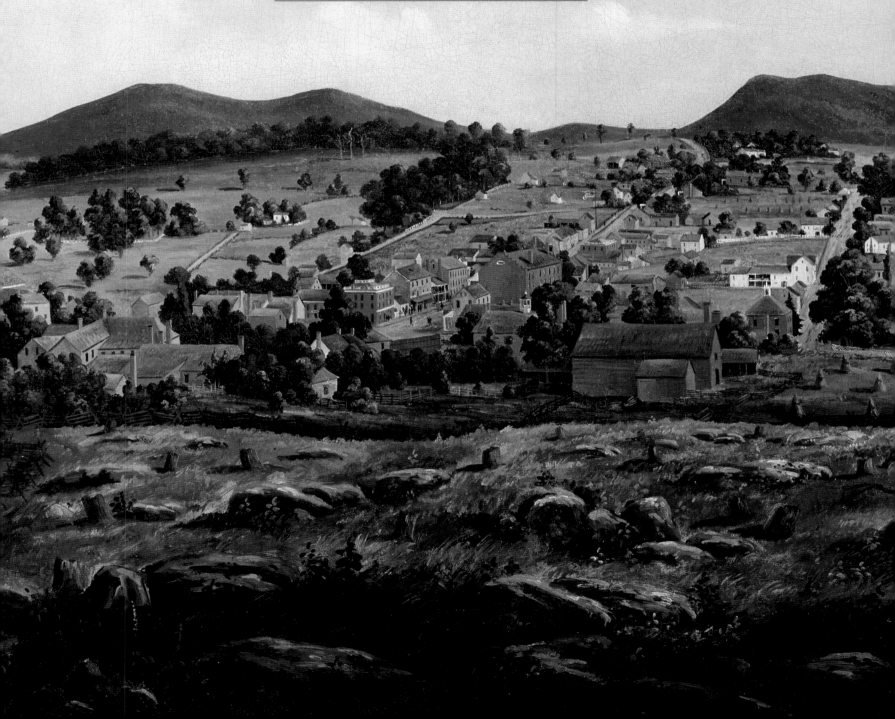

II
VERIFIABLE
VISIONS

If then the visible, the mechanical part of the animal creation, the mere material part, is so admirably beautiful, harmonious, and incomprehensible, what must be the intellectual system? that inexpressibly more essential principle, which secretly operates within? that which animates the inimitable machines, which gives them motion, impowers them to act, speak, and perform, this must be divine and immortal?

WILLIAM BARTRAM

II

VERIFIABLE VISIONS

Discovery of the North American continent fulfilled some deeply-held notion in the European consciousness that there was indeed a world beyond the one they knew. This ancient longing, manifest in the building of pyramids and the rise of monotheistic religions, sought to reassure the individual with the promise that a great reward, held in a distant locale or in another life, would make immediate difficulties more bearable. Although considerable literature has been devoted to the impact which this discovery had upon the imagination of the settlers who sought refuge and riches on the North American continent, it is a point which can never be over-emphasized.

With a virgin land of unbounded natural resources, the brave new world of the colonial settlers was indeed an earthly paradise. While the struggle for life was always hard, the South's moderate climate, fertile soil, lush vegetation, and abundant wildlife created easy circumstances for human development.

Art follows exploration. The naturalist writers and artists who came to the North American continent in the eighteenth century were idealists who wanted to see and experience at first hand the wonders of the wilderness of which they had dreamed so long. In their art and thought they combined certain prevailing ideas about the state of man and his role in the world and

in the universe. To these men of progress the material corruption of humanity was made worse by the decadent excesses of the European hierarchy. It was their hope that a new beginning could be found in the new world, and many arrived on these shores with a keen desire to observe in accurate detail the splendors which they perceived to be at hand.

From a technical perspective the abilities they brought, as artists, spring from a well-meaning, yet amateurish sensibility. Formal art training in Europe during the eighteenth century had reached a plateau of precision in style, flattering to the subject, disinterested in the environment.

Pictorial realism, which is to say, presenting things as they really were, had few adherents. Yet an earnest strain of realism enters the canon of early Southern art, and becomes one of the most important indigenous manifestations in the region. While the naturalist artist cannot be thought of in the same sense as a court painter or one who exhibited to great acclaim at the royal academies in England or on the continent, he sets the tone for much of the art created in the South up until the time of the War Between the States.

William Bartram, the English explorer-naturalist, who wrote a widely-read account of his travels in Florida, Georgia, and the Carolinas, speaks well to this issue. Bartram's wonder at the evidence of the eye is integral to an appreciation of the first art of the South. By applying what he has said about creation and the wonders of what the eye actually sees to the intellectual system, he raises ancient questions about the division between the body and spirit, between appearance and reality. The suggestion that the interior, reasoning element of society is profound demonstrates a faith in humankind that it not always confirms, but which certainly accounts for the motivations of dreamers, reformers, and prophets creating new civilizations in a spirit of virtue and hopefulness.

The verifiable vision of which Bartram writes is a cornerstone for the strain of realism in Southern art, accountable for motivation, if not technique. One function of the artistic imagination is to observe, either with the fiercely accurate, yet highly romantic eye of John James Audubon or John Abbot, or with the idealistic accuracy of certain mid-nineteenth-century painters of historical subject matter.

From these circumstances the early naturalists fashioned an artistic tradition of observation and idealism, which, if not always engrossed in

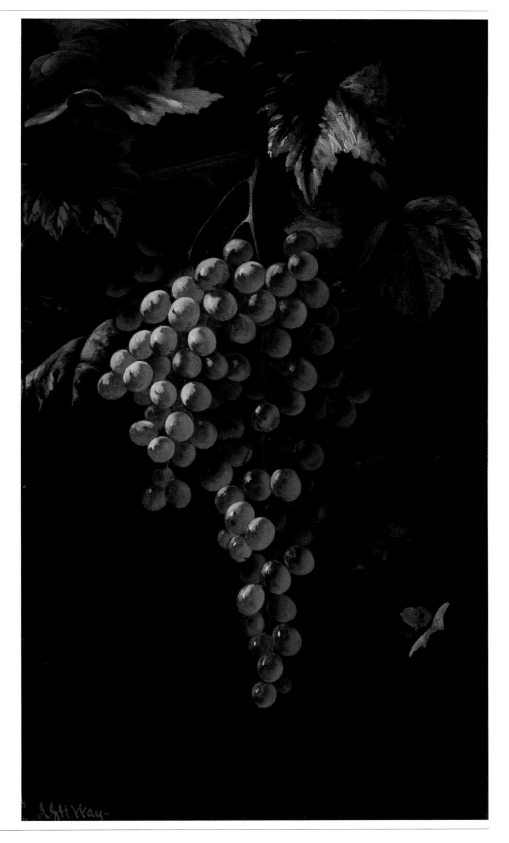

ANDREW JOHN HENRY WAY (1826–1888), *Red Grapes,* oil on panel, 24 x 13½ inches, undated, Robert M. Hicklin Jr., Inc., Spartanburg, South Carolina. Way was the most successful painter of still lifes working in Baltimore during the mid-nineteenth century, and this at a time when still life was not a greatly admired form of art. He specialized in paintings of grapes with great naturalistic accuracy, always depicting them hanging, as they might be found in nature, and in accord with prevailing theories of what was "truthful" in art. The work shown here is rare in the artist's *oeuvre,* for he is known to have used a black background in only two other paintings.

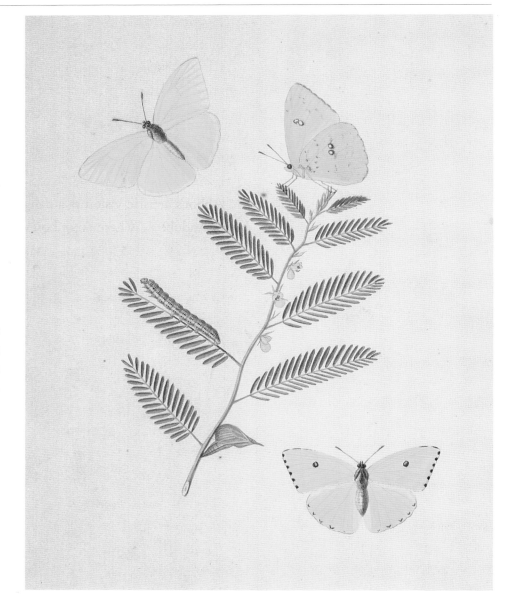

JOHN ABBOT (1751–1840), *Phoebus Sennae Eubula on Cassia,* watercolor on paper, 13⅛ x 9⅜ inches, undated, from the private collection of Mr. and Mrs. Charles O. Smith, Jr.

pictorial realism, certainly had at heart a concern for the naturalistic elements of life, environment, and society. This strain of realism in Southern art from colonial development to war and economic depression results in pictorial evidence of a culture's progress from symbolic virgin state through the cycles of agricultural exploitation which depleted the soil to the devastations of war and the collapse of social order.

While the writings of William Bartram and the watercolors of Mark Catesby, who was working in the South as early as 1712, provide a foundation for naturalism, it is in the art of John Abbot that we see a fully mature

development and use of the subject matter at hand. And in Abbot's case, that was literally immediately at hand.

John Abbot settled in Georgia in the very year that independence was declared from the British Empire. He had originally landed in Virginia in 1773, but as war became more likely he moved South and settled in the Savannah River basin. After marriage in 1784, he and his young family moved to Burke County, Georgia, and there they were to remain for the rest of his life.

Abbot's artistic vision is a delightful contrast to the ambition of John James Audubon. Where Audubon was consumed by a passionate desire to travel, seeking out new specimens, Abbot was content to remain in a very small corner of the world, recording the insect and bird life about him with meticulous detail. He is thought to have created over 5,000 watercolor sketches in his lifetime, a number of which were engraved with great accuracy of detail and faithful likeness by John Harris and published in 1797 to a list of enthusiastic subscribers.

There is a highly sensitive and very gentle quality, bordering on the naive, about these works. Pale of color and light of line, they communicate something of the fragile quality of the wildlife under observation. Butterflies still flutter by in the works of Abbot and his artwork leaves an important record of some of the delicate and mutable things lost from the Southern soil. In its smaller way, it is the same achievement that we regard with such awe in John James Audubon.

Audubon was not the first explorer-naturalist to see the abundant potential at the end of the great Mississippi River in Louisiana, but the energies he gave to his task and the clarity of his vision mark his achievement as a landmark use of the region's resources to create and make public a unique art form. To this task Audubon brought his own fledgling abilities as an artist, abilities which were modest by comparison to the skills of his peers in the field, a fact of which he was well aware and which he often expressed in his journals.

But what Audubon lacked in ability he more than possessed in idealism and in the determination to fulfill his goal of creating a definitive ornithological survey of North America's birds and their patterns in their natural habitat. "Without any money," he wrote in his journal as he began

his trip downriver, "my talents are to be my support and my enthusiasm my guide in difficulties, the whole of which I am ready to exert to keep and to surmount."

Enthusiasm and a passionate sense of self were always among Audubon's most recognizable characteristics. Whether he inherited these traits or developed them in the environment in which he was raised remains a subject for speculation as extensive as the mystery of Audubon's identity. By some accounts he was the son of a French nobleman and by others even the lost Dauphin of France. By any account he was a hybrid, born in the new world, carried to the old world as a child and given the advantage of a French education, but then brought back to this country in his youth to live on a farm in Pennsylvania. Throughout his childhood and young adolescence, one obsession seems to have been his daily occupation. He liked to draw birds and he relished the outdoors.

"Ever since a boy I have had an astonishing desire to see much of the world & particularly to acquire a true knowledge of the birds of North America, consequently, I hunted whenever I had an opportunity, and drew every new specimen I could...." Audubon made these remarks in an entry in the journal he kept on his long voyage down the Mississippi River which he undertook in the autumn of 1820.

Behind him lay nearly thirty-five years of difficulty. He was never able to successfully sustain a business, despite having been given sufficient capital by his father and by his wife's family to open several mercantile concerns. In his journal he mentions the inevitable difficulties he had with the various partners he was forced to accept in these businesses, but one cannot help but think that it was indeed his desire of seeking out his beloved birds that often kept him from business. When the weather was good, Audubon was one of those men who took to the fields and hunted, daring, as he writes in the journal, to "steal time from my business."

While living in Henderson, Kentucky at the time he was supposed to be operating a general store, Audubon conceived of his great project. His intention to record the birds of the Deep South was both spiritual and scientific. "I set myself to make every object that presented itself, and became imbued with an anxious desire to discover the purpose and import of that nature which lay spread around me in luxuriant profusion."

JOHN JAMES AUDUBON (1780-1851), *Mockingbirds,* watercolor on paper, 41 x 31 inches, 1825, courtesy of The New York Historical Society. When Havell's edition of Audubon's prints appeared in 1827, many critics took exception to this image of the birds and rattlesnake. Seemingly, Audubon had departed from the code of truth in art and indulged in a pathetic fallacy of wildlife emotion. Actually, it has been proven that snakes can climb trees, although the especially vicious look on the mockingbirds' faces might be rather far-fetched. Audubon made extensive notes on his first drawing of a rattlesnake in Louisiana, at the Perrie Plantation near St. Francisville. "Anxious to give it such a Position as I thought would render it most interesting to Naturalist, I put it in that which that Reptile generally takes when on point to Inflict a Most severe wound...." (*Journal of John James Audubon made during his trip to New Orleans in 1820–1821*, Boston: The Club of Odd Volumes, 1929, p. 191.)

Throughout his journals and in the text which accompanies the plate of each print for the *Ornithological Biography*, Audubon offers an earnest narration that combines a sense of wonder at the natural beauties he sees with pensive observations on the state of man as it relates to his own being. He is a man with a dream, but he seems conscious that he may not have many more chances to pursue that dream, much less realize it. At times this drives him on, at other times he lapses into melancholy, punctuating his normally cheerful entries with morose reflections. Audubon's approach to his art is not altogether that of the dispassionate, naturalistic observer, for he often sees in nature symbolic configurations of life, death, hope, and change.

Arriving at the confluence of the Mississippi and Ohio rivers, he sees a parable of innocence and experience. "The meeting of the two streams reminds me a little of the gentle youth who comes into the world...spotless he presents himself...he is gradually drawn in to thousands of difficulties that makes him wish to keep apart...but at the last he is over done mixed, and lost in the vortex...."

Mingling artistic perception and naturalistic enthusiasm is what infuses the art of Audubon with a spirit of genius. As he slowly descends the Mississippi from Cairo to Natchez, the sights along the way give him ample opportunity for discourse. Coming upon a tribe of Indians causes him to reflect yet again upon the innocent state of man in the wilderness. While a rainy day on the squalid deck of the flimsy flatboat depressed him enough to make a few genealogical notes, the sight of variety in the world around him returns the artist to his cause.

"The aspect of the country entirely new to us distracted my mind from those objects that are the occupation of my life...I looked with amazement ...and surrounded once more by thousands of warblers and thrushes, I enjoyed nature." Sustained by this nourishing vision of the Southern frontier, he arrives in Natchez, anxious to find any mail sent ahead from his family, and seething with excitement to continue the search for new specimens.

Once in Natchez, Audubon encounters more jolly flatboatmen of the George Caleb Bingham type than serious ornithologists. "I found few men interested towards Ornithology except those who had heard or pleased to invent wonderful stories respecting a few species." This detection of the tall

tale penchant in the camps below Natchez on the bluff is entirely in keeping with the spirit of the place.

From its earliest days Natchez attracted not only settlers, merchants, and the like, but was home to several portrait painters. Audubon arrived in Natchez in the same era that the great Kentucky portrait artists, William Edward West, Matthew Harris Jouett, and Joseph Henry Bush were making their first appearances in Natchez.

By first-hand account it is hard to determine whether the manners of the people or the climate was more offensive. A Northern visitor to Natchez, Ben Morgan, found "the towns of the river and the excessive heat of the weather made us sometimes think we would have been more comfortable in Morgantown or even Philadelphia." He continues by outlining the various diseases, "principally fever and ague and yielding quickly to medicine sooner than with us. Indeed by temperance, keeping out of the night air, avoiding getting wet and living a few miles from the river, nearly the same state of health can be enjoyed as to the northward," by which he surely means Pennsylvania and not nearby Vicksburg.

The state of health can only have been rivaled by the state of the streets which, according to one account in 1818, "were not paved, nor have they even the convenience of a paved sidewalk, consequently in wet weather it must be disagreeable walking." But matters are often relative, and a circuit-riding Methodist preacher felt that Natchez was "or the inhabitants of the town are, as much given to luxury and dissipation as any place in 'America.'"

So taken with Natchez was Audubon that he painted a city view of the place, his only known work of this type and one of the best examples of the nineteenth-century city view technique. He also recorded his impressions of the city in his journal, which were published in the Edinburgh edition of his work in 1839.

"From the river opposite Natchez, that place presents a most romantic scenery, the shore lined by steam vessels, barges, and flatboats...." Natchez was a town with a marked dual nature. Down on the river there was a squalid settlement peopled by those who counted upon the raucous flatboatmen for their livelihood. Natchez-under-the-hill, so called because the main town was built on the high bluff, was a place of grog houses, the refuge of the flatboatmen.

Their life was one of persistent hard work and consistent abandon. By one contemporary account they were "in turn extremely indolent, and extremely laborious." As they are often raucous, "it is well for the people of the village, if they do not become riotous in the course of the evening." These observations, by one Timothy Flint, published in 1826, concur with Audubon's account.

He found the lower town to be a place where the architecture could be described at best as rather haphazard: "the houses were not regularly built, being generally dwellings formed of the abandoned flatboats, placed in rows as if with the view of forming a long street."

The upper town met with far greater approval and he explored the old Spanish fort, met some of the nabobs of Natchez, whose portraits he painted, and all in all, "visited the whole neighborhood of Natchez." From his description of the town in his journal, he apparently crossed the river to the Louisiana side and observed the town from a distance. "From the river opposite Natchez, that place presents a most romantic scenery...." His pleasure in the sight is heightened by the vantage, as he finds the town "reduced to miniature by the distance renders the whole really picturesque."

Though rare, Audubon's view of Natchez is not the only city view from the canon of ante-bellum Southern art. The painter George Cooke, who worked as an itinerant throughout the Deep South in the 1840s, based himself in Athens, Georgia, a university community. Although his view of Athens, as seen from Carr's Hill, has a primitive quality, an enchantment with the topographical possibilities of the scene is very apparent.

In keeping with the discussion of the South as both theme and setting for the non-Southern artist, the Southern landscape and the small Southern town attracted many painters in the mid-nineteenth century. The Natural Bridge of western Virginia and the many natural springs which attracted both convalescents seeking a soothing cure and vacationers happy with the delights of the rambling old frame resort hotels also drew a variety of artists.

Perhaps the most successful of these was the German painter Edward Beyer, who brought the subtle blue/green light of German romantic art to the cool Blue Ridge mountain area. Beyer became so enchanted with the possibilities of the Virginia landscape that he created a series of works which were collected together in the publication, *Album of Virginia*, which was

GEORGE COOKE (1793–1849), *View of Athens from Carr's Hill,* oil on canvas, 24⅛ x 30⅛ inches, c.1845, Hargrett Rare Book and Manuscript Library, University of Georgia. Cooke is thought to have painted this work on a return visit to Athens in 1845. He had lived in the city early in the decade while sketching and writing a series of articles for the *Southern Literary Messenger* on the scenes of Georgia. His young friends Augusta Clayton and John Howze were married at this time, and he presented them the painting with the comment, "take Athens with you," knowing, according to family legend, that the return trip to the wilds of Alabama would be a difficult undertaking. The Howzes named their son George Cooke Howze in the painter's honor, and a descendent gave the work to the University. (The incident is related in the article "George Cooke and His Paintings," by Marilou Alston Rudulph, *The Georgia Historical Quarterly*, 44, No. 2, June, 1960.)

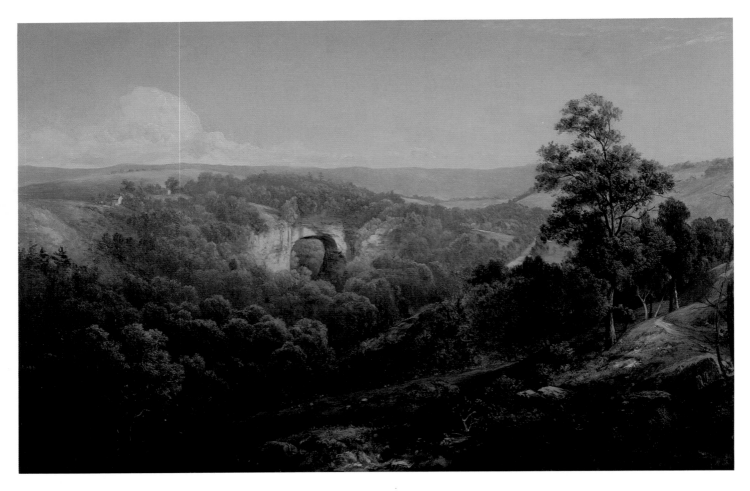

DAVID JOHNSON (1827–1908), *Natural Bridge of Virginia,* oil on canvas, 14½ x 22¼ inches, 1860, Reynolda House, Museum of American Art, Winston-Salem, North Carolina. Although David Johnson was a New York painter who had studied under Jasper Cropsey, he developed a technique and style that had far more in common with the work of his English Pre-Raphaelite contemporaries than the Hudson River School. Johnson's passion was the accurate detailing of geological elements in the landscape he drew on site. Throughout the 1850s he was drawn to the South, and his excursions in Virginia did inspire several versions of this scene of Natural Bridge. (For a discussion of the views of the Natural Bridge of Virginia, see Pamela H. Simpson, *So Beautiful An Arch: Images of the Natural Bridge 1787–1890,* Lexington, Virginia: duPont Gallery, Washington and Lee University, 1982.)

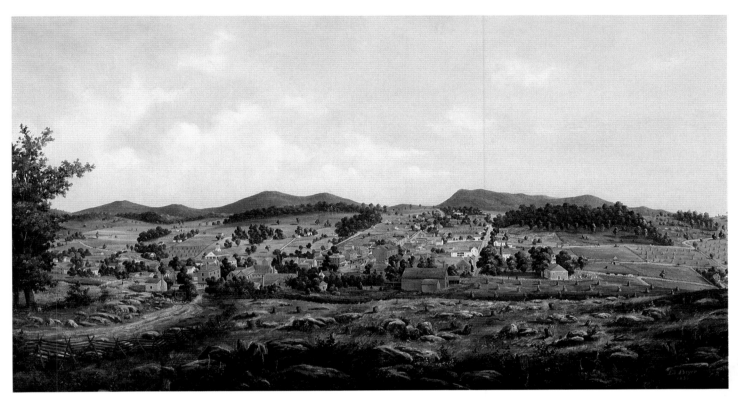

EDWARD BEYER (1820–1865), *Lewisburg, Virginia,* oil on canvas, 26¼ x 48 inches, 1854, Robert M. Hicklin Jr., Inc., Spartanburg, South Carolina. Lewisburg is located in what is now West Virginia.

issued on a subscription basis through the Richmond *Dispatch* in 1856.

Though an artist of considerably less talent, the appealing German artist William Frye, who worked in Huntsville, Alabama between 1848 and 1872, has left behind a view of Demopolis, Alabama which impresses upon the viewer something of the drama of the setting. Demopolis sits atop a dramatic chalk bluff, high above the Tombigbee River. By the time Frye came to paint it around 1855, it was more than forty years old, having evolved from an idealistic settlement of Napoleonic exiles in search of a land on which to grow olives and grapes. While this proved unsuccessful, Demopolis became one of the lush, prosperous city-states of the Alabama black

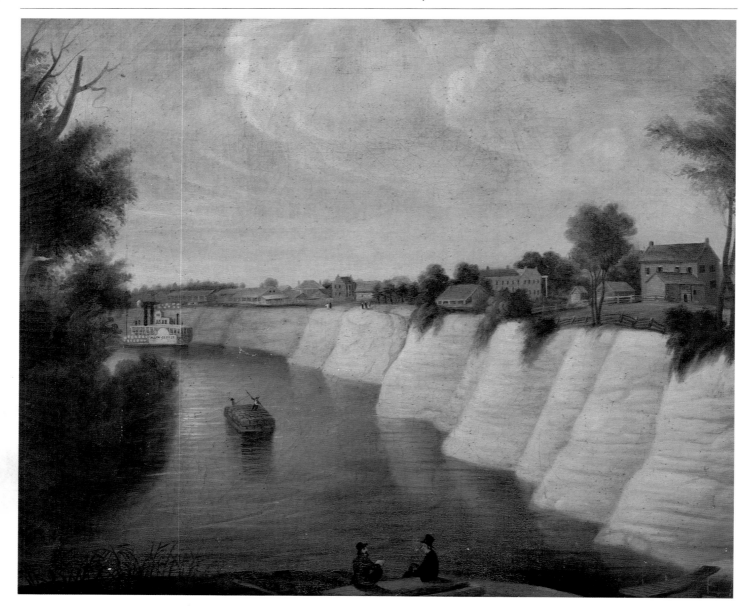

WILLIAM FRYE (1819–1872), *White Bluff, (View of Demopolis, Alabama),* oil on canvas, 24⅞ x 29⅞ inches, c. 1855, David C. Long. This view of Demopolis was commissioned by Mary Ann Diven Glover, widow of the entrepreneur Allen Glover whose efforts helped bring prosperity to the town. Originally settled by French followers of Napoleon who attempted to grow grapes and olives in the Alabama countryside, the town became instead an important trade center and the residential site for the many cotton planters in the rich and fertile black-belt region. Frye was a very talented itinerant whose portraits often used delightful fantasy creatures posed with children. (For further information on Demopolis and the Frye painting, see Winston Smith and Gwyn Collins Turner, "History in Towns: Demopolis, Alabama," *The Magazine Antiques,* CXVII, February, 1980.)

belt, the heart of the cotton kingdom.

All of this settlement of the interior of the Deep South was achieved by displacing the native North American population. Though never depicted with the frequency and intensity of the black in the South, the Indian did, on at least one occasion, inspire an important painting in the historical genre mode, *The Captive Wildcat* by Seth Eastman. The expulsion of the Indian from the land occupied and developed by the colonial Southerner is a lost theme of ante-bellum culture, abandoned to the black and white melo-dramas of the western self-image.

The interracial issue between blacks and whites is a curious matter of being bound in the same relationship, the cruel master/slave vortex. So fraught with overwhelming psychological implications was that relationship that an ultimate solution, a liberation, was inevitable. Lacking a binding dynamic, the Indian faced no prospect of integration. No abolition move-ment or self-improvement drive was at hand for them. The treatment of the Indian, especially the expulsion of the Cherokee from the Deep South, was truly a trail of tears, an ethnic disgrace. Responding with a fierce aboriginal heroism, not all departed in peace.

One of the greatest members of the Indian resistance movement was the Seminole chief and warrior, Wildcat. He lived in the Florida Everglades and eluded capture at every juncture where the Federal forces attempted to subdue him. Throughout the course of the Florida Wars with the Indians he proved the most difficult opponent, delighting in frustrating the enemy and being captured only after a treaty, signed with the tribes and guaranteeing their freedom, was violated by General Thomas Jesup.

The painting of Wildcat in captivity reveals the possibilities of histori-cal genre art. Seth Eastman, the painter, was a graduate of West Point, a military man but also an artist of great sensitivity to the subject at hand. His appreciation of Wildcat and the torments of the captivity are clearly estab-lished by the manner in which the Indian sustains visual contact with the viewer. Though crouched in his prison tent and closely guarded by the soldiers, he projects a wary alert mood, as though he were ready, at any moment, to spring free.

The tension of the scene is heightened and sustained by the use of various Baroque devices, the turning of the soldier's head, the positioning

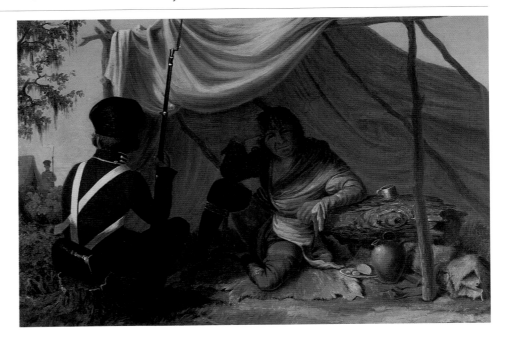

SETH EASTMAN (1801–1875), *The Captive Wildcat,* oil on canvas, 18¼ x 26 inches, undated, courtesy of Gerold Wunderlich & Co., New York.

of the figure with his back to the viewers, and the subtle suggestion of right and left and top and bottom. Eastman brought to this composition a measured ability as a draftsman, derived in part from his training at West Point as a military engineer in the tradition of Robert E. Lee. What he has achieved is a rare look at an important moment in the interaction of cultures in the ante-bellum South, one far less notorious than the melodramatic interaction of black and white, but one nevertheless to be considered in the ultimate disposition of the Southern landscape.

The question of who is Southern and what constitutes a Southern artist can be no more debatable than in the instance of the painter George Caleb Bingham. Bingham was born in Virginia and moved with his family at an early age to the Missouri territory. Bingham, a devout Baptist, was largely self-taught as an artist. His character, his ambitions, and the life he pursued flow into the very mainstream of Southern thought at the time.

Bingham himself had deeply-held personal convictions and an intense ambition to be a figure of importance in the community. Although this most often took the form of art work, in the late 1840s he sought public office and was elected to the Missouri legislature. It was an experience which he brought to bear in the series of political pictures he painted in the early 1850s, of which *The County Election* is perhaps the most vivid.

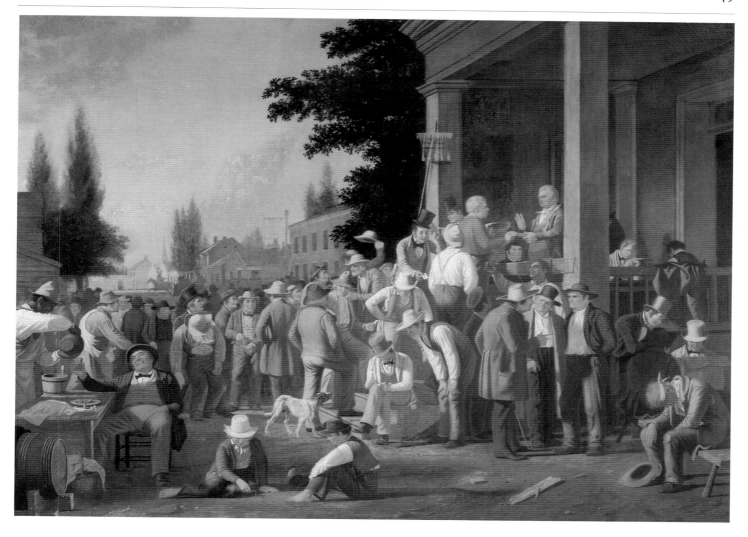

GEORGE CALEB BINGHAM (1811-1879), *The County Election,* oil on canvas, 35⁷/₁₆ x 48¾ inches, 1851/52, The Saint Louis Art Museum, Museum purchase. Bingham painted a second version of the work in 1852. Slightly larger, it was sent on tour as means of encouraging support for the print, which was engraved by Sartain of Philadelphia and offered through the American Art Union. (See E. Maurice Bloch, *The Paintings of George Caleb Bingham, a catalogue raisonne,* Columbia: The University of Missouri Press, 1986.)

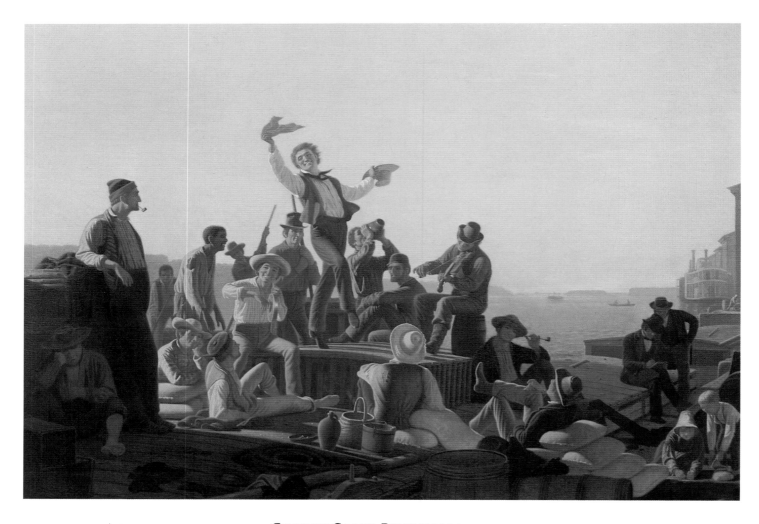

GEORGE CALEB BINGHAM (1811–
1879), *The Jolly Flatboatmen in Port,* oil
on canvas, 46¼ x 68¹⁵/₁₆ inches, 1857,
The Saint Louis Art Museum, Museum
purchase.

But Bingham's greatest importance as an artist rests in his creation of a series of pictures which depict the ongoing vitality of the flatboatmen. From Audubon's days in Natchez through the outbreak of the war and beyond, flatboatmen continued to supply the labor essential to the growth of the Southern economy which depended upon the constant exchange of agricultural commodities between the upper South, the land of hemp and tobacco, and the lower South, the land of cotton.

Once these burly boisterous types had been given greater cultural currency by being etched into stone and metal and widely distributed through the medium of the popular print, they have a substantial impact upon the forms and activities of popular landscape art. The dancing figures of the flatboatmen, black or white, will appear time and again as potent symbols of the imagined contentment of the labor class. In this sense they become appealing inheritors of the myth of the noble savage in the literature of the eighteenth and early nineteenth centuries. That these frontiersmen should embody notions of freedom and prosperity is a general assumption which makes them the most visible elements of the way in which a deeply troubled culture sought to see itself.

Prosperity, especially during the decade of the 1850s, was the key ingredient in the Southern self-image. Cotton prices were rising, spurred on by the increasing demands of the burgeoning looms of New England, sustained by the continuing needs of the English mills. In the midst of all this activity, the port at New Orleans became the most active and important in the South, and at least some of the international art community assembled in the Crescent City painted the scene.

Hyppolite Sebron's giant steamboats, docked on the levee at New Orleans, their boilers stoked and smokestacks billowing plumes of black coal smoke, await the attentions of porters and merchants and rivermen who teem upon the levee. The golden aura which falls upon the scene is the light of prosperity, a prosperity born of the energies of a hierarchic labor structure of planter and slave, themselves held hostage by cotton factors and Northern bankers.

All through the early morning and midday the big boats would be loaded or unloaded, made ready for the return trip north, or relieved of passengers and goods destined for the hotels and warehouses of New Orleans. Then,

like the allegorical vessels in a painting by J. M. W. Turner or Claude Lorrain, they would make ready to sail into the evening light.

"It was always the custom for the boats to leave New Orleans between four and five o'clock in the afternoon," Mark Twain observes in *Life on the Mississippi*. His description seems perfect for the painting by Sebron: "Two or three miles of mates were commanding and swearing with more than the usual emphasis; countless processions of freight barrels and boxes were spinning athwart the levee and flying aboard the stage-planks; belated passengers were dodging and skipping among these frantic things" while passengers "were losing their heads in the whirl and roar and general distraction."

Though far less sophisticated in style and coloration, the painting of *The* Belle Creole *at New Orleans* made in the same era, gives the requisite air of activity and excitement. In keeping with Twain's observation that "every outward-bound boat had its flag flying at the jack-staff, and sometimes a duplicate on the verge staff astern," the *Belle Creole* and the *Music* have run up their colors. Only the perspective has changed, for behind the *Belle Creole* we can see down river.

Just visible behind one of the *Music's* smokestacks is the red store of L. D. G. Develle. It seems to be on fire with the burning light of economic prosperity fueled by the giant steamboats, whose black clouds must have filtered the natural light in a manner to make the truly vulgar end of the French Market seem all the more wicked, illuminated by the suggestive fires of hell.

All this frantic work and dramatic lighting are right for the dizzy level of activity which characterized the city during this period, the time of plantation baroque, when it seemed the landscape had been made to conform to the will of the planter caste, and genre and landscape art imitated this full order with sharply defined, hard-edged visions of a deeply-longed-for reality …a prosperous agrarian society.

During this same decade, the political turmoils of the sectional crises increased. As the decade began, Henry Clay, John C. Calhoun, and Daniel Webster, that intrepid group whose bonds began in the years of the young Republic and whom Samuel Eliot Morison has called "the galaxy of 1812 that had seemed to bind the heavens together" strove to preserve the Union.

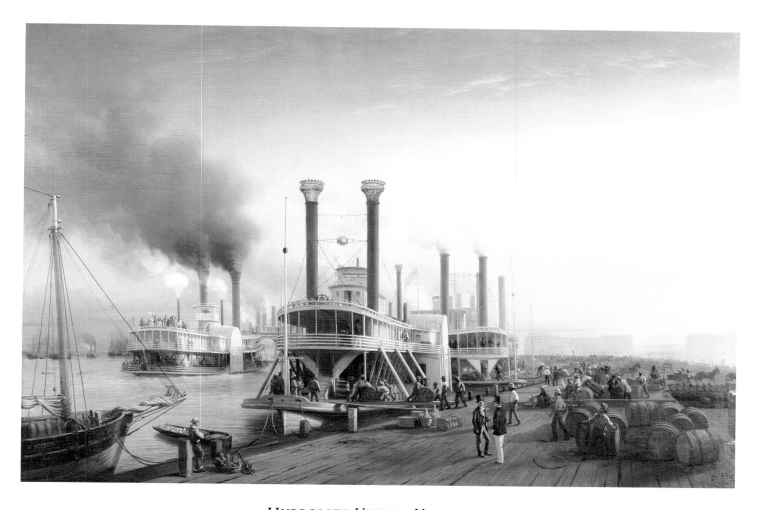

HYPPOLITE VICTOR VALENTIN
SEBRON (1801–1879), *Giant Steam-
boats at the Levee in New Orleans,* oil on
fabric, 48½ x 72⅜ inches, 1853, Art
Collection, Tulane University, New
Orleans, Gift of D. H. Holmes
Company.

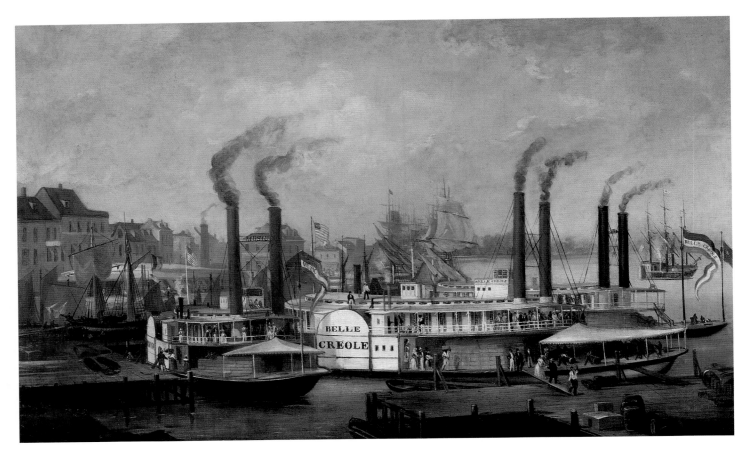

UNIDENTIFIED ARTIST, *The* Belle Creole *at New Orleans,* oil on canvas, 48 x 72 inches, c. 1845–49, in the collection of The Corcoran Gallery of Art, Gift of the Estate of Emily Crane Chadbourne.

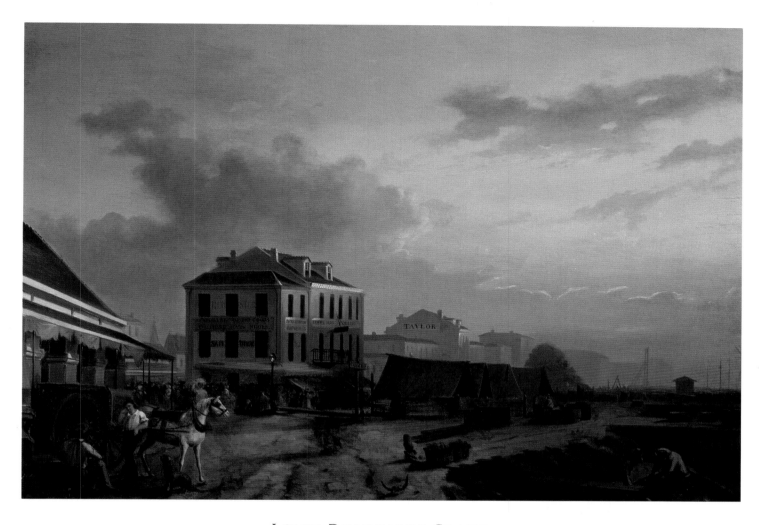

LOUIS DOMINIQUE GRAND-
JEAN DEVELLE (1799–1868), *French
Market and Red Store,* oil on canvas, 35 x
51½ inches, c. 1829–1850, The Historic
New Orleans Collection, Museum/Re-
search Center, Acc. No. 1948.1. Accord-
ing to the *Encyclopedia of New Orleans
Artists 1718–1918,* published by the His-
toric New Orleans Collection in 1987,
Develle was best known as a set designer
for theatrical and musical productions
which may account for the stagy lighting
in this work.

The Compromise of 1850 ensured the entrance of California into the Union as a free state, coupled with the issuance of more stringent fugitive slave laws. No one, North or South, thought that their inevitable conflict had been dismissed, but most seemed to agree that it was now to be held in abeyance and handed back to a volatile public for further debate.

Gazing into one of Bingham's election series paintings of the early 1850s, one has the sense of the follies and passions of that public. All male, all white, but in many guises, drunk and sober, these individuals serve very well as a symbolic representation of the voice of the people. Whether haranguing one another in favor of one candidate or another or assisting a fallen comrade to the polls, they enact the spectacle of a people seeking to come to terms with states, rights, slavery, and economic change.

As the decade passed, so did the great leaders of the past. Clay, Webster, Calhoun all died before the lackluster presidential election of 1852. Within eight years the country was at war, and the careful observations of the naturalists of the old South vanished in the sharply focused images of carnage captured through the relentlessly realistic lens of photography, communicated through the penny press.

Once the war broke out there was an immediate market for news, and for the first time in the history of printing, this news reporting was accompanied by illustrations, usually of the woodcut or line type. The most important American artist to cut his teeth on this experience was Winslow Homer. His images for the periodical *Frank Leslie's Illustrated Newspaper* account for one of the most important aspects of his entire body of work, and was certainly the experience which resulted in his producing a remarkable series of drawings of life in camp on the front lines. This was also his first opportunity to produce a series of essays on the black experience in the South.

Of foreign visiting artists working in the South as war correspondents, Alfred Waud is among the better known. Waud was an Englishman who had been trained in one of the schools of the Royal Academy. He appeared in New York in 1850 to work as a scene designer for Brougham's Lyceum Theatre in New York. While that did not prove to be a successful lure to this side of the Atlantic, the subsequent training he pursued in Boston as a woodcut artist ensured his future. Waud was on the staff of the *New York*

ALFRED WAUD (1828–1891), *Picket in Front of Fort Mahone, Petersburg, Virginia*, oil on canvas, 22 x 27 inches, undated, Robert M. Hicklin Jr., Inc., Spartanburg, South Carolina.

Illustrated News in 1861, when he was sent to Washington to cover events on the emerging war front. Less than a year later he was offered a position as a correspondent illustrator for *Harper's Weekly* and his career began.

Waud was one of the most productive artists of the entire period of the war. During the years of conflict between blue and gray he made more than 2,300 field sketches. He was a tall and genial man who looked more like a romantic subaltern of the Army of the British Empire, riding off to a glorious adventure in the defense of the realm, than an ordinary illustrator for one of the weekly periodicals.

Waud was a quick study, most often working in a sketch format that

XANTHUS SMITH (1839–1929), *Monitor* Weehawken *& Flag Ship* Wabash, pastel on paper, 10¾ x 14¾ inches, 1863, Robert M. Hicklin Jr., Inc., Spartanburg, South Carolina. Smith served as a captain's clerk aboard the *U.S.S. Wabash*.

would be subsequently engraved and published. Seldom did he return to the studio and compose an oil based on those sketches. *Picket in Front of Fort Mahone, Petersburg, Virginia* is one of those rare oils.

Art of the war years is a vast and fully catalogued subject. There are strains of realism. Xanthus Smith's depiction of a warship at Hilton Head is one example of that realism. Though not as graphic as the photography of the epoch, the romantic battle pictures of John Adams Elder and others combine a factual assessment with a continuing strain of heroic longing. That brave heroism floats on the breeze waving Conrad Wise Chapman's banner aloft over Fort Sumter.

Everett B. D. Julio's search for a verifiable vision of heroism lead him to create the monumental history painting, *The Last Meeting of Lee and Jackson*. Julio's interest in the two premier Confederate leaders is made all the more remarkable by the fact that he was neither Southern nor involved in the secession controversy as a youth nor had his family any great interest in the conflict. Julio was born on the island of St. Helena in the South Atlantic, a somewhat barren and forgotten place whose only claim to fame rests in its use as a final prison for Napoleon, the scene of his natural demise, or murder, depending upon one's point of view.

Although little is known of Julio's youth, or his art training for that

CONRAD WISE CHAPMAN (1842–1910), *Evening Gun of Sumter,* oil on panel, 10 x 13⅞ inches, c. 1864–65, Charles V. Peery, M.D., Charleston, South Carolina. Chapman was the son of the artist John Gadsby Chapman. Although born in America, he spent most of his youth in Rome where his father had moved in 1848, becoming part of the large American expatriate colony in Italy. However, Chapman's Southern sympathies were so pronounced that he sailed for America and enlisted in the Confederate Army when war broke out in 1861. He was severely wounded during the battle of Shiloh, and ultimately transferred to the command of General P. G. T. Beauregard in Charleston where he was ordered to paint numerous views of the city's fortifications. According to recent biographical accounts, he may have suffered from a type of post-war shock syndrome. His proud, resilient banner, aloft in a southern breeze, is a suitable symbol of his own commitment to the Southern cause. (For an account of Chapman's early war experiences, see Ben Basham, "Conrad Wise Chapman: Artist-Soldier of the Orphan Brigade," *The Southern Quarterly,* XXV, No. 1, pp. 40–56.)

matter, he seems to have studied for some period of time in Paris at the end of the 1850s, and turns up in Boston near the start of the war. While in Boston he attended the celebrated lectures William Rimmer was giving on anatomy and art at the Lowell Institute, an experience which could well reflect his intense ability as a draftsman which is apparent in the painting of the two Confederate generals.

Rimmer was a colorful character, doctor, sculptor, painter, and theorist in the nineteenth-century phrenological tradition. According to Rimmer and many others like him, the character of individuals could be determined by the shape of their craniums, and that analysis extended into art by presenting characters with either benign or malignant features depending upon their cranial shapes. Such thinking is provocative and can lead to the worst sort of racism and broad generalization. It was, however, very in vogue at that time and included among its supporters Herman Melville.

At some point during the war Julio left Boston and moved to St. Louis. At least one nineteenth-century biographical account held that "the fragility of his constitution and his natural sympathies induced him to move South." He may have been in St. Louis as early as 1864. *The Last Meeting of Lee and Jackson* is signed and dated 1869, meaning that Julio accomplished one of the largest and most ambitious historical compositions of the nineteenth century before the age of twenty-six. That, considering the paucity of his subsequent output, is an enormous achievement for a little-known artist of modest ability. As far as can be determined, *The Last Meeting of Lee and Jackson* was the artist's first serious work.

In painting this work, Julio firmly placed himself in the tradition of history painting. This form of the art involved creating a scene of importance from the past or current events, and investing it with a grand and noble air, thereby communicating a likeness both of the individuals and the actual events of the scene.

Julio was a sensitive soul and in mood reminiscent of Audubon, often comparing himself to birds in flight. Bemoaning his fate as an artist held hostage to financial need, he describes his longings in a letter to the daughter of one of his patrons. The birds "are indeed heaven blessed; being free... and as high as their winged flight is above this cloud shrouded earth, so are they above the grovelling and slavish condition of godlike (!) man."

EVERETT B. D. JULIO (1843–1879), *The Last Meeting of Lee and Jackson,* oil on canvas, 13 feet 10¾ inches x 9 feet 7 inches, 1869, Robert M. Hicklin Jr., Inc., Spartanburg, South Carolina.

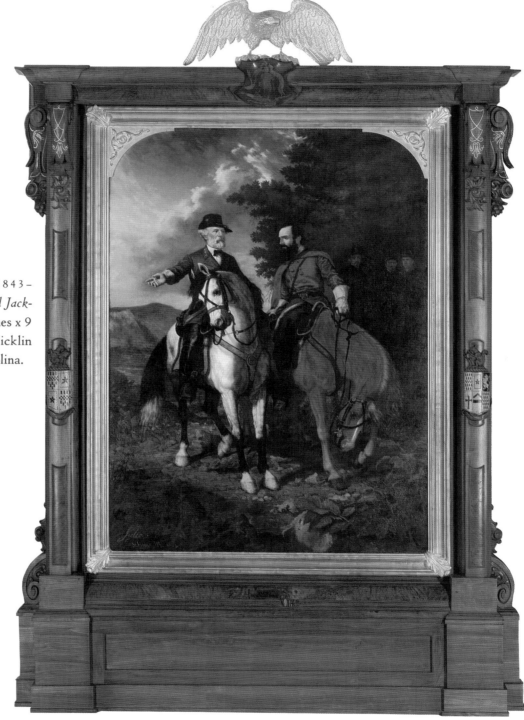

Considering that Julio never saw either Jackson or Lee and could only have grasped the events at hand from the accounts of various aides and staff members publishing their memoirs during the period, it is a very reasonable depiction. Drawing upon photographs and engravings, Julio has captured the most familiar image of Lee, gray-bearded, clad in a gray uniform, and riding a gray horse. The image of Jackson, drawn from a popular photograph of the General taken some two weeks before his death, shows the staunch and pious commander in profile, his head inclined in proper respect towards his commanding officer.

Lee gestures towards the west in a motion that recalls the simple democratic virtue of Washington as painted in the guise of civilian leader by Gilbert Stuart in the well-known Landsdowne portrait. Lee is the most commanding presence in the painting, his authority and direction affirmed even to the extent of his horse Traveller looking in the same direction. They are both indicating that General Jackson should indeed pass through the wilderness of the Catherine Furnace and come upon Hooker's men by surprise, thereby enabling General Lee to complete a pincer action and defeat the Federal forces in what would prove to be the last significant victory by the South in the long and bloody war.

As with *The Burial of Latane, The Last Meeting of Lee and Jackson* was made into a print and enjoyed tremendous popularity in the South during the late nineteenth century. Julio, whose business acumen was as poor as his tuberculosis-ridden health, lost control of that print's copyright and never realized the great profits from the print that its engraver Halpin gained. Instead he died in poverty and obscurity in Georgia, attended, according to at least one account, by the genre painter William Aiken Walker.

The Last Meeting of Lee and Jackson should be considered as an interesting example of the transition from historical sentimentality to a deeper realism and naturalism in the depiction of the South and Southern leaders. While there is an undeniable effort to present these figures in the best light possible, there is enough of a sense of Ruskinian truthfulness in the painting to lift it out of melodrama and into the ranks of a work like Emanuel Leutze's image of *Washington Crossing the Delaware,* which was intended to inspire and nourish, at least according to its accompanying catalog during the tour it made of the United States in 1851. "This is a picture by the sight of which,

in this weary and exhausted time, one can recover health and strength." Though perhaps alien to our own time, the idea that art could inspire and nourish was an integral part of the idealism of the nineteenth-century cultural mentality.

While Julio's work may be clouded by the emotional response to the scene, it does herald an interest in realism and naturalism that would permeate much of Southern art in the years immediately following the war. Nowhere is that realistic impulse more apparent than in the works of the post-war Louisiana landscape painters, and nowhere has it been more ignored or misread.

The first and most significant of these artists is Richard Clague. In his life and art Clague represented the most substantial heritage of the old Louisiana families of French descent. Clague himself was of mixed parentage, his father being from the Isle of Man, England, but his mother, with whom he lived after his parents' divorce in 1832, was from an old Creole family, the de la Roches, and with his mother, they provided the young artist with his cultural orientation.

A review of Clague's youthful itinerancy demonstrates the breadth and sophistication of both his education and his exposure to prevailing French theories in art. He was in school in Switzerland and in Paris, as well as studying for some time with the New Orleans muralist and portrait artist Leon Pomarede. It was during the decade preceding the war that Clague began to realize his fullest potential as an artist, and throughout this period he continued to move back and forth, with apparent ease, between the world of the French academic artist and the provincial Louisiana painter.

While a nascent interest in realism is clear from the artist's hauntingly penetrating self-portrait of 1850, his familiarity with prevailing trends in academic art is also apparent in a portrait of Madame Rivière Gardère, painted in 1851, after a period of study at the École des Beaux Arts. That portrait has the quality of startled wide-eyed femininity that might be expected in the age of Bouguereau and Delaroche, with little hint of what was to follow.

During a trip down the Nile with the de Lesseps expedition in 1856, however, Clague began to combine a highly evolved ability as a draftsman with an eye devoid of sentiment and commentary. The de Lesseps expedition

drawings have a solid quality of light and shadow, fulfilling the artist's role as a painter and as an "artiste photographe," the term used to describe Clague's activities in the dispatches of the expedition.

Of course, throughout the 1850s all academic art was competing with photography in its first days as a popular fad. As it began to develop into a serious art form, it incited a realistic response in the artistic community that has not been fully explored, but which does seem to have had an impact upon Clague.

Clague returned to New Orleans in 1857, never to visit or work in France again. When the war came, he enlisted in the company of Colonel Mandeville de Marigny, and served as a second lieutenant in the New Orleans Blues, 10th Louisiana Infantry. Though nothing in the historical literature indicates why, he resigned his commission less than a year later, returning to New Orleans to live with his cousins, the de Brueys, whose portraits he painted in 1862.

The portraits of the de Brueys family by Clague represent the most important pieces of realist portraiture in the history of Louisiana art. Nothing has been done to flatter the sitters whatsoever. Madame de Brueys in particular is presented as a matron with a slightly drooping chin and mature gaze looking toward the viewer. While Monsieur de Brueys' eyes burn with a dark intensity, the receding hairline is not denied and there is a quiet wariness in the father's wartime gaze.

By 1867 Clague resumed a studio career and lived in the Tremé section of the city, a market spot on the lake side of the French Quarter. He painted and exhibited landscapes of the local area with considerable success, winning a gold medal for landscape art in 1868 at the Grand Mechanics and Agricultural Fair, an event organized and held in New Orleans as a means of encouraging economic recovery.

Clague's landscapes are not essays on the mystery, mood, and romance of Louisiana swamps and bayous. They are detailed studies of the countryside around the artist, which he was at his leisure to observe, whether during his visits to Spring Hill, Alabama, or the north shore of Lake Pontchartrain. Clague's cabin pictures, in particular, have a powerful, minimal honesty that transforms the humble vernacular shacks of hunters and fishermen into highly evocative statements of atmosphere, texture, and the very

RICHARD CLAGUE, Jr. (1821–1873), *Back of Algiers,* oil on canvas, 13¾ x 20 inches, undated, New Orleans Museum of Art, Gift of Mrs. B. M. Harrod.

nature of place.

In 1871 Clague moved across the Mississippi River to Algiers, a point opposite the French Quarter and reached by a ferry. Remote, somewhat desolate, far from scenic, and bordering on the seedy, this was the spot that provided the artist with the subject matter for one of his last and greatest works, *Back of Algiers.* Here is one of Clague's most subtle statements. A scene of the most basic components confronts us. A pool of water in the foreground reflects the light of the sky and the humid atmosphere. Across the river, and just barely visible on the horizon, are the spires of two great New Orleans ecclesiastical structures, the St. Louis Cathedral and the Church of St. Patrick.

There is no apparent sentiment in this scene unless one can derive a vague glimpse of the pastoralism of the Barbizon school in the placid cows

sauntering into the shed. This is a scene of life as it must surely have been during the 1870s when the Deep South struggled for economic recovery amid the rigors of Reconstruction. Compared with the literature of romance emerging in the same era and the hidden agendas of the genre painters working across that very river, it is a work of great penetrating reality.

Clague's death in 1873, from typhoid contracted while living in the Algiers section, was tragic, ending the artist's career while in its most mature phase at the age of fifty-two. One could have expected the artist to live far longer, perhaps achieving in his old age the same degree of success Martin Johnson Heade realized well into his eighth decade.

An obituary in the New Orleans *Bee* for November 30, 1873 closes, after some didactic remarks on the artist's discipline, with the remark that "What he did will live almost as a school itself." How true this statement is may be seen in the work of his most famous pupil, Marshall J. Smith.

Smith was born in Norfolk, Virginia in 1854 and brought to New Orleans as a child, perhaps before the war. His father was a successful insurance agent, with the means to send young Smith to Virginia to be educated. At this moment Robert E. Lee was developing his theories of education as a means of graciously accepting defeat and returning to cultural strength.

When Smith returned to New Orleans in 1869, he continued a study of art by painting with Clague in his studio in the Tremé section. He became, by all contemporary accounts, Clague's favorite pupil. Upon Clague's death Smith's father bought for him Clague's sketchbooks, and these Smith used to paint a series of cabin pictures on Lake Pontchartrain. While in exact compositional imitation of his teacher, they are far more brilliantly colored, sacrificing an interest in realism and naturalism for brightly colored atmospherics in the tradition of the lesser-known painters of the luminist movement.

However, in 1874 Smith left New Orleans for a period of study abroad including a critical time spent in the academies in Munich. When he returned to this country he began to paint a series of images of the Louisiana countryside that are far more naturalistic and controlled, and reveal his tremendous abilities as a master of subtle and sensitive brushwork.

The war had brought darkness to the South, in the form of economic

MARSHALL J. SMITH, JR. (1854–1923), *Bayou Plantation,* oil on canvas, 17 x 36¼ inches, undated, New Orleans Museum of Art, Gift of Mr. William E. Groves.

change, destruction, and privation. At the same time the tides of realism and naturalism, so apparent in the exploratory and historical works of Southern artists, were ebbing, the spirit of the new South began surging into the popular consciousness in the form of the genteel romances and children's stories of the 1880s and 1890s. Though they may be seen at this point as mildly subversive parables about racial relations, they represented to their own times the full expression of race and class distinctions existing in the ruins of an ancient and established culture seeking new ground.

To glimpse that art, and to experience the genteel South on its own terms is to leave the course and pattern of history behind and enter the far more seductive realm of artistic imagination.

III

GENTEEL
GLIMPSES

The social life formed of these elements in combination was one of singular sweetness and freedom from vice. If it was not filled with excitement, it was replete with happiness and content. It is asserted that it was narrow. Perhaps it was. It was so sweet, so charming, that it is little wonder if it asked nothing more than to be let alone.

THOMAS NELSON PAGE

III

GENTEEL GLIMPSES

A veil of sentiment is drawn between ourselves and a true understanding of the old South, a time we look back upon with both deep nostalgic longing and severe misgiving. So encumbered with illusion and so overshadowed by the implicit controversy of human bondage are those times that it is difficult to glimpse the substance in the shadow of an overwhelming mythology. Yet myths spring from human longing, and that which we consider trite in any popular culture is more than likely a manifestation of those longings in the human heart which mingle, in the words of T. S. Eliot, "memory and desire."

Thomas Nelson Page, in his post-war assessment of ante-bellum Southern culture, would have us believe that it was formed of elements of "singular sweetness and freedom from vice." Wrapping the ante-bellum South up in a restricting cocoon ignores aspects of life apparent in all cultures. It also does great disservice to the dynamic variety of peoples in social and economic interaction whom we have just seen depicted in the naturalist and realist modes of Southern art.

Page's theories and the theories of other post-war writers have been seriously challenged by successive generations of social historians. During the years of the Great Depression, W. J. Cash, a North Carolinian with a pronounced distaste for the Virginia establishment, wrote *The Mind of the*

South. With this volume he sought to puncture the plantation myth he laid at the doorstep of genteel Virginia legend. Documenting in statistical terms and cultural analysis the actual distribution of land, ethnic origins of the people, and per capita ownership of slaves created, for him, a truer understanding of the social and economic makeup of the ante-bellum South. Cash asserted that the old South was not a land of vast plantations with thousands of slaves, a land of "happiness and contentment," but a land of small farm holders, struggling to hold their own in the midst of an oppressive elite.

Southern inadequacy to grasp an accurate history was, to his thinking, a manifestation of a deep character flaw within the Southern personality. This was reflected in a "tendency toward unreality, toward romanticism, and in intimate relationship with that, toward hedonism." Be that as it may, at the same time Cash was seeking to find the real "truth" about the South, the Fugitive/Agrarian writers at Nashville were overhauling the myths of moonlight and magnolias and finding new critical strength in the presence of a symbol-ridden culture, prone to those very dualities of appearance and reality which they thought made good literature, even if they were not aware that it might make good art as well.

For these writers, the Southern character served as a symbolic line of defense against the debilitating intrusion of industrialization. Rather like their counterparts in the England of Wordsworth and Ruskin, they saw the encroachment of the industrial state as a genuine threat to individualism. John Crowe Ransom, in his keynote essay, "Reconstructed but Unregenerate," regards the affection the sentimental Southerner holds for Southern history as a "philosophy of establishing the foundation of the spirit." By holding to that idea, he writes that the "South may yet be rewarded for a sentimental affection that has persisted in the face of many betrayals."

Donald Davidson argues in his essay, "A Mirror For Artists," that Southern creativity should be directed towards diminishing the divisions between the reality and the sentiment of Southern life. To that end, art, art appreciation, and art museums should not be remote and merely the subject of cold antiquarian study, but a living organic force within the larger community.

Fugitive criticism, though never applied to the plastic arts, offers a much-needed challenge in our own time to regard the Southern art of the

past as a manifestation of Southern life and culture. Disparaging any notion of art appreciation which "requires me to think that a picture has some occult quality in itself and for itself that can only be appreciated on a quiet anonymous wall," Davidson declines to consider any work "utterly removed from the tumult of my private affairs."

Unquestionably, art tells us far more about what a people may aspire to, or at the most basic level of representation, how they would have themselves seen, than how they really were. The economic statistics of production, labor organization, and debt does cast the ante-bellum South in the same unfavorable light that might be shone upon the Romans who enslaved the Greeks for a great empire, or the medieval church which enslaved the peasantry in the name of great cathedrals, or the English who ended slavery but exploited native populations to build a global system of prosperity and progress.

In none of these instances is there a reluctance to view the art these cultures have left behind. Only in the consideration of Southern portraiture and genre painting does an uncomfortable feeling arise, because in these forms of art we are brought face to face with the most archaic forms of Southern social interaction, as remote to us now as a trite nineteenth-century novel of manners.

The clearest way to actually see a wide cross-section of the different peoples of the South is to look at the portraiture of the period. Portraiture is the most specific form of the visual arts. It involves an interaction between a sitter who has a clear objective and an artist who has a clear need. With this basic, indeed somewhat Marxist, set of circumstances in mind, it is easy to see nineteenth-century Southern portraiture as a visual document of social ambition and artistic talent.

Whether there was a more pronounced taste for portraiture in the South than in other parts of nineteenth-century America is a topic for further debate. However, the traditions of Southern portraiture remain the keystone of cultural studies in the area for two very distinct reasons: there is a large body of extant portraiture and a powerful oral tradition surrounding them.

The appeal of portraiture for a frontier people in the era before photography is obvious enough. Preserving the likeness of a family member or

recording some particularly critical event, such as marriage, the image of a child, or memorializing a dead loved one, was integral to the ritual of life. Portraits served two functions. They were decorative objects, indeed in many cases the only example of the plastic arts in the household, and they became important possessions for the owners. A preserved image, passed down from generation to generation, ensured a continuity in the family history and provided a source for family veneration. For these icons, the rural Southerner depended upon the itinerant artist.

The Southern artistic imagination loves the idea of an itinerant artist traveling from plantation to plantation taking likenesses. As with most myths, there is a substantial body of fiction and few attendant facts caught up in the story. The most troublesome notion in the mythology of the Southern portrait might be called the headless body theory. This theory asserts that many itinerant portraitists went about with fully-painted bodies upon which they applied heads as the occasion, or the market, warranted.

The most likely source for this idea is the frequent recurrence of stock poses within the canon of certain individual artists. Art training was a random matter in the early years of the Republic, when there were few art schools and almost no master teachers. Many portrait artists were but little removed from the sign painters and cabinet makers in the artisan community. Natural skill, some experience in the studio of an established artist, and perhaps a trip to a major urban area in the East would have been the extent of an artist's exposure to formal art aesthetics.

However, there are two basic skills which the portrait artist would have developed in order to pursue his trade. He would have mastered a technique for rendering an acceptable image of his customer; he would have some ability to set that image within a reasonable context. He would employ fashion and the style of the day in determining pose.

A lady posed with her arms decorously draped around the corner of a chair, a gentleman in stiff collar sitting upright at his desk, or a small child nestled in a mother's embrace are images found repeated again and again in the annals of portrait composition. A convention is a standard pose and a vehicle for proper presentation. Frequency of certain conventions leads the eye to conclude that objects composed in a similar manner actually have the same source and are indeed the same image except for a change of face.

Certain practical issues stand in the way of the headless-body theory. While paint on canvas has a certain elasticity, it would still be difficult to carry around rolled painted canvas with an intact image. In the marketplace these images might have a worn or frayed aspect which would not enhance their desirability. Furthermore, the psychology of accepting an alien body upon which one might allow one's head to sit is very disturbing.

Final evidence disputing the theory consists of the objects themselves. There are no known extant canvases upon which one may see a headless body. On the other hand, there are many floating heads, attached to no body, which reveal the technique of the portraitist.

It seems far more likely that the portrait artist traveled with his basic materials from plantation to plantation or from seasonal studio to seasonal studio seeking commissions. When he set up for the portrait sitting, his first effort would have been to prepare the canvas and begin sketching in the facial details, completing that process in a relatively short time through repeated sittings. It then seems likely that the sitter departed the studio, or the assigned room in the house, and the anatomical features, background drapery or other details were painted according to the terms of the commission.

The Itinerant Artist, a painting by Charles Bird King, himself an itinerant in the upper South, illustrates the points at hand. A traveling artist sits before his easel, upon which we can clearly see a canvas with the head of a woman. The subject sits before him, calm, dignified, and with a determined air, hopeful of being captured in the best possible light.

As a genre painting, the work is also interesting for the spatial arrangement and the assembly of characters. At the foot of the mistress of the household sits a young black girl, absorbed in the proceedings. An older woman, who we can assume is the sitter's mother or mother-in-law, leans over the canvas with a critical attitude. Various children scramble about the room, the painting of which offers a delightful glimpse of rural material culture. Large, full of hanging hams and storage racks, it is the all-purpose assembly room. Through the door on the left we can just see the man of the house departing, gun in hand, to hunt. In the background we are able to see into and through a bedroom, bright, sunlit, and tidy, in contrast to the great room of the modest cabin.

Most important for the saga being told is the actual canvas before the artist. As we can see, he is using a painter's stick of a nineteenth-century type to judge perspective and assist in placing the figure on the picture plane. There is no headless body, but rather a head floating above an anatomical outline.

All of these proceedings are in keeping with William Dunlap's account of Charles Bird King's technique, recorded in *History of the Rise and Progress of the Art of Design in the United States*. Dunlap, himself a painter, and the chatty chronicler of the art of the young Republic, was dubious of King's inventions. "He has contrived several mechanical machines for facilitating the labor of artists. He uses a slender rod of wire about a foot long, to ascertain proportions of his picture compared to the original. It is gauged with white paint, about an inch from the top, which is held upright at such a distance from the subject as to effect one division—the face of a sitter for example." Dunlap continues to observe that by "applying this gauge to the picture you may correct the proportions. But all mechanical aids are mischievous. The artist should depend alone on his eye."

Sitters were most often interested in having their likenesses taken in the most current mode. When Mary Ann Randolph Custis Lee wrote home to Arlington concerning her portrait and that of her husband Robert, she asserts that William Edward West was fine for the young Lieutenant Lee. "But as for me, I prefer Sully." Sully and West had both been itinerant artists in their youth, working in different parts of the South. They are but two of what must have been several hundred painters working with diverse ability upon very diverse paths.

While it seems unlikely that frontier limnists carried around fully-painted bodies onto which heads were rendered from life, they were, nevertheless, messengers of prevailing taste glimpsed from academic sources and displayed to a hungry provincial gentry anxious to demonstrate sophistication.

Itinerant may be defined in two ways. First there were those artists, of all types, who simply wandered from place to place seeking work. Charting their course is a matter of determining principal trade and travel routes, as well as locating objects rendered on site, which have not moved. Thus, fifteen portraits scattered across three states tell us something about one

CHARLES BIRD KING (1785–1862),
The Itinerant Artist, oil on canvas, 44¾ x
57 inches, c. 1850, New York State His-
torical Association, Cooperstown.

kind of itinerancy.

Within the framework of a more substantial itinerancy, it can be determined that a group of artists, interconnected by family and profession, made regular trips to certain areas of the South over a long period of time. These artists created a body of work, resonant with the tenor of their native locale projected into the visitation site. The Kentucky painters who worked in Mississippi between 1810 and 1860 represent one of the most precisely identifiable schools, sharing as they did common sources for composition and commission. This knowledge provides the means for a rather exciting archaeological effort: if a specific Southern style can be defined in the Bluegrass, then it can be excavated in the Delta.

William Edward West, Matthew Harris Jouett, and Joseph Henry Bush were three Kentucky itinerants whose work offers the best examples of communicating a prevailing high style into a provincial circumstance. All three were influenced by the neo-classic portrait as defined by Gilbert Stuart and romantically interpreted by Thomas Sully. West and Bush even sought out Sully, and Jouett has the distinction of being one of Stuart's last pupils. All three artists were from Lexington and followed the great river downstream to Natchez and New Orleans, keeping company with Kentucky hemp and Louisville flatboatmen, between 1815 and 1825. The portraiture these members of the Kentucky School created at each stop is marked by insight and a distinct style.

For sheer effective use of paint and subtle interpretation of character, the portrait of Joseph Emory Davis by West may be the best work from his Natchez period. Davis was a learned lawyer and the guardian of his youngest brother, Jefferson Davis. Joe Davis accumulated a magnificent library for his plantation, The Hurricane, which was used for kindling in 1862. There is a probing quality to this portrait and a spare neoclassical elegance. The muted background, vivid jabot, and deep eyes combine to make it a masterpiece of minimal restraint.

West left the Deep South in 1819 for further study in Florence. While there he painted Lord Byron, and after a rather exuberant life on the continent and in England, he landed back in Baltimore in 1837, in time to paint the Lees and further compliment Sully's introduction of romanticism into Southern portrait styles.

WILLIAM EDWARD WEST (1788–1857), *Joseph Emory Davis,* oil on canvas, 22 x 27 inches, c. 1818, Percival T. Beacroft, Jr., Rosemont Plantation, Woodville, Mississippi.

Jouett would be dead by then, a victim of "bilious fevers" in 1827 at the age of thirty-nine. He left behind a somewhat uneven body of work, which continues to inspire interest because successive generations of Kentuckians have always considered him an "old master of the Bluegrass," to use the term applied by Samuel Woodson Price, a Kentucky art historian.

Jouett seems to have learned from Stuart directly what Sully had learned and passed on to West: the importance of mixing spirits of turpentine in the white drapery of the portrait. "It assists to evaporate the oil & leaves the white a standing white & free from the yellowness occasioned by the oil," to quote Jouett on Sully. So it is that we are very conscious of an ecstatic,

vibrant whiteness about the fabrics of many of Jouett's works, giving the amusing characterization a jumpy, kinetic quality, in which the face is often besieged, especially in the case of the ladies, by a wealth of anxious lace. Jouett's portrait of Henry Clay offers none of the insight that West gave to the identity of Joseph Davis, while repeating the exact composition. Jouett is thought to have had little admiration for the "Great Commoner" as Clay was called, though Clay was certainly a generous patron of the Kentucky School.

Clay provided Joseph Henry Bush with the money to travel to Philadelphia and study with Thomas Sully. Twice he forwarded additional sums to Bush, until the young painter returned to Lexington in 1818. Thereafter he began his Southern journeys. Bush was more truly itinerant than either Jouett or West. While those tended to establish seasonal studios in Natchez or New Orleans, Bush seems to have wandered from plantation to plantation, at least in his youthful career. During this time, playing upon certain romantic techniques of Thomas Sully and Thomas Lawrence, he developed a very distinct style.

What is particularly interesting about Bush's later style is a tendency to stack the heads of his subjects, often placing a parental figure in the air, over two children. This exaggerated composition, part affectation, and in part a clever means of compressing a group of figures onto a limited expanse of canvas, may be seen in several of his lower Mississippi River Valley works.

The portrait of the sons of Henry and Frances Minor Chotard of Natchez is a contrasting example. Here the heads are reversed, with the two older brothers stacked on top of the youngest brother. The boys look out from a rondel of the sort made popular by Rembrandt Peale in his famous porthole portraits of Washington. The highly stylized and very perky lips on these boys is a convention that Bush frequently employed in the 1830s and 1840s. The work is remarkable, warmly colored, and composed in a manner at once sentimental and clever. Imagine getting the three boys to sit in such close proximity for the entire length of the composition!

West, Jouett, and Bush were not the only itinerants working in the Deep South. Other examples abound. A mysterious painter named C. R. Parker worked from Savannah to New Orleans and back painting hundreds of works with the exact same anatomical composition making him the leading

MATTHEW HARRIS JOUETT (1787–1827), *Henry Clay,* oil on panel, 30 x 25 inches, c. 1818, Diplomatic Reception Rooms, U.S. Department of State. Jouett painted Clay from life in 1816. This portrait is a replica of that work which now hangs at Ashland, the Clay estate in Lexington, Kentucky. Clay was Speaker of the U.S. House of Representatives and was beginning to test the waters of diplomacy as well; indeed, by 1824 he was Secretary of State. Jouett had apparently made his first trip to the Deep South as a part of the great Kentucky-Mississippi Itinerancy. Most importantly, Jouett had travelled to Boston in 1816 and studied with Stuart. He was a far better mimic than painter and he adapted Stuart's neo-classical technique brilliantly, combining it with his own slightly whimsical compositions which have a certain folksy charm. At his best, however, as in this work, he was a penetrating interpreter of the prevailing high style. (The definitive works on Jouett are by William Barrow Floyd, *Jouett-Bush-Frazier, Early Kentucky Artists,* privately printed in Lexington in 1968, and the catalog *Matthew Harris Jouett, Portraitist of the Ante-Bellum South,* which accompanied an exhibition at Transylvania University in 1980. See also, E. A. Jonas, *Matthew Harris Jouett, Kentucky Portrait Painter,* Louisville: J. B. Speed Memorial Museum, 1938. Jouett's itinerant work is discussed in the author's article, "The Kentucky-Mississippi Itinerancy: West, Jouett, Bush and Lambdin" *The Southern Quarterly,* XXV, No. 1, pp. 3-21.)

JOSEPH HENRY BUSH (c. 1800–1865), *The Chotard Boys*, oil on canvas, 24¼ x 30¼ inches, c. 1838, from the collection of Mr. and Mrs. Richard D. Chotard, Jackson, Mississippi. The three Chotard boys are Richard DeMeyere Chotard, John Charles Chotard, and Henry Chotard, the sons of Henry and Frances Minor Chotard of Somerset Plantation in Natchez.

candidate and perhaps perpetrator of the headless body theory.

Several international artists worked on the Mississippi as well. Trevor Thomas Fowler, a first-rate Irish painter, rendered several children's portraits with considerable skill. Most important, perhaps, were the French painters who worked among the Creole aristocracy in New Orleans. Through interaction with the legions of young American artists appearing in the city, they assisted in turning taste away from the more minimal efforts of the neo-classicists towards a coy and courtly demeanor.

With the rise of photography in the 1850s the taste and demand for portraiture began to diminish, but not before several artists painted mourning portraits for the benefit of grieving parents or spouses. The tradition of

mourning portraiture is an old one, and evidence survives in the canon of art from the Renaissance on. However, in the decade before the war, these works take on an especially ghoulish urgency. Often the portrait artist had daguerreotypes or photographs to work from, some made from posing the dead in a suitably dignified manner suggesting they were "not dead, but merely sleeping."

In at least one rather remarkable instance, the portrait commission made direct use of an inspiration print for the composition. The artist was William Browning Cooper, one of two Cooper brothers, the other being Washington Bogart Cooper, who had successful careers in middle Tennessee, often traveling into northern Alabama and Mississippi as well. Despite a certain confusion about the actual style of each in their first phases, their works display skill and originality.

William Browning Cooper received one of his most provocative commissions in 1853. Mrs. John Bell Hamilton was the mother of Izora Hamilton Wilson, who died after the birth of an infant son, himself a fatality some twelve hours later. Mrs. Hamilton asked Cooper to paint the portrait of her only child and grandchild in death, with herself in an attitude of reverential mourning, seated beside the dead bodies.

Above their heads floats an angel, aglow with a celestial light and pointing the way towards heaven. The angel was drawn from the print of Daniel Huntington's *Mercy's Dream,* one of the icons of the Gothic Revival movement in America, and distributed by the American Art Union as a part of the same series that had made Bingham's work famous.

Though one of the most disturbing works to survive from the antebellum period, Cooper's work is an awesome statement of loss and suffering. By family tradition the work was hung with a protective drapery. Only the face of the grandmother and the angel were visible. Upon discreet inquiry the drapery could be pulled back and the departed mother and child revealed.

Deathbed scenes and dying words obsessed the mid-Victorian mind throughout the English-speaking world. Robert Weir's painting of *The Last Communion of Henry Clay* offers a dignified and fitting tribute to a man who spent much of his life, as a Southerner, attempting to save the Union and continue the elasticity of the Constitution he so respected.

WILLIAM BROWNING COOPER (1811–1900), *Mrs. John Bell Hamilton,* oil on canvas, 48 x 42 inches, 1853, Mr. and Mrs. Howard Williams Cater, Jr., Birmingham, Alabama.

Clay was always the favorite son of the Southern moderates. His four runs for the Presidency were prompted by a deep personal ambition, but sustained by considerable support in the Deep South. Following the election of 1824 he was held responsible for the defeat of Andrew Jackson when the vote was cast in the Congress to break the stalemate of an insufficient plurality. Though he never recovered the national momentum he had at that time, he remained a powerful centrist force. Twice, in 1820 and 1850, he played a prominent role in the compromises which saved the Union.

The strains which the Compromise of 1850 wrought upon the triumvirate of Clay, Daniel Webster, and John C. Calhoun proved to be the final blow to their aged constitutions. By 1852 they were all dead, Clay being the last to go. One of his biographers, Clement Eaton, notes that he died with "calmness and fortitude."

Robert W. Weir's fanciful depiction of that scene is painted with as much piety as may be seen in the Cooper mourning portrait of the Hamilton family. Weir was a devout Episcopalian, who approached "religious painting not simply as an academic exercise," according to Kent Ahrens, "but also as a means of inspiring the faithful with religious zeal." Here we see Clay, known more for an energetic political disposition than a pious devotion, upon his death bed.

An Anglican clergyman hovers nearby, ready to deliver the final communion. In the absence of the stateman's family, a black servant kneels by his bedside, symbolizing the devoted followers who would subsequently turn out by the thousands to pay their last respects. On the window ledge, illuminated by the light pouring through the window are symbols of mutability, the watch and the vase of flowers.

Clay sits up in bed with the same attitude of calm which Eaton reports. According to one nineteenth-century biography, he "remained a winner of hearts to his last day." The eulogies spoke of his "lofty patriotism" and he was memorialized with a great tomb in the Lexington, Kentucky cemetery. Within eight years the order he sought to maintain dissolved in Civil War. Outside Kentucky his reputation has not survived the passage of time, and at this writing there are no biographies of him in print. *Sic transit gloria mundi.*

Passage of a more fervid and sincere type is to be seen in John Antrobus'

ROBERT WEIR (1803–1899), *The Last Communion of Henry Clay*, oil on canvas, 28⅛ x 35¾ inches, 1852, Robert M. Hicklin Jr., Inc., Spartanburg, South Carolina.

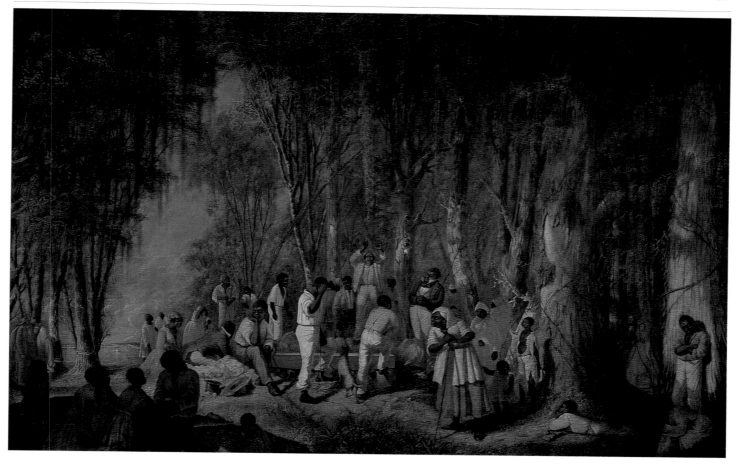

JOHN ANTROBUS (1837–1907), *A Plantation Burial,* oil on canvas, 52¾ x 81⁵/₁₆ inches, 1860, The Historic New Orleans Collection, Museum/Research Center, Acc. No. 1960.46.

A Plantation Burial which was painted and exhibited in New Orleans in 1860. Religion was a profound emotional outlet for the slave. As analyzed in Eugene Genovese's *Roll, Jordan, Roll,* it becomes a tool for passive resistance. The gospel hymns which sing of freedom on the other side of the river are anthems which herald the arrival of change.

Here, a compendium of faces, as exactly composed as a Baroque mortality piece, conveys attitudes from despair to boredom. So clearly is the focus upon the activities of the slaves, that the master and mistress are only remote figures, hidden in the forest shadows on the right. Antrobus' work is a rather unusual and sensitive treatment of the black as subject matter in an ante-bellum painting, and this by an Englishman who did enlist in the Confederate Army. Once the war was over, the black became a far more familiar figure in the genre painting of the Reconstruction era.

Of these works, the best known at this time are the paintings of William Aiken Walker, a native of Charleston, South Carolina. During the late

nineteenth century he was an active itinerant in the manner of the older portraitists, creating imaginary scenes of blacks and selling them in resorts from St. Augustine to New Orleans.

The paintings of William Aiken Walker have recently secured a place in the genre painting of the South that is at once enviable, expensive, and provocative. While neither works of social realism nor works of particularly sensitive cultural insight, they seem to appeal to Southerners and Northerners, and even to Europeans, if recent international auction records are a gauge.

Precisely who we see when we gaze through the narrow window opened by these tiny and intricately painted little pictures is not a mystery at all. Wandering about in cotton fields, standing in front of forlorn cabins, or en route to Natchez or New Orleans are the former slaves of the old South. Though there is a strong strain of caricature in their depiction by Walker, his paintings provide the same glimpse into the imagined life of a people that is to be seen in the portraiture of the less ambitious itinerants.

The enormous social and political tragedy of slavery came to an abrupt end, anticipated by the Emancipation Proclamation in 1863, and arriving with the cessation of hostilities between North and South when the surrender was signed at Appomattox Court House in April, 1865. Overnight, thousands of slaves became freedmen, under the care of the Freedmen's Bureau which was to supply each of them with forty acres and a mule.

In actuality, the world of sanctified freedom was far more frightening. Nothing in the background of these people had prepared them to live in a society where they cared entirely for themselves. Obtaining the most fundamental necessities of life posed a nearly overwhelming challenge, which might have proven to have had the same instructive quality experienced in colonial cultures had not the circumstances been so dire. The South was no longer a primeval wilderness with abundant natural resources, peopled by aboriginal tribes who could be displaced by force.

Lacking education and gaining freedom without opportunity, and more importantly without access to capital, the former black slave faced a land devastated by war. They shared this land with what remained of the old order, seeking through the bitterness and hope of reconciliation a new world whose social boundaries were unclear.

WILLIAM AIKEN WALKER (1838–
1921), *In the Cottonfields,* oil on canvas,
20 x 12 inches, c. 1885, The Morris Mu-
seum of Art, Augusta, Georgia.

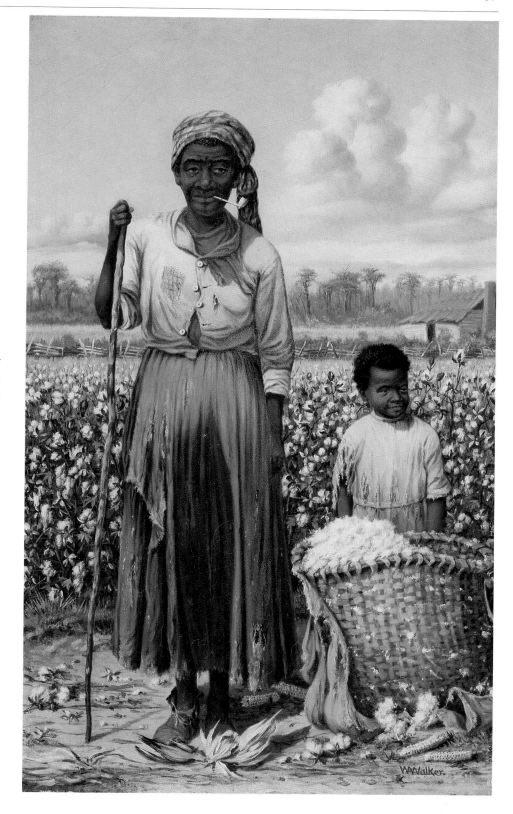

In the first months after the war a widespread chaotic migration took place throughout the South. Thousands of former slaves left the plantations on which they had been held and flocked to the cities, depleting the rural labor force and creating enormous social problems in the cities. Many followed the federal forces, seeing them as saviors of religious proportions. Once disillusioned, or frightened, they returned to rural cabins.

Like those blacks described by young Bayard Sartoris in William Faulkner's novel, *The Unvanquished,* these former slaves came back to "find their families and their owners gone, to scatter into the hills and live in caves and hollow trees like animals...not only with no one to depend on and no one depending on them, caring whether they returned or not or lived or died or not: and that I suppose is the sum, the sharp serpent's fang, of bereavement and of loss...."

When the high tide of social change began to subside, and the days of Reconstruction fervor passed, the black laborer found himself in a position little better than he had known under slavery. Although free, he now faced the political backlash created by the vituperative nature of the Reconstruction Congress. To some extent the black was caught in an unfortunate middle between Southern and Northern extremes. Both factions were seeking a new national order, but each side had a different agenda.

Throughout the decades of the seventies, eighties, and nineties, a literature of longing for the self-fulfilling securities of a bygone era, an era of imaginary proportions created and sustained by the cultural establishment, emerged from the popular presses with great financial success and widespread public response. As the American public recoiled in guilt and reached for nostalgia brought on by the internecine conflict, reform gave way to the familiar, and those unable to fit into the accepted order were largely ignored.

Much of this retreat might be seen in the spirit of the nation on the eve of the Philadelphia Centennial. The celebration surrounding that event inspired a new admiration for a colonial American past which had little foundation in reality, but a jingoistic appeal to the public.

Events during the summer of the Centennial did not bode well for the peace constructed by the Republican Party. Still waving the bloody shirt of conflict, the Republicans faced a South beginning to emerge from the war,

with Bourbon politicians who were willing to join forces with the agricultural interests of the western states to elect the Democrat, Governor Samuel J. Tilden of New York, to the presidency. When they succeeded, the Republican-controlled Congress managed to have the electoral votes of Florida and Louisiana held in dispute. Through the compromises which followed, a new freedom was secured for the white Southerner, while the black field hand was consigned to continued poverty and neglect. When Rutherford B. Hayes was inaugurated, Reconstruction ended and the last of Federal forces occupying the South departed.

It is tempting to think that it was at this moment in the political and cultural life of the nation there came into being those stereotypes of the black, as depicted in the writings of Thomas Nelson Page and Joel Chandler Harris and in the paintings of William Aiken Walker. For it was at this moment in the life of the nation that the social roles of blacks and whites jelled into the stratifications they would occupy for seventy-five years. From the end of Reconstruction until the Brown v. Board of Education ruling in 1954, the nation indulged itself in notions of separate but equal and saw the black as a faceless stereotype, sometimes loving and devoted, often talented, but always considered inferior.

To reinforce that division, a wide variety of acceptable patterns of genteel behavior emerged as the stock of popular culture. The passive white female, the dominant white male, and the innocent white child through whose eyes the world is seen became the stuff of novels and theatrical melodramas. The dependence of these figures upon a kindly black sharecropper or house servant lends a note of curious ambiguity to the entire scenario. Frequently the black figure is wise and compassionate, teaching the child more through fable than it is likely to learn through observing the actions of those around him.

Joel Chandler Harris' *Uncle Remus* stories, which were first published in 1880, combine paternalism with what appears to be a sincere interest in preserving an important oral tradition. Harris, in his introduction to the volume, makes the very earnest statement that his "purpose has been to preserve the legends themselves in their original simplicity." To do so, he tells the stories "through the medium of which they have become a part of the domestic history of every Southern family."

We should not allow the lens of our own time to obscure cultural motivations which now seem to us to be, at best, quaint, and in the worst scenario, cruelly stereotypical. Many writers in the late nineteenth century used the medium of dialect to give their works a rich flavor, which they believed preserved a certain indigenous spirit. The poems Rudyard Kipling wrote about the foot soldier of the British Army in India offer an interesting parallel. Closer to home, the stories of George Washington Cable, told in *Old Creole Days,* have a similar agenda, but a vastly different goal.

Our sense of who a people may be and what substance their cultural patterns or oral history may have is directly related to the way in which they speak. For the past two hundred years there has been a steady homogenization of language, sharply focused in our own time by the foolish consistency of droning videos. But language can be a way of classing and categorizing people, and in a moment of fierce irony, no one should be more aware of this than Southerners, whose broad vowels and languid diphthongs have often caused them to be dismissed as hicks.

In his introduction to *Uncle Remus* Harris does make a serious comparison of his work to the efforts of several well-known late-nineteenth-century cultural anthropologists. John Wesley Powell of the Smithsonian Institution and several English writers concurred in the worthy intent of preserving the Uncle Remus stories. At the same time Sir James Frazer was collecting the archetypal remnants of western civilization and laying the groundwork for Carl Jung, Harris' little boy, whose nights with Uncle Remus were as "entertaining as those Arabian ones of blessed memory," was listening to another episode in which Brer Fox and Brer Rabbit acted out the ancient drama of seduction, betrayal, and heroic triumph.

Joel Chandler Harris had another agenda, however, one that provides a more unsettling backdrop to paintings like Karl-Wilhelm-Friedrich Bauerle's *The Old Plantation Hand.* At the conclusion of his introduction Harris asks his reader to imagine that the stories Uncle Remus tells are imparted by one "who has nothing but pleasant memories of the discipline of slavery." With that in mind, Harris reassures us, we can have little trouble "sympathizing with the air of affectionate superiority which Uncle Remus assumes as he proceeds to unfold the mysteries of plantation lore to a little child who is the product of that practical reconstruction which has been

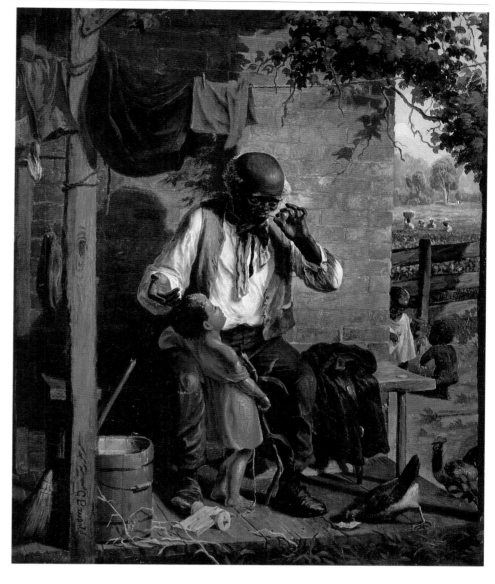

KARL-WILHELM-FRIEDRICH
BAUERLE (1836–1912), *The Old Plan-
tation Hand,* oil on canvas, 20¼ x 16¼
inches, undated, Robert M. Hicklin Jr.,
Inc., Spartanburg, South Carolina.

going on to some extent since the war, in spite of the politicians."

This is a very chilling idea to be told in such friendly terms, for it
suggests that slavery was a benign means through which the black African
could be absorbed into the great democratic experiment. We must remem-
ber U. B. Phillip's admonition, expressed in his essay, "The Central Theme
of Southern History," that slavery was "defended with vigor and vehemence
as a guarantee of white supremacy and civilization. Its defenders did not
always take pains to say that this is what they chiefly meant, but it may nearly
always be read between the lines, and their hearers and readers understood it
without overt expression."

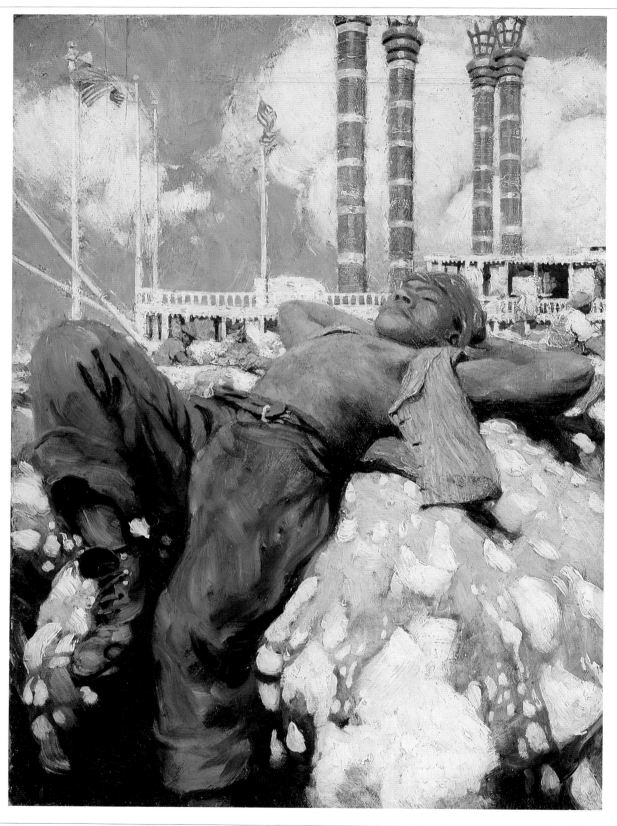

To Phillips' remarks it seems appropriate that we should append the phrase, "see it," as well. For what we see in the art of William Aiken Walker and many other painters of black genre scenes is the hidden agenda of racial prejudice. To balance that agenda with a genuine regard for the historic existence, as well as the contribution, of the black to Southern life and culture is to go to the very heart of the ambiguity upon which a love of the South and an awareness of her problems rests.

While these images and attitudes now seem remote, condescending, and discriminatory, they served a specific social function. By creating a lens through which the disparate elements of two cultures bound together in paternalism and strife could be seen at some basic level of emotional and economic interdependence, the art of the period created an organic unity. Though one-dimensional, the legions of benign black figures from Uncle Remus to Faulkner's Dilsey possess philosophic minds unrestrained by caste or race.

Developments in the uses of black figures in the visual arts have a more international cultural specificity. Images of the rural laborer had come to be identified in the minds of many American and European painters with the flight from the savage inhumanity of the emerging industrial state. As experienced in the art of certain French Barbizon school painters, these humble workers became figures of great appeal, the first anti-heroes, epitomizing the virtues of rural life, a romantic yearning at one with the pensive mood of nineteenth-century art.

Rural workers, black or white, standing in the field and contemplating the rising or setting sun, or bending to the back-breaking effort at hand came to be the standard fare of the middle-class home, emblazoned in vivid chromolithography, framed in gilt.

The archetypal man with a hoe was a symbol of virtue, piety, noble individualism. To our eyes he is seen in condescending terms, denied humanity at the level of human expressiveness, locked into a system in which he is tragic victim and heroic exemplar. The complexity of both our response and the psychological projections of the nineteenth century rests in the very need to "see" such an individual in so elaborate a disguise.

Developments in the larger arena of American painting of the same period in which Walker was working demonstrate that a number of Ameri-

THORNTON OAKLEY (1881–1953), *Stretched Out, Basking in the Torrid Glare,* oil on canvas, 22 x 16 inches, undated, Robert M. Hicklin Jr., Inc., Spartanburg, South Carolina.

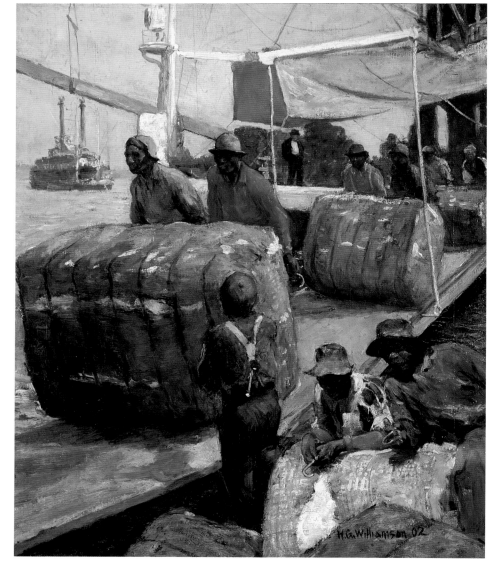

H. G. WILLIAMSON (?–1937), *Loading Cotton Bales on a Southern Wharf,* oil on canvas, 23½ x 19½ inches, 1902, the collection of Jay P. Altmayer. Life dates are uncertain for Williamson, but he is known to have been a member of the Society of American Illustrators at the turn of the century. This work has the look and feel of an illustration which may have appeared in a popular journal of the time. The element of realism in the laborers' faces and the lack of sentiment in their depiction renders this an unusual black genre painting, especially when compared to the later work of William Aiken Walker.

can artists used black life and black figures with varying degrees of sensitivity. Of these, perhaps the most outstanding is Winslow Homer. Homer's tour of duty in the Virginia Theatre during the war resulted in a series of paintings that evoke the full power and ambiguity of the new relationships between black and white.

A Visit from the Old Mistress is perhaps the most successful of these paintings. It has a stage-like quality, for the old mistress has entered from the right and greets a group of former slaves, who have arranged themselves like a dubious chorus on the left. It is not a scene of sentimental rejoicing, but one of a mildly contemplative nature. The black women gaze at the visiting

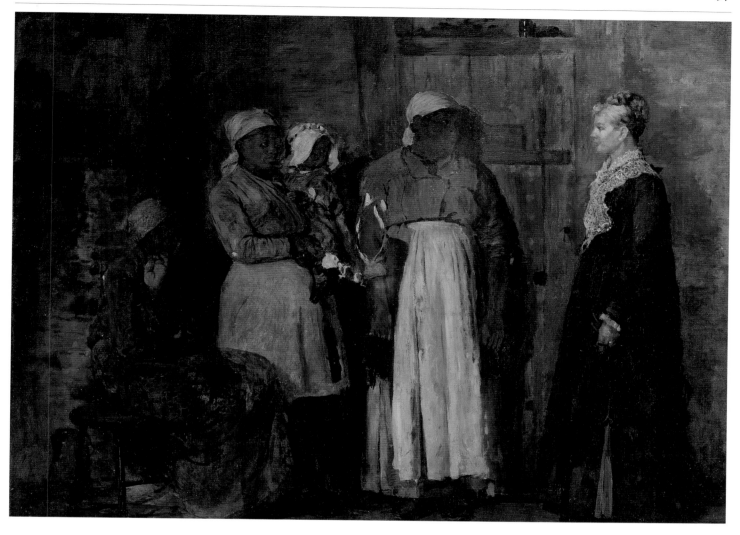

WINSLOW HOMER (1836–1910), *A Visit from the Old Mistress,* oil on canvas, 18 x 24⅛ inches, 1876, National Museum of American Art, Smithsonian Institution, Gift of William T. Evans.

white woman with an air of vague interest, to which she responds with a similar awkward air. As the two principal figures, black and white, face each other in profile, it is tempting to see this confrontation as a draw, albeit a cordial one.

However insightful we may consider Winslow Homer's art to be, it was not in the mainstream of popular American culture, nor, save for the fact that it depicts a Southern scene, can it really be considered Southern art. Popular literature and popular art in the years after the war were preoccupied with images of a lush landscape, beautiful happy children, dreamy women standing in the moonlight by garden gate or columned mansion. Though many of these images were not created by Southerners, they depended upon the genteel mythology of the old South for success.

ALFRED WORDSWORTH THOMPSON (1840–1896), *Southern Landscape with Children,* oil on canvas, 14 x 20 inches, 1880, photograph courtesy of Robert M. Hicklin Jr., Inc., Spartanburg, South Carolina. Thompson was born in Baltimore, Maryland to a family with very clear Southern sympathies and little interest in his career as an artist. Although intended for the practice of law, he instead opened a studio on Mulberry Street. During the first year of the war he worked as an illustrator for *Harper's* and *Illustrated London News*. However, he spent most of the war years studying in Paris perfecting his technique as a genre and landscape painter. Upon his return, he too worked in the Tenth Street Studio Building, and like his peers Homer and Eastman Johnson, he sought out Southern themes. In the 1870s and the 1880s he worked in the Carolinas, perhaps the site of this work. An important painting, *Virginia in Olden Time* (1875), was shown at the Philadelphia Centennial of 1876 and was a work very sympathetic with the ideas of Thomas Nelson Page and the emerging moonlight and magnolia school. (See Alfred Wordsworth Thompson file, manuscript collection, New York Historical Society.)

JOHN BEAUFAIN IRVING (1825–1877), *The Patient Fisherboy,* oil on canvas, 18⅜ x 14 inches, 1873, private collection.

JOHN BEAUFAIN IRVING (1825–1877), *Little Johnny Reb,* 18½ x 14 inches, 1866, Robert P. Coggins Collection of Southern American Art. The similarity in sizes between these two paintings suggest that although they were painted at different times, they do have a pendant quality and represent a formulaic approach to genre painting on Irving's part. As he maintained a space in the prestigious Tenth Street Studio Building in New York City, he came into contact with the most important American artists of the period, a contact and continuity further insured by his membership in the National Academy of Design after 1872. Irving was married to the former Mary Hamilton and was the father of eight children, two of whom may have figured in these works. A benefit was held for his family by his patron August Belmont after his premature death. (See Bruce Chambers, *Art and Artists of the South: The Robert P. Coggins Collection,* Columbia: University of South Carolina Press, 1984.)

One Southerner who did create sentimental genre painting in the aftermath of the war was John Beaufain Irving. Irving was from a Charleston family ruined by the war. Throughout Reconstruction he lived in New York, painting images of the vanished courts of Europe and occasional works with Southern themes. *Litte Johnny Reb* and *The Patient Fisherboy* owe far more to the tastes of John George Brown and Seymour Joseph Guy than to any indigenous aspect of a Southern art movement. Bruce Chambers' observation that *Little Johnny Reb* possesses a "curious sentimentality in the immediate aftermath of the nation's most destructive war" rings true. Surely Irving was far more committed to the sentimental possibilities of a child than to the frightening implication that he might grow up and take part in yet another bloody battle. But sentiment would prove to be the soothing balm for the ravaged Southern soul and much of that balm would be applied through the medium of popular prints and genre paintings.

In the years immediately after the war, Currier & Ives had their greatest success with prints based upon Southern themes. An entire run of prints ignored both social and economic reality, depicting the happy content of former slaves, the great prosperity of the planter class, and the enduring pastoral beauty of the Southern plantation setting. Although entirely divorced from the realities of the severe economic depression of the Reconstruction era, they reflect some popular will that the great devastations of the war be forgotten, even if old times there are not. In each of these prints a full vocabulary of symbolic form conveys a comforting message.

The Mississippi in Time of Peace is a work of fantastic implications. Down a long run of rippling water we can look towards a benign life-giving sun illuminating the scene in a warm glow of prosperity and harmony. Activity is divided neatly between left and right. On the left we can see a steamboat tied up at a plantation dock and receiving the crops from the hands of anonymous servile workers. On the right, huge steamboats in a long line are making their way up and down the river, with all the grandeur and stateliness which befits their role as vehicles for commercial success. Moving toward the foreground with an amusingly archaic motion in the face of more rapid progress are the imitations of Bingham's flatboatmen...still jolly, still sitting on top, still dancing.

Remnants of the romantic landscape abound...looming cypress and live

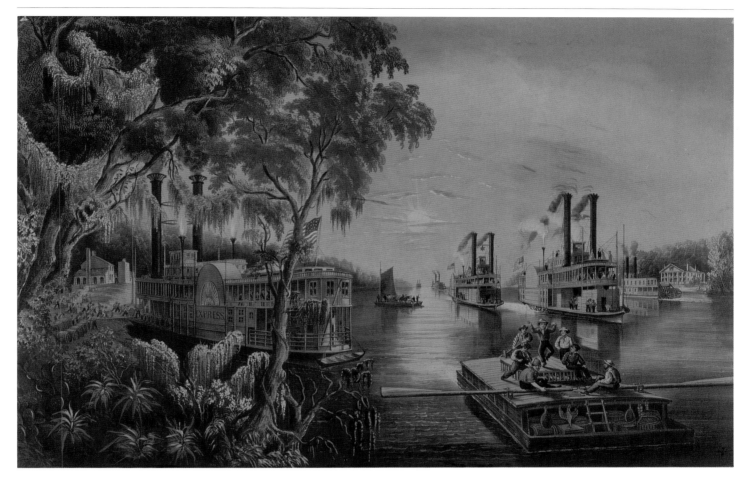

FANNY PALMER (1812–1876), Currier & Ives, *The Mississippi in Time of Peace,* hand-colored lithograph, 18¼ x 27⅝ inches, 1865, Engineering-Transportation Library, The University of Michigan. Fanny Palmer was one of the most prolific artists working in the Currier & Ives firm. She was a native of England, but moved to this country with her family in the early 1840s. Originally, her husband Edward Palmer was the principal designer, but as he was a drunk, she soon became the breadwinner for the family and is thought to have been continuously involved with Currier & Ives from 1845 to 1876, working until the time of her death. She is thought never to have been in the South which makes her fantasy images of Southern life even more appealing as an act of imagination. (For an account of her relationship with Currier & Ives, see Harry T. Peters, *Currier & Ives, Printmakers to the American People,* Garden City, New York: Doubleday, Doran & Company, 1942.)

JULIAN SCOTT (1846–1901), *Surrender of a Confederate Soldier,* oil on canvas, 20 x 16 inches, 1873, the collection of Jay P. Altmayer. Scott, a native of Vermont, enlisted as a musician with the Third Vermont Regiment and became the first man to receive the Congressional Medal of Honor for bravery on the battlefield. After the war he became a member of the National Academy and painted a series of genre works. This painting offers a symbolic compendium of Southern types...the surrendering soldier of Celtic coloring, submissive but noble in attitude and bearing, the frail wife and child sitting on the road by his side, and the black slave standing in attendance behind him. Such depictions reflect the respect which emerged after the war for the determination of the Southern soldier, a respect enhanced by the growth of the cult of Robert E. Lee admirers after 1870.

ROBERT LOFTIN NEWMAN
(1827–1912), *Girl Blowing Soap Bubbles,*
oil on canvas, 10 x 7⅛ inches, undated,
Dr. and Mrs. Glenn H. Shephard, New-
port News, Virginia. Newman was born
in Richmond, Virginia, but grew up in
Clarksville, Tennessee where he painted
two monumental group portraits of the
Warfield family while still a young man.
He studied in Paris with Thomas Cou-
ture in 1850, apparently developing his
very experimental technique and vision
after encountering various theories of
memory painting and atmospherics. He
was a soldier in the Confederate Army
during the war and was badly wounded.
After the war he opened a studio in New
York and had a very important artistic
interaction with his fellow American
symbolist Albert Pinkham Ryder. New-
man's dreamy, somewhat obscure can-
vases were radical in their day and have
subsequently received little attention out-
side the academic world where he re-
mains greatly appreciated. (For a
complete study of Newman, see Marchal
Landgren's volume, *Robert Loftin New-
man, 1827–1912,* Washington, D.C.:
Smithsonian Institution Press, 1973.)

oak, hanging moss, and lush foliage growing right down to the river bank. Staged with great depth and perspective, this dense composition impresses the viewer with extensive evidence of abundance and by subliminal suggestion, political cooperation.

So the South departed the nineteenth century, and as the wounds of war healed, a spirit of reconciliation pervaded both sides. The popularity of Southern romantic writers throughout the country was proof that the general public wanted sentimental stories with readily identifiable heroes. For whatever reason, and it must be admitted that a lost cause is often more appealing than a victorious one, the Southern saga entered the national consciousness with hallowed ease.

Many artists of little note participated in this effort, with small works of sentiment displayed among the greater names at national exhibitions. William H. Baker, a New Orleans painter who found it impossible to make his living in the South during Reconstruction, moved to Brooklyn, and while teaching at the Brooklyn Academy, painted *Home Regatta.* A group of children with no defined regional orientation are seen sailing paper sailboats across a wooden tub in a back yard.

Upon the wall behind them, one flower, outlined in sharp detail against the crumbling wall, reminds the viewer of the moral of Alfred, Lord Tennyson's poem, "Flower in the Crannied Wall."

> *Flower in the crannied wall,*
> *I pluck you out of the crannies...*
>
> *Little flower—but if I could understand*
> *What you are, root and all, and all in all,*
> *I should know what God and man is.*

Recently, a painting has come to light by the artist William D. Washington, who created *The Burial of Latane.* It is a scene of a christening, which takes place within the fashionable Grace Episcopal Church in New York City in Gothic Revival splendor. Through the stained glass windows a powerful light flows, making the scenes of religious piety above and human devotion below glow with the proper genteel spirit. Within the small crowd watching the christening we can discern the face of a black woman, perhaps the nurse of the child or an old family retainer. Her countenance is a lovely

WILLIAM H. BAKER (1825–1875),
Home Regatta, oil on canvas, 20 x 24
inches, 1872, Collection Lauren Rogers
Museum of Art, Laurel, Mississippi.

counterpoint and a precise reminder of those ambiguities which cloud our true understanding of Southern culture.

Human feeling often defies and eludes the sociologists, while appearing with regularity in the genre of everyday life. The much recounted parable of General Lee's singular acceptance of communion with a black man who wandered into the Episcopal Church in Richmond after the war is an example of the ironic bond that persisted between servant and master, oppressor

WILLIAM D. WASHINGTON (1833–1870), *The Christening,* oil on canvas, 30½ x 25 inches, 1868, Robert M. Hicklin Jr., Inc., Spartanburg, South Carolina/Knoke Galleries, Atlanta, Georgia.

CATHERINE WILEY (1879–1958), *By the Arbor,* oil on canvas, 26 x 30 inches, 1923, private collection of Eleanor and Irv Welling. Catherine Wiley, a native of Tennessee, studied painting in New York at the turn of the century under Frank Vincent Du Mond, an instructor at the Art Students League. During the summer months she also studied with the American impressionist painter Robert Reid who combined an interest in rather lush still-life painting with new painterly techniques. His vivid colorations seem to have greatly influenced Wiley whose work is often characterized by a highly-keyed color contrast. *By the Arbor* is an example of cross-cultural reference. Using contemporary impressionist techniques, Wiley has infused the rather traditional Southern subject of an elegant woman in a beautiful garden with a spirit of innovation, creating a new design for an old theme.

CLARENCE MILLET (1897–1959), *Moonscape,* oil on canvas, 22 x 26 inches, c. 1935, Roger Houston Ogden Collection, New Orleans, Louisiana. Clarence Millet began his studies of art in the lobby of the old St. Charles Hotel under the instruction of visiting artists Robert Grafton and Louis O. Griffith, Chicago itinerants who wintered in New Orleans during the First World War. Millet's style initially reflected certain late impressionist tendencies, but as he matured, a more personal expression emerged. During the decade of the Great Depression he painted a series of moonlit pictures which looked back to older Southern themes, much as the regionalist painters, Curry, Benton, and Wood, returned to American folk tales and history for their work.

and oppressed, even after the cessation of hostilities.

Eugene Genovese, in a *New York Times Book Review* article, speaks of the old South culture as composed of "admirable men and women who struggled heroically to build a Christian civilization. They built churches and schools under conditions difficult even by frontier standards; they raised towns that brought civility, culture, and order to an atomized frontier. And they created an array of supporting, caring, loyal personal and family relations that our own age might envy. They qualified, by any reasonable standard, as good and decent people who tried to live decently with their slaves. They were doomed to fail for, at bottom, their relations with their slaves rested on injustice and violence, and therein lay the tragedy that has made them, individually and as a class, the most arresting of Americans."

So as we pause beneath the arbor, or watch the full moon rise, we are reminded of the old South and the aura that culture still sheds, for good or ill, upon the present. The longing for a faraway country of comfort and custom and the hedonism of life in the quarters or on the veranda excites us with surreal promise. Shadows fall fast in the moonlight. Whether refuge for a mind overwhelmed by the choices of modernity or backdrop for grotesque illusions, Southern culture will persist until those genteel glimpses are withdrawn and we see no more.

IV
LANDSCAPES
OF LONGING

For the verdant meadows of the North, dotted with cottages and grazing herds, the South has her broad savannas, calm in the shadow of the palmetto and the magnolia; for the magnificence of the Hudson, and the Delaware and the Susquehanna, are her mystical lagunes, in whose stately arcades of cypress, fancy floats at will through all the wilds of past and future.

T. ADDISON RICHARDS

IV

LANDSCAPES

OF LONGING

Landscape painting is a very seductive art form. Lured into an imaginary world created by the artist, we are, at first, lulled by the warm and comfortable feeling which springs from a visual familiarity with the elements of nature…trees and mountains and clouds dotted about on a perfect blue sky. Once in this Arcadia we begin to realize that what we are actually seeing is the highly symbolic backdrop for the setting sun of the painter's imagination, illuminated by his personal understanding of natural light.

Light is the all-pervading source for this seduction, for it is the suggestion of natural light in its many phases, especially at the transitional times of dawn and dusk, that has most intrigued the painters in the Western tradition. In its most powerful evocations, natural light becomes the actual subject of the work, substituting for concepts of God or providing an unshaded lens through which we can see, far too clearly, the works of man.

Light spilling across the skies of nineteenth-century art rises in the reason of the eighteenth century and sets amid the nostalgic longings of late-Victorian pastoral idealism. Throughout the nineteenth century landscape art was regarded as the highest art form, a form infused with the spirit of intellectual search, natural observation, and creative power. Apart from these high-minded ideas, it also became the very stuff of the private home owner's collection. It was the art the public embraced. Landscape art was

sanctioned by the critical establishment and nourished a vague deistic notion of the godhead, which John Ruskin called a "disembodied spirit." Simply enough, it was pretty.

As Kenneth Clark has written, "A peaceful scene, with water in the foreground reflecting a luminous sky and set off by dark trees, was something which everyone agreed was beautiful, just as, in previous ages, they had agreed about a naked athlete or a saint with hands crossed upon her bosom." Such sanctity is infectious. When combined with the widespread availability of popular prints, it created a public taste for rich proportion, imaginative detail, and a recurring vocabulary of form that marked the landscape out as surely as a road sign on a current-day interstate.

Nowhere is this repetition of form more evident than in the landscape art of Louisiana, which began to emerge in the late nineteenth century as the most important expression of a local Southern scene. The extended image of the Deep South, augmented by the issue of popular prints, had already created a lush and certainly idyllic image of Louisiana.

Through the window of Louisiana landscape art we seem to see the passing of the colors of the day. Early in the morning John James Audubon may be seen searching through the French Market of New Orleans for fresh specimens. By noon the levee is crowded with steamboats, billowing with soot and smoke, receiving or unloading the goods of the cotton kingdom. In the afternoon, as the sun sets, a pensive mood falls upon the landscapes of swamps, bayous, live oaks, and cypress hung with the misty gray Spanish moss.

Once the sun has set, the moon appears over the river and casts a pale reflected glow upon the scene of plantation houses and sharecropper shacks and on steamboats charting a dangerous course through bayous by torchlight. Farther upriver, two steamboats race against each other in the moonlight to fulfill a challenge of deadly intent.

Offsetting this fantasy landscape art, the more serious artists in Louisiana, and later in Florida, combined an interest in certain ongoing techniques of nineteenth-century American landscape painting with an emerging visual realism, the implications of which we have already seen. Luminism, a passionate interest in the interaction of the effects of light and air upon bodies of water, as reflected over the landscape, is most often associated with the

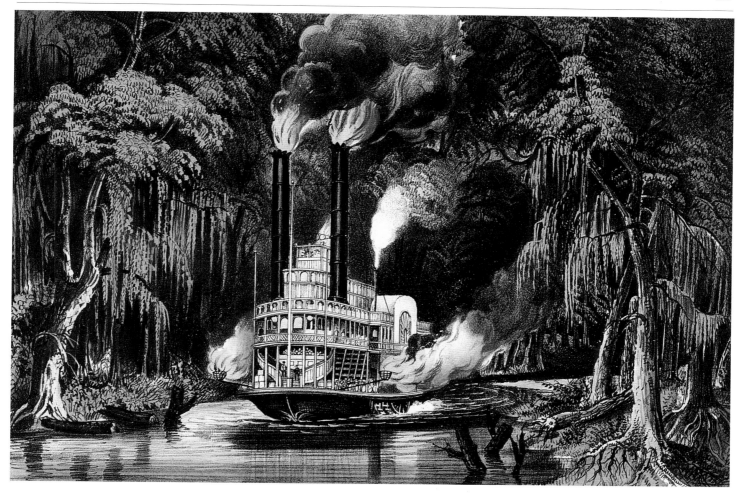

UNIDENTIFIED ARTIST (attributed to FANNY PALMER, 1812–1876), Currier & Ives, *Through the Bayou by Torchlight*, hand-colored lithograph, 8½ x 12½ inches, undated, Knox College Library, Galesburg, Illinois. For sheer melodramatic visual effect, this print is difficult to surpass. Although undated, it would seem to be in the group of prints which Currier & Ives released in the ten years following the Civil War, most of which were drawn by Fanny Palmer. The menacing nature of the dark trees and the fiery spectacle of the smoking stacks and burning torches compounds the lurking sense of danger. Unlike many of the late-nineteenth-century steamboat prints which focus on the sides of the vessels, this boat lunges out from the picture plane toward the viewer.

Hudson River School, but it found expression on the bayou as well.

Before any truly insightful understanding of the light in Southern landscape painting of the middle to late nineteenth century can be found, the simple interpretative and influential qualities that luminism evokes must be considered. Luminism was not a self-conscious theory in any way taught or propounded as theory either in the North or South. Rather, it is a way of seeing natural light and using it to create an especially brilliant effect.

Light is both a tool of observation and the actual observation itself. An especially moving sunset, colorfully captured in the full panoply of golden orb disappearing into a dazzling play of orange light dissolving into a pinkish glow, thrills the romantic heart. Yet, however symbolic this event may be to the active imagination, it is also a natural phenomenon caused by the refraction of light as the sun sets over the corona of the earth which acts as a lens to filter the vanishing light through the prism of dust and particles of moisture. These concepts are more relevant, in many ways, to nineteenth-century ideas of nature than to art.

For the Southern artist, the two great sources of luminism would have been found in the well-known efforts of Thomas Cole and Frederic Edwin Church. Cole's works were available in the South in engraved form and Church's paintings frequently made excursions to Southern cities, where they were displayed to great interest and acclaim.

While American luminist landscape art cannot be said to actually begin with the art of Thomas Cole, his large, brilliantly-colored moral fables created a great sensation when they appeared. Cole's art drew from existing traditions in landscape painting, especially the stormy works of J. M. W. Turner, the alluring vistas of Claude Lorrain, and by association, the sublime, romantic light of Caspar David Friedrich. But Cole's work is an accurate landscape art with a moral intention. In Cole's vast allegorical panels man rises and falls, and nature continues to creep, lusciously, around his ruins.

Cole felt, and wrote, that the technique of a work should never be considered to have a greater importance than the "meaning" the artist was attempting to convey. As a painter of moral fables, Cole was a man with a message, a message he carried by his palette, but a message he placed above his abilities as a technician. Precisely what impact his palette may have had

upon the emerging Southern landscape artist is difficult to determine. It is far more likely that the forms of his landscape art, easily accessible after their mass distribution by the American Art Union in the 1840s, resulted in some of the familiar symbols we encounter throughout Louisiana and Florida.

Perhaps the most important element in Cole's landscapes of moral intention is the juxtaposition of trees, living and dead. Often in the works of Cole we are made aware of these trees, one blasted, decayed, and truncated, another living and green, towering above the scene at hand. That contrast between life and death, prosperity and decay, will take on even greater implications in the post-war South.

Thomas Cole's most famous follower was his young pupil, Frederic Edwin Church, who inherited the master's mantle of popular success after Cole's death in 1848. Church was well known in New Orleans, where he traveled before and after the war, and where his monumental work *Niagara* was displayed to rapturous acclaim in 1859.

Church began to paint his vast, highly dramatic canvases at that moment in the history of the culture of the nineteenth century when the tenets of romanticism and the idea that nature was a benign and friendly force somewhat akin to the Biblical Eden were giving way in the face of rapid industrial change.

The new aesthetic of landscape art, especially as it was formulated by the English critic John Ruskin, sought to merge the old moral intention of Cole with a new spirit of natural observation. Where once it had been considered high art to paint a beautiful landscape and people it with tiny figures caught up in the maelstrom of human anxiety, acted out beneath a brilliantly-lit heaven, it now became incumbent upon the artist to accurately describe the violent changes of nature itself.

The depiction of those changes became part of the search for visual "truth." Writing of truth in landscape painting was one of Ruskin's several obsessions. He admonishes the landscape artist to remember that he has "two great and distinct ends: the first, to induce in the spectator's mind the faithful conception of any natural objects whatsoever: the second, to guide the spectator's mind to those objects most worthy of its contemplation, and to inform him of the thoughts and feelings with which these were regarded

by the artist himself."

For sheer impact upon a local art audience, little can match the effect Church's painting of Niagara Falls had when it was shown in New Orleans in 1859. Displayed in a room over Bloomfield and Steele's bookstore, next door to the *Times-Picayune* office in the American district, the work created a smashing sensation. The New Orleans *Daily Crescent* for March 5, 1859 praised him for painting "nature, nature's whole, the entire nature which is made up of many parts, great and small, their contrasts and harmonies, the lights and shades, the arrangements which evolve effect."

But of greater interest here is the last line of the review, which announces that the work, in facsimile, "beautifully printed in oil colors...is now ready to deliver to subscribers." With the fanfare of a trumpeter announcing a royal appointment, luminism enters the canon of Southern art. Sweeping aside the gigantic issues of the intention of landscape art, we can assume that the warm, melodramatic colors of chromolithography are what the Southern artist experienced in the art of Church and others whose works were so rendered. For as we shall come to see, it is more often drama and high effect which concern the painter of swamps and bayous than a full-blown aesthetic or a devout faith in nature.

Incidents of luminism occur in Southern landscape painting before and after the war, in works created by Southerners and in works which use the South as a theme. On a commission from Lord Ellesmere in England, Régis Gignoux travelled to the South and painted the Great Dismal Swamp. The oil sketch for that work has a fiery intensity and vaguely distant melancholy air. Artists of the Hudson River School often used light to impress the viewer with the heroic aspects of the majestic Hudson Valley. In Gignoux's works and other Southern swamp pictures, the effect is employed to emphasize the same sense of wilderness and isolation in a landscape whose characteristics render it uninhabitable, offering little assistance to the march of human progress.

Alone of the ante-bellum Southern artists, Thomas Addison Richards attempted to achieve the same fusion of intellectual appreciation of place with current artistic technique. He was born in Penfield, Georgia, a remote site near Athens where a fine school with an impressive compound of Greek Revival structures stood like a beacon of classical learning on the Southern

RÉGIS GIGNOUX (1816–1882), *Sunset on Dismal Swamp,* oil on canvas, 12 x 18 inches, c. 1845, Roger Houston Ogden Collection, New Orleans, Louisiana. Régis Gignoux was a French artist, trained in the manner of the Ecole des Beaux Arts, who appeared in this country around 1840 and became an influential member of the New York art community. His early luminist works rival those of Thomas Cole for the crispness and clarity of color. His monumental paintings based on his trip to the resort hotel at the Dismal Swamp are in public and private collections in this country and in Europe. (For an account of the hotel and the swamp, see Robert Arnold, *The Dismal Swamp and Lake Drummond, Early Recollections,* Norfolk, Virginia: Green, Burke & Gregory, Printers, 1888.)

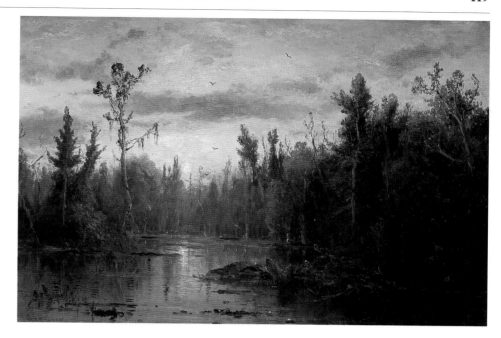

frontier.

In 1842, while still a very young man, he published with his brother a volume illustrating the beauties they had seen in the Georgia countryside called *Georgia Illustrated.* The Richards brothers used the scenic vistas of northern Georgia, the dramatic plunge of Tallulah Falls that had excited George Cooke as well, and the valley of the Nacoochee which combines a high plateau with a sweeping circle of mountains. Although Richards received a certain amount of attention in the popular press for these efforts, there was not a sufficient audience for his works to keep the artist in the South, and he was forced to move to New York.

Taste has a tenuous and intriguing connection to the creative process, but plays a heavy role in the marketplace. As noted, a recurring trend in the dynamics of Southern taste, the echo of cavalier Anglo-Colonial culture, has been a greater love of things produced outside the immediate environment. Southerners, as a remote rural people, sought art works and decorative objects which indicated they, while yet a provincial people, had taste.

The landscape, as subject matter, held little interest for a rural people who depended upon that land for the very means to survive. As most Southerners lived in a rural context, be it plantation or small farm, the landscape was at hand, outside the door or window. What Southerners wanted to hang

upon their walls were those glimpses of their ancestors or visions of the fancy world of history and romance projected into the home through the print medium.

When Richards laments that "little has yet been said, either in picture or story, of the natural scenery of the Southern States," he feels that "so inadequately is its beauty known abroad or appreciated at home." These remarks were made in one of the most important articles published on antebellum Southern scenery, "The Landscape of the South," which appeared in *Harper's New Monthly Magazine* in 1853. His further remarks in that same article define the most critical distinctions between Southern and Northern landscape art.

"For the verdant meadows of the North, dotted with cottages and grazing herds, the South has her broad savannas, calm in the shadow of the palmetto and the magnolia; for the magnificence of the Hudson, the Delaware and the Susquehanna, are her mystical lagunes, in whose stately arcades of cypress, fancy floats at will through all the wilds of past and future."

Richards' remarks are certainly in the mainstream of Southern self-image in the frenzied decade before the war. Throughout this time the South retreated with an ever fiercer self-defense, behind a willful, self-fulfilling imagery of rural Utopia under siege from frantic, degrading mercantilism. He had already acknowledged the absence of a strong Southern literature, a despairing cry that would become the rallying call for the postwar writer. Now, with his clear definition of the differences between the landscape scenery of the North and South he goes to the very heart of visual distinctions between the art of the Hudson River and the art of the Deep South.

What Richards suggests in these comments is evident in the body of Southern landscape art. At one level it may be seen that the art of the Hudson River School used the magnificence of the scenery as a setting for projecting transcendental ideas about nature into the public consciousness. Serenity and awe are the most frequent themes in these paintings, working in narrative combination with a subtle use of natural light, so close to reality as to provoke in the viewer a response more akin to religion than to art.

Prophetically, with his observations Richards unknowingly perceives the

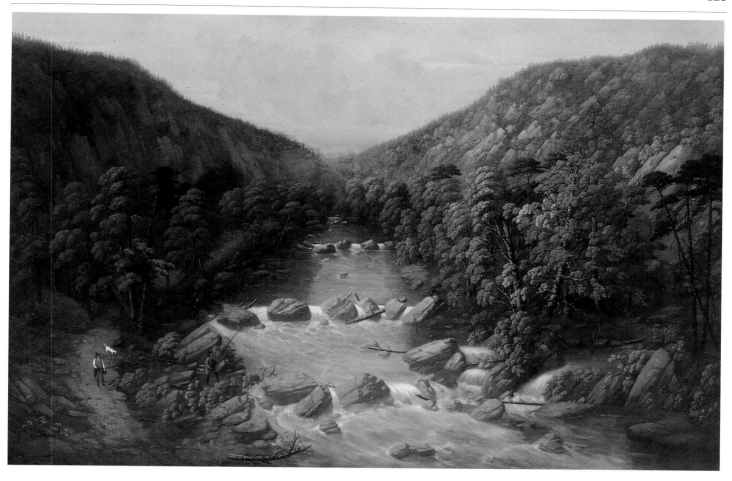

E. T. H. FOSTER (?–?), *Evening on the French Broad, N.C.,* oil on canvas, 36½ x 54¾ inches, 1877, Robert M. Hicklin Jr., Inc., Spartanburg, South Carolina. Apart from painting, signing, and dating this canvas, nothing else is known about this artist. As the stretcher carries the inscription, "Evening on the French Broad, N. C.," the locale is precisely determined. Whoever this artist was, he seems to have been familiar with both painting technique and chromolithography. The warm coloration of the sky in a transitional mood and the foliage are well-rendered aspects of a very satisfying work. The depth and sense of movement of the river are also admirably handled.

T. Addison Richards greatly admired the scenic possibilities of the French Broad region which extends from the Blue Ridge Mountains to Knoxville, Tennessee and many ante-bellum planters made summer homes there. As a painting it fulfills Southern notions of nostalgia. Considering the late date and the picturesque sense of isolation, it is a work which looks back for both technique and mood instead of forward for experimental forms of design.

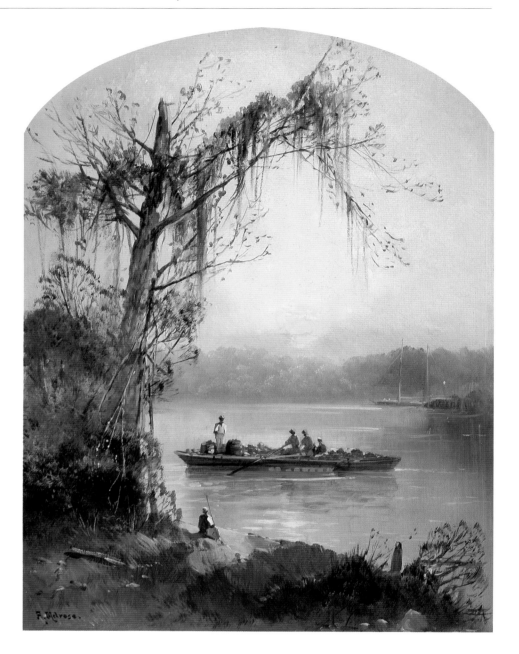

ANDREW MELROSE (1836–1901), *Early Morning on the Ashley River—Going to Market,* oil on canvas, 16½ x 12½ inches, undated, Robert M. Hicklin Jr., Inc., Spartanburg, South Carolina. Melrose, a native of Scotland, traveled throughout America and Europe searching for locations to paint in a picturesque manner. His Southern works seem to date from the late 1870s and 1880s when he explored the Carolinas. Other Southern works from this period have the same bright, almost pastel coloration and delicacy of brush work.

most important themes of post-war Southern landscape art. When he speaks of "calm in the shadow of the palmetto and the magnolia," he foresees the quiet, melancholy, nostalgic air that will permeate the twilight paintings of the Louisiana and Florida schools. Light and shadow are useful symbols for suggesting reality and sentiment, constant themes in this visual history.

Sentiment often divorces the facts of the actual landscape from the longing and desire of the hungry eye. When "fancy floats at will through all

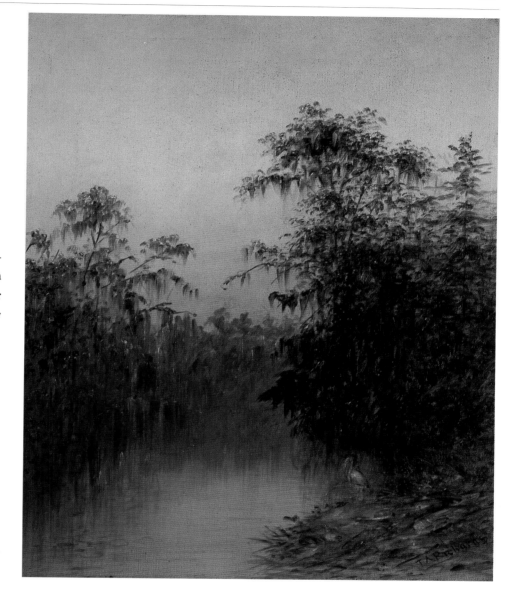

T. ADDISON RICHARDS (1820–1900), *Swamp Scene with Egret,* oil on canvas, 14 x 17 inches, c. 1855, Roger Houston Ogden Collection, New Orleans, Louisiana.

the wilds of past and future," landscape art departs from the naturalistic urge to record and document a virgin territory and enters a land where the comforting presence of primeval wonders proves a gentle balm for the suffering soul. We should be grateful that in far fewer words, but with no lesser substance, Richards functions for us as a Southern Ruskin, giving one of the few articulated theories of the possibilities of the Southern scene.

It fell to an artist from St. Louis who served as a paymaster on a Union gunboat in Louisiana during the war to evoke that sense of awe and comfort in an impressive series of paintings based on the Southern landscape. Joseph

Rusling Meeker was a native of Newark, New Jersey, and grew up in Auburn, New York. His exposure to theories of art and luminism in landscape painting was secured during his adolescence when he studied in New York with Asher B. Durand.

Meeker's difficulties in establishing himself as a landscape artist parallel Richards' experiences. One account of Meeker's early struggles, published in 1878 after he had become a success, notes that the "taste for art, notably landscapes, was not pronounced here, but there were a few who were willing to give remunerative prices for such pictures." The few willing buyers were not enough to keep Meeker from enlisting in the Federal Navy in 1861.

What Meeker saw in those four years of service in the Deep South remained with him for the rest of his life, for while he never actually lived in Louisiana, he became one of the principal creators of a mythic landscape art. References to Henry Wadsworth Longfellow's poem, "Evangeline," abound in his work. There are also subliminal references to Walt Whitman's poem, "I saw in Louisiana a live oak growing," which give his works a quiet narrative appeal, the sense of being scenes of loneliness and loss, in which nature acts as a great canopy or a backdrop for minute, yet devastating human experiences.

Meeker's landscape art before the war is far more clumsy and derivative than the work he painted after his return to St. Louis. His appreciation of J. M. W. Turner's work, which he would eventually express so beautifully in an article for *The Western* in 1878 is apparent, as are the lessons of Durand in the importance of proceeding and receding color values. Still, there is missing in those early works the odd sense of passion and intimacy which characterizes the works based on his sketches in Louisiana.

Louisiana Bayou is signed and dated 1866, and as such is one of the first works, extant, in which Meeker essays the swamp theme. Many conventions of the Hudson River School are evident. The dead tree in the right foreground is a direct reference to the moral landscapes of Thomas Cole. Life and death are thus juxtaposed in a scene devoid of human life. Surely this is the type of afternoon which Audubon described as "one of those sultry days which render the atmosphere of the Louisiana swamps pregnant with baneful effluvia...."

Redeeming the sense of despair and isolation are points of what Meeker

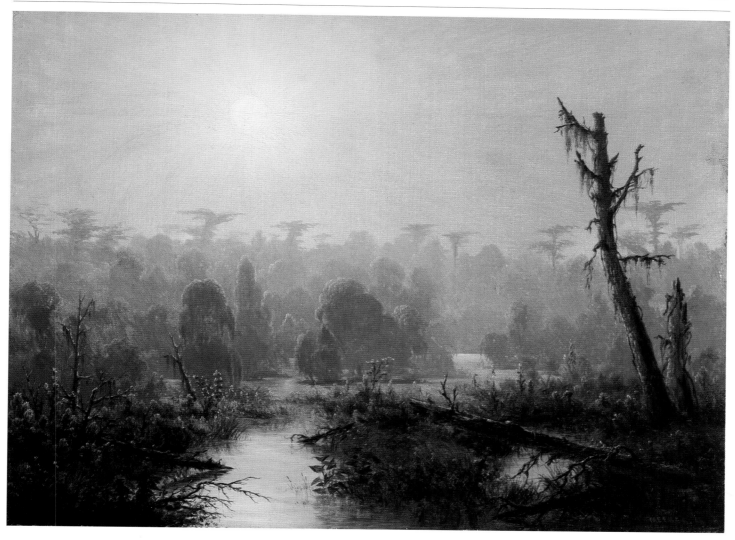

JOSEPH RUSLING MEEKER (1827–
1887), *Louisiana Bayou,* oil on canvas, 14
x 20 inches, 1866, Roger Houston
Ogden Collection, New Orleans,
Louisiana.

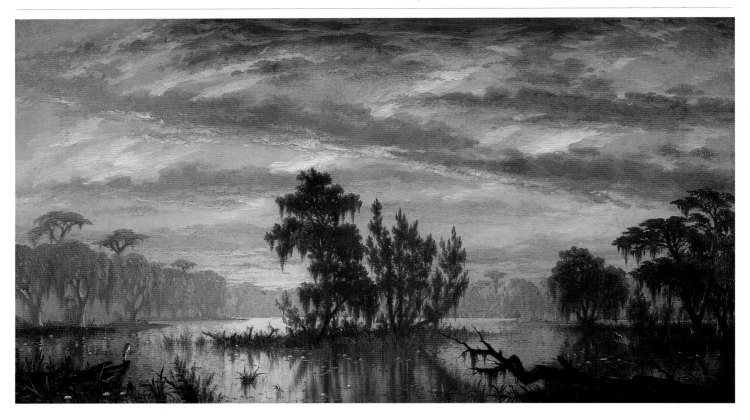

JOSEPH RUSLING MEEKER (1827–1887), *Bayou Plaquemines,* oil on canvas, 20½ x 36 inches, 1881, Roger Houston Ogden Collection, New Orleans, Louisiana.

termed "repose." His comments on Turner could just as easily be applied to his own art. Meeker's colors "are disposed so as to produce the utmost harmony; and the major and minor lights and shades are so arranged that the tone of the works shall give a satisfying sense of completeness—a high light there, a lesser light there, and so on through the scale, repeating a like gradation in the darks, and at last carrying the eye by deft combinations of line and tone to the final element of repose beyond all."

Two elements of repose are visible in *Louisiana Bayou.* The range of trees across the horizon line are painted in complimentary tones of gray and green and shimmer with a moist living glow. The sun, high in the sky overhead, draws the eye towards this pervasive source of light, the unifying transcendental feature of the work, where "the eye rests peacefully, in refreshing indolence, after scanning the multitudinous detail."

Meeker was certainly capable of the same high drama of vivid light and shadow that is to be seen in the works of Church. Perceiving that a "quality of mystery" was "essential to the completeness of a picture," Meeker creates a very precise vocabulary based on the interaction of color. "Understanding

the value of this," the artist "vaguely defines such of his outlines as would offend the eye by their boldness, and by the use of mists and nimbus clouds lending obscurity to portions of the picture suggestive of…vistas." Boldness, obscurity, and suggestive vistas are all prominent features of Meeker's *Bayou Plaquemines*.

Here, in a far smaller scale, is an achievement which rivals Church's *Twilight in the Wilderness*. Overhead, the clouds are on fire with the last light of day, which throws a suggestive light, deep blue-green and mauve, upon the clump of live oaks isolated in the murky swamp. The absence of sharp definition in the background has the effect of heightening depth and perspective, while flattening out the altitude of the sky.

Alone with nature, we seem to see deeply into this picture, drawn for repose to a light source which is simultaneously nurturing and threatening. The effect must surely be what Meeker loved, for as he wrote, "every artist ought to paint what he himself loves"…for if his love may "be pure and sweetly toned, what he loves will be lovely." Sweetly-toned love is a very clear counterpoint to the passion in this painting.

Meeker's literary sensibility and vision of the Louisiana landscape are joined in a series of paintings in which the artist draws upon the poem "Evangeline," continuing his technique of light and shadow, illuminating the Gothic imagery in Longfellow's poem of lost love. Evangeline has been separated from her lover Gabriel by the cruel diaspora of French Canadians, called "Acadians," in an ironic reference to the wilderness mythology of the seventeenth century. Many of those Acadians landed in southern Louisiana, and are still present in that homogeneous culture known today as "Cajuns," currently in vogue for their spicy cuisine.

Together with her companion, Father Felician, Evangeline searches for her loved one in a boat borne upon "the golden stream of the broad and swift Mississippi." In Meeker's painting of 1871, *The Acadians in the Achafalaya, "Evangeline,"* the moss-hung cypress trees comply with the poem's description.

> *Over their heads the towering and tenebrous boughs of the cypress*
> *Met in a dusky arch, and trailing mosses in mid-air*
> *Waved like banners that hung on the walls of ancient cathedrals.*

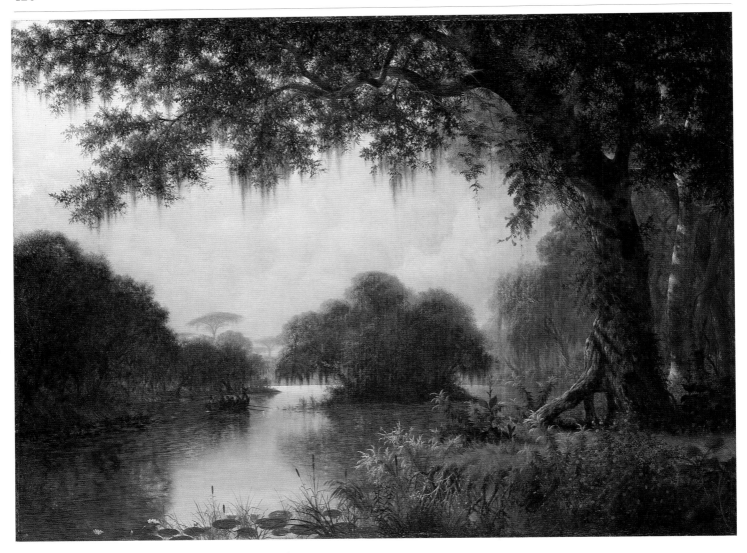

JOSEPH RUSLING MEEKER (1827–1887), *The Acadians in the Achafalaya, "Evangeline,"* oil on canvas, 32⅛ x 42³/16 inches, 1871, The Brooklyn Museum, 50.118, A. Augustus Heal Fund.

In this first work, the figures in the gliding boat are remote, a vague focal point for a well-known narrative. The painting of 1874, *The Land of Evangeline,* has a more obvious narrative focus. Evangeline, exhausted from her search, has taken refuge beneath the boughs of a cypress tree, which, while still living, is more dead than alive, a suggestive reference surely intended by Meeker. Still she continues her search, and inspired by the vision of hope she gleans from nature, she sleeps beneath the tree.

Such was the vision Evangeline saw as she slumbered beneath it.
Filled was her heart with love, and the dawn of an opening heaven
Lighted her soul in sleep with the glory of regions celestial.

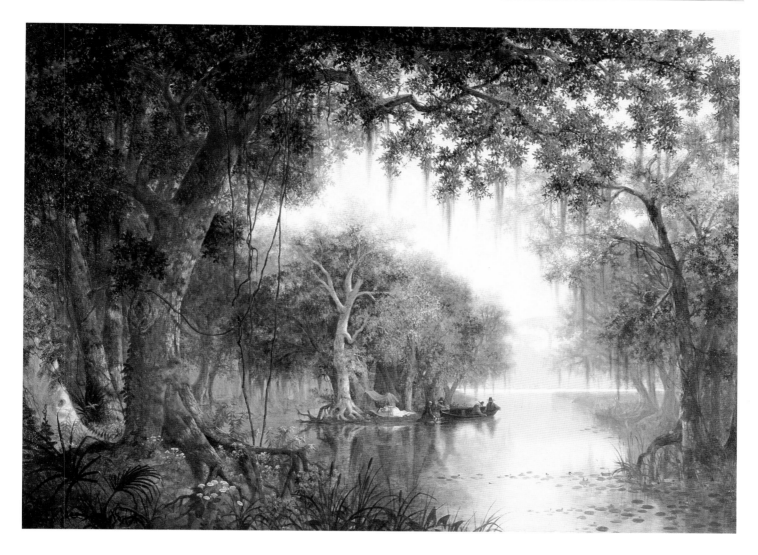

JOSEPH RUSLING MEEKER (1827–1887), *The Land of Evangeline,* oil on canvas, 33 x 45½ inches, 1874, The Saint Louis Art Museum, Purchase: Funds given by Mrs. W. P. Edgerton, by exchange.

As Meeker in the remoteness of his St. Louis studio painted these themes of loss and reconciliation, the artists of Louisiana, confronted with the economics of defeat, attempted to create and sell their own visions. During the decade of Reconstruction Richard Clague, Marshall Smith, and William Henry Buck came into their full maturity as artists. As we have seen, Clague's art took on a note of realism. His swamp pictures lack the colorful tone of Gothic melodrama we see in the works of his contemporaries.

Clague was capable of moments of luminism, as in his painting of *Spring Hill,* Alabama painted in 1872. While not a scene of inspiring poetic proportion or intent, it still has a dazzling quality of light. The vernacular shack

and the sparse trees are evidence of Clague's naturalistic impulse, but the sky above, whose clouds have just taken on the pink hue of the setting sun, may reflect all the promise Clague could feel in the depressing circumstances of Reconstruction Louisiana.

The ruined plantation houses, deserted levees, and urban decay which followed the war provide those symbolic elements of trauma and change upon which art thrives in the search for subject matter. Ruin and the remembrance of things past is the theme of the next chapter of these essays, a theme preoccupied with the grotesque and the creation of an existential counterculture. But that lies ahead, and in the declining days of the nineteenth-century South, the creeping nostalgic light of the bayou acted as a counterpoint to the imaginary sunset of a vanished culture, whose demise was evoked in dreamy longings for a landscape of comforting isolation.

Edward King, a northern journalist traveling through the South in the waning days of Reconstruction, writes with just that flourish we seek as verification of the concurrence of thought and art. "Louisiana to-day," he wrote in 1875, "is Paradise Lost." Writing as though the Bayou State was some vast classical empire which had fallen into the dust of time, King laments that a "shadow has fallen over Louisiana."

This shadow has all the advantages of reality and sentiment. As evidence of genuine emotion, it is a reminder of the poverty which followed in the wake of the war. "The struggle is over, peace has been declared, but a generation has been doomed. The past has given to the future the dower of the present...that is what the faces say; that is the burden of their sadness."

Amid all this sadness, real and imagined, the wild splendor of the Louisiana countryside persisted, and it was at this time that the landscape artists of Louisiana seem to have found their subject matter. King may be permitted a parting shot. Making a journey out into the Teche country that would come to mean as much to the Louisiana painters as the Hudson River had meant to the artists of New York state, he pauses. Along the banks of the Teche he sees "where the live oak spreads its ample spray over some cool dell upon whose grassy carpet grow strange bright-hued flowers; and where vistas of forest glade—happy sylvan retreats—open as by enchantment, and moonlight makes delicious checkerwork of gleam and shadow."

Almost as if to oblige the writer, and others like him, by the recreation

RICHARD CLAGUE (1821–1873),
North Shore of Lake Pontchartrain at Mandeville, oil on canvas, 29½ x 41½ inches, undated, private collection. This is one of Clague's best works and a departure from the somber tones of his Barbizon style. Notice how the background light, as it moves from blue through the reddish glow of sunset, is reflected in the water in the tracks of the road, adding a quality very similar to prevailing luminist trends.

of this imaginary world, landscape artists such as William Henry Buck, Marshall J. Smith, George David Coulon, and Harold Rudolph began to paint the swamps and bayous with a luminescent light. Convention is so strong in these works that a recurring vocabulary of form can easily be detected.

In Rudolph's work, for example, the light source is submerged in the middle of the picture plane. As with several of the artist's more appealing works, a vivid yellow-orange light spills out onto the scene with riveting intensity. Though small, the work is intricately detailed, and the large trees to the right resemble characters in a luminous pageant. Some final daylight soliloquy is being delivered without the advantage of audience or other characters. The imagination, fired by the dying glow of the sun, can only wonder what role humanity has to play in this provocative setting of light and animated undergrowth.

Rudolph's work may have been inspired in part by his own tragic circumstances. He and his cherished brother-in-law were both struggling artists who contemporary accounts suggest were too poor to allow the paint to dry upon their canvases before they rushed them to a local gallery to secure a modest payment. At one point they seem to have quarreled, and the brother-in-law, perhaps under the influence of drink, committed suicide. So distraught was Rudolph that he is said to have stopped painting and he disappears from the annals of Southern art shortly thereafter.

Smith and Buck's careers were devoid of that level of melodrama, but their art is no less concerned with the same haunting imagery. While both artists were inspired by the technique of Clague, who was their master teacher, it appears that they responded to their times as well. The moss-hung live oak becomes a central feature in all their work, prompting some thoughts on the role of that tree as a heavily-laden symbol.

Moss-draped live oaks appeared in Southern art before the war, but most often in the background of mourning portraits. One of the first uses made of the live oak dripping Spanish moss, seen against the backdrop of the setting sun, is to be found in a mourning portrait by Adolph Rinck.

Rinck was a German artist working in Louisiana as a portrait itinerant, when he was asked to paint a likeness of Charlotte Mathilde Grevenburg DuMartrait for her grieving family. The facial image was taken from a daguerreotype, a process which had just been introduced into Louisiana.

HAROLD RUDOLPH (c. 1850–
1884), *Swamp Scene,* oil on canvas, 12 x
18 inches, undated, Roger Houston
Ogden Collection, New Orleans,
Louisiana.

ADOLPH RINCK (c. 1810–post 1872), *Charlotte Mathilde Grevenburg DuMartrait,* oil on canvas, 35 x 28 inches, 1843, Peter W. Patout, New Orleans, Louisiana. Rinck was a French painter who followed Jean Joseph Vaudechamp to New Orleans in 1840 after training at the Royal Academy of Berlin. This portrait makes one of the first uses of the live oak as a symbol of mourning. The distinctive moss-hung silhouette of the tree stands against the glow of the setting sun. Charlotte (1819–1843) was the young bride of Jean Adolphe DuMartrait when she died and it was he who commissioned her portrait, which was painted from a daguerreotype in 1843. Rinck continued to paint in New Orleans until his death, although most of his later years were spent on his farm in nearby Algiers where he was deeply involved in agricultural experimentation.

While the subject appears much as she may have in life, the symbol of the live oak is unmistakable. The orange glow and shadowy outlines are also rather remarkable harbingers of what was to come after the war.

If from the solitary live oak hung with moss in the Rinck portrait we can deduce a melancholy message of human frailty and sorrow, then what are we to make of that same tree in the works of Buck and Smith? While Smith seldom makes dramatic use of the tree as an obvious visual symbol, it does appear frequently, most often as a central point of orientation, in his essays on the picturesque of the Louisiana scene.

William Henry Buck, however, often makes the tree the entire visual

WILLIAM HENRY BUCK (1840–1888), *Louisiana Pastoral: Bayou Bridge,* oil on canvas, 26 x 40 inches, c. 1880, Roger Houston Ogden Collection, New Orleans, Louisiana.

focus of his paintings, hung with dripping gobs of moss and set against a spectral vision of twilight. Even when his works are fully realized, devoid of suggestive light and quiet essays on the harmony of the landscape, those trees appear, with more presence than accuracy of detail would demand.

In each of these artist's work, the live oak takes on a semeiological importance that is unmatched in any other aspect of American landscape art. True, Martin Johnson Heade turns the banal haystacks of New Jersey into powerfully subliminal mounds upon the quiet salt marshes at sunset. Yet those stacks lack the vigor and force of the Southern live oak.

A consciousness of the metaphoric importance of the mossy live oak enters the literary imagination long before the war. In 1848, the poet and critic Walt Whitman traveled south on the great river to New Orleans to work for the *Daily Crescent.* Although he stayed only three months, churning out hack articles for the paper, he did remain long enough to see, "in

MARSHALL J. SMITH (1854–1923), *Gulf Coast with Cypress Grove,* oil on canvas, 16¾ x 29 inches, c. 1880, Roger Houston Ogden Collection, New Orleans, Louisiana. After Smith's return from Munich in 1876, he ceased to paint in a style derived from Richard Clague, indeed actually using Clague's sketches for compositional source, and developed a more personal style. That style is best seen in this work, where a subtle light, combined with the dense and tight brushstroke in the foliage, give a penetrating sense of presence to an otherwise ordinary scene.

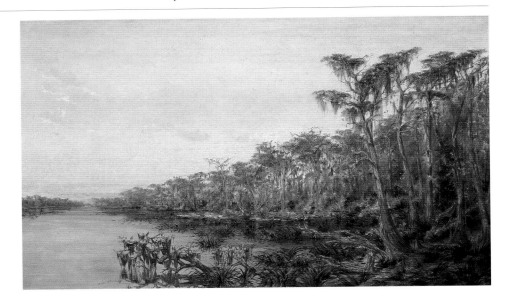

Louisiana growing" a live oak.

Whitman's live oak is a solitary form of great presence upon the landscape,

> *All alone stood it and the moss hung down from the branches,*
> *Without any companion it grew there uttering joyous leaves of dark green,*

and his response to that solitary form is forlorn and disturbing.

> *But I wonder'd how it could utter joyous leaves standing alone*
> *there without its friend near, for I knew I could not,*

Whitman's clever depiction of the tree "uttering joyous leaves" is indeed a poetic evocation of the life cycle of the live oak. That tree does not turn in the autumn and shed colorful foliage. Instead, the old leaves drop from the ends of the limb, pushed aside by the new green leaves.

Fascinated by this process, and by the seeming self-sufficiency of the tree, Whitman

> *...broke off a twig with a certain number of leaves upon*
> *it, and twined around it a little moss,*
> *And brought it away, and I have placed it in sight in my room.*

Although he continues by informing the reader that he does not need the organic souvenir to remind him of the importance of friends, he has "placed it in sight in my room."

Despite the rather obvious homoerotic undercurrent of the poem (it "makes me think of manly love"), Whitman transforms the live oak into a symbol of potency, "rude, unbending, lusty," which inspires a heroic admiration. Whitman, the poet and naturalist, feels that unlike the individual live oak which

> *...glistens there in Louisiana solitary in a wide flat space,*
> *Uttering joyous leaves all its life without a friend a lover near,*
> *I know very well I could not.*

Whether icon of self-sufficiency or image of romantic isolation, the solitary live oak came to represent the lingering exotic element in the Southern landscape, and this at a time when the entire continent was slowly being absorbed into the great nation state. It was an image engraved in the popular imagination through the efforts of the Currier & Ives prints, especially *Tropical Southern Landscape*, which departed from the jolly image of the old South plantation scene to carve in stone a remote bayou overshadowed by moss-hung trees.

The enduring popularity of this symbol is most apparent in an object like the primitive fireboard, painted to resemble a semi-tropical Southern environment. All the naturalistic parts of the landscape are present, from the glowing sunset to the dense foliage to the moss-hung trees. In a pensive mood we may pause and consider this simple fireboard as a point of continuity with the early settlers and explorers of the South. Much as Bartram delighted in the natural world which he found and explored, the traveler of the late nineteenth century continued to revel in discoveries of exotic, unspoiled locales. Perhaps it says something about the ongoing search for virgin territory and new-found lands that this image endures to the present.

Not all the landscape artists of the Louisiana School were preoccupied with the potential melodrama to be found in the bayou. At least one painter, who remains something of a mystery, pursued a landscape of tranquility and created a series of small pictures which achieve something of the harmony of certain Hudson River School painters.

Charles Giroux's identity remains unclear. He may have been the visiting French artist known to have been in Louisiana in the early 1880s. He may also have been a cotton broker whose talent for painting finally persuaded him to undertake that career on a full-time basis. A Charles Giroux

Fireboard, oil on canvas, 34 x 39 inches, undated, Robert M. Hicklin Jr., Inc., Spartanburg, South Carolina.

does appear in the 1880 census for Louisiana as a cotton broker, and is listed as a male artist from France, aged fifty-two.

If this is the Charles Giroux who painted the remarkably detailed and delicately colored paintings which survive, then he would have had an opportunity to develop his talents in the classrooms of the artists' associations of New Orleans. By 1880, the artists of New Orleans had organized themselves, and various instructors, such as Andres Molinary, George David Coulon, and Paul Poincy, were providing at least a rudimentary art education.

Coulon, whose painting of the Bayou Beauregard is a very fine achievement in the Louisiana idiom, may have been the most successful instructor. It was Coulon's habit to note on the back of his works the compositional source. From this evidence and the existence of large numbers of his paintings, it is clear that he frequently copied late-nineteenth-century chromolithographs of the type previously mentioned with regard to Church's painting *Niagara.*

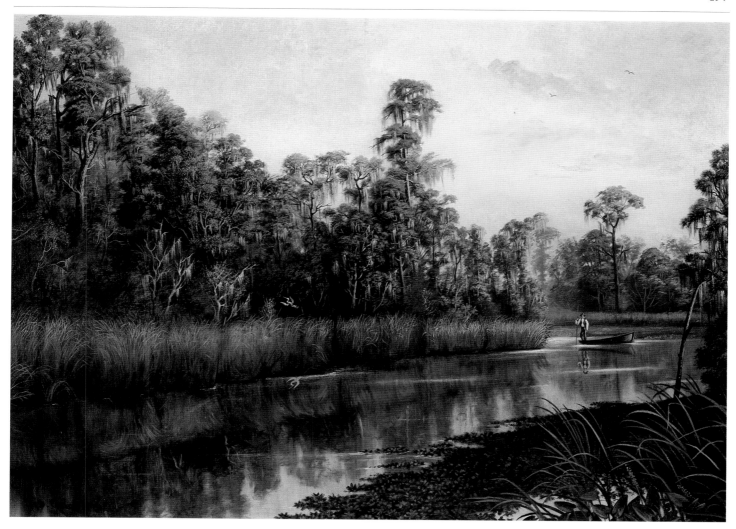

GEORGE DAVID COULON (1822–
1904), *Bayou Beauregard, St. Bernard Parish,* oil on canvas, 24 x 33 inches, 1887,
Roger Houston Ogden Collection, New
Orleans, Louisiana. Coulon's largest and
most superbly realized landscape was inspired by scenery on the downriver side
of New Orleans and perhaps also by the
efforts of his son, George Joseph Amede
Coulon, who published *350 Miles in a
Skiff through the Louisiana Swamps* in 1888.

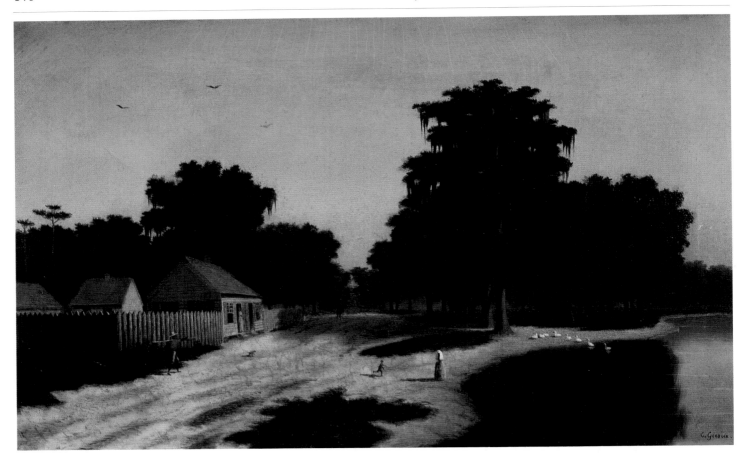

CHARLES GIROUX (c. 1828–1885), *By the Bayou, Rural Louisiana Landscape,* oil on canvas, 14 x 23 inches, c. 1879, Roger Houston Ogden Collection, New Orleans, Louisiana. Giroux's accomplished handling of light at a transitional time of day is most apparent in this work where an almost tactile sense of the setting sun, fading out in a soft warm glow against the lingering coolness of the deep blue sky, offsets the scenic charm of a Louisiana bayou.

CHARLES GIROUX (c. 1828–1885), *Untitled landscape,* oil on canvas, 10 x 5 inches, undated, the collection of Jay P. Altmayer. Such minute visions as Giroux's tiny essay on the moss-hung cypress seen against the swamp light of Louisiana may have been painted for the tourist trade in late-nineteenth-century New Orleans. Motivation seems unimportant, however, when the quiet intent renders the trees, even at this scale, with so much transcendental force, making them one with the more philosophic appreciations of nature.

Chromolithography would provide the fledgling painter with far more than a compositional source. Many chromolithographs were strongly colored and featured the popular convention of light in transition. The orange glow along the horizon line, romantically linked with the more evocative works of the luminist movement, was very dear to the heart of the public. Coulon shamelessly copied numbers of these works insuring their continued currency in the Louisiana School.

Giroux, whoever he may have been, became an accomplished master of this idiom. In the most readily identifiable of his works he depends upon two compositional elements. First, an extended vanishing perspective is established by the use of a dirt road receding far into the background, drawing the eye down a long corridor growing ever more narrow and remote. Above this road he often creates a sky that is lit by the sun in transition. The harmonic values of blue and orange are most compatible in these works, creating a warm sense of intimacy, unmatched by the efforts of his more illustrious and celebrated peers.

On at least two occasions, the local newspapers in New Orleans commented upon Giroux's work. The *Times Democrat* for July 17, 1883 found that the "keynote of all" his work was "refinement, each having a certain collective harmony…the tranquil waters of the Teche, in shadow and sunshine, are splendidly copied. The one defect is a want of transparency in the sky…." Critics can be the worst viewers. What this anonymous critic condemns, a lack of transparency, is actually one part of Giroux's most brilliant effect. He makes his skies a symbol of the same strength and ambiguity most of his contemporaries were achieving with the live oak, hung with the ever-present Spanish moss.

Much as those oaks really had very little to do with nature and served instead as characters upon a carefully prepared stage, so Giroux's skies serve as a canopy for the imagination, and not a source of rain, or the atmosphere through which sunlight is filtered.

As fascinating as these works are, they do remind one of the tranquility which can be seen in the works of Martin Johnson Heade and Fitz Hugh Lane. Heade, in particular, was an artist whose life spanned most of the nineteenth century, and whose efforts, unlike those of Church, were as strong in old age as they had been in youth.

MARTIN JOHNSON HEADE (1819–1904), *The Great Florida Sunset,* oil on canvas, 53 x 96 inches, 1887, © 1988 Sotheby's Inc. This vast canvas was one of the principal successes of the artist's later years. It was purchased by his most significant patron, Henry Morrison Flagler, and hung for many years in the lobby of the Ponce de Leon Hotel in St. Augustine where it must have created the ultimate illusion of Florida romance, in the days before the onset of the pink flamingo motif. (The definitive work on Heade is by Theodore E. Stebbins, Jr., *The Life and Works of Martin Johnson Heade,* New Haven and London: Yale University Press, 1975.)

Heade was born in Pennsylvania, and had spent most of his life painting and exhibiting in the East before he moved to Florida in 1883. His earlier work combined a quietly realized sense of the beauty of natural light reflected on the waters of the marshes of New Jersey, with a curious fascination with the rounded haystacks dotting the fields. Once in Florida, Heade applied the same perspective to the spectacular setting of swamp and palm.

Heade was drawn to Florida by the efforts of Henry Morrison Flagler, a wealthy developer who was turning Florida's east coast into a winter resort for the wealthy from the cold Northeast. Flagler's hotel empire charged the sleepy Spanish provincial town of St. Augustine with a cultural mission. Artists, invited by Flagler to take up residence in the Ponce de Leon Hotel, began to develop a vocabulary for the Florida swamp which rivals the Louisiana School in energy, if not in depth.

Heade's enormous 1887 canvas, *The Great Florida Sunset,* could just as easily have been titled, "The Hudson River Flows South." Most of the familiar conventions of the Hudson River School are present, including the vibrant orange coloration and the heightened sense of panoramic depth.

PAUL FRENZENY (1840–1902), *Moonlight on the Everglades,* oil on canvas, 10 x 14 inches, undated, Robert M. Hicklin Jr., Inc., Spartanburg, South Carolina. Frenzeny was a French soldier and explorer who traveled extensively in this country in the late nineteenth century scouting sites for illustrations for popular journals. He seems to have been in Florida in the late 1880s. This work is painted "en grisaille" and composed as a source for an engraving for use in *The Campfires of the Everglades or Wild Sports in the South* by Charles E. Whitehead, published in Edinburgh in 1891.

HERMAN HERZOG (1832–1932), *Picnickers in Florida,* oil on canvas, 20¼ x 28 inches, c. 1890, private collection. Herzog, a German artist who settled in Philadelphia after the Civil War, was among several painters with national and international reputations who worked in Florida in the late nineteenth century. His approach to the landscape is far less formulaic and does not depend for atmosphere upon the literary conventions of swamp and sunset. Instead, he combines a fresh palette with impressionist overtones to capture the sparkling, light-filled mood of the Florida coast.

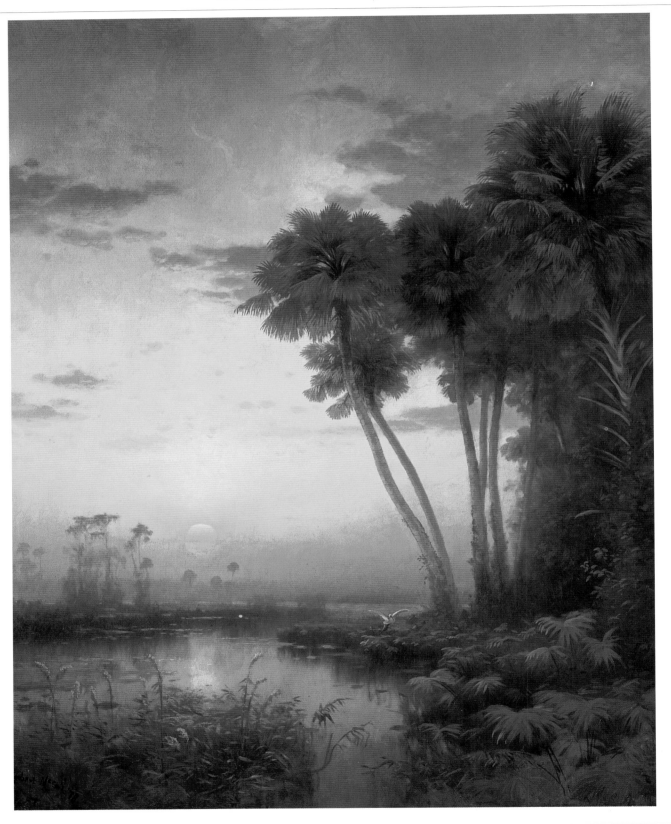

GEORGE HERBERT MCCORD (1848–1909), *Untitled,* oil on canvas, 34 x 26 inches, 1878, Roger Houston Ogden Collection. Not only is this one of McCord's largest works, it is also his most successful handling of depth and perspective as may be judged by the imagined distance between the majestic palm in the foreground and the radiant sun behind.

The clarity one finds in this work by Heade is indeed admirable, but it lacks the murky, evocative quality of mystery one finds among the nativists in Louisiana.

Florida would prove to be a source for several minor painters of note, including Paul Frenzeny, George Herbert McCord, and Herman Herzog. For the most part, the works they created have a technical finesse, demonstrate an appreciation for the local setting, and are accomplished with a colorful palette. But with the exception of McCord's work, a sense of the dramatic possibilities of the place is missing, and these artists seem more like tourists visiting a new site than inspired artists with a literary sensibility and a cultural investment in the landscape at hand.

McCord's work is indeed the exception. His tropical landscapes are his best work. The golden-orange light which pervades the wild and reckless scene is a last, fading glimpse of the luminist tradition. McCord, like Heade, painted in the twilight of the nineteenth century. Already the impressionist revolution and the tonalist onset had diminished the market and the interest in luminist color and moral intention.

Before the light of longing disappears below the horizon line of Southern landscape art of the nineteenth century, one last painter creates a compelling set of symbols which result in a landscape art of repetitive form strengthened by a fine technique. Alexander John Drysdale, the son of an Episcopal priest in New Orleans, became one of the most celebrated painters of his time in the Deep South, while leaving behind a heritage of ambiguity as mystifying as the biography of Charles Giroux.

Drysdale received his initial training in New Orleans, in the same schools where Poincy, Coulon, and the surviving members of the Louisiana tradition were still important figures. Then, in 1903 he traveled to the East and studied in New York at the Cooper Union and the Art Students League.

When he returned, Drysdale began to paint a series of works which drew upon the image of the live oak, shadowed in mists, and set beside a curving stream receding into the distant background. This was a compositional device which the artist repeated thousands of times. Locally, this repetition served to diminish his reputation, without affecting the market for his works, whose familiarity made them ideal gifts for special occasions. Owning a Drysdale became part of the local art consciousness.

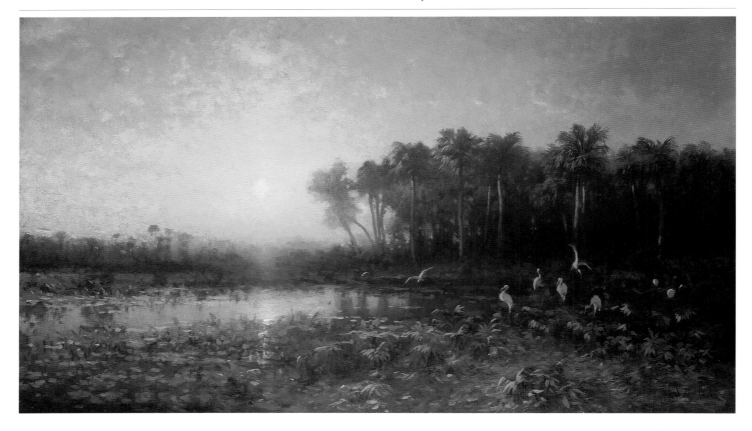

GEORGE HERBERT MCCORD (1848–1909), *Florida Sunrise,* oil on canvas, 14 x 24 inches, c. 1880, Robert M. Hicklin Jr., Inc., Spartanburg, South Carolina. Playing to an audience in search of the exotic and the endless promise of wilderness terrain, McCord, an inveterate traveler, made several trips to Florida in the 1870s and 1880s. In his works McCord made frequent use of a warm yellow-orange light which washes over each individual scene in an alluring way.

Drysdale's particular gift was the curious manner in which he mixed his paints. Using kerosene, he would dilute oil paint to achieve a watery effect on the canvas or more often, paper, not unlike that of watercolor. These "oil washes" had the added advantage of the luminosity of the kerosene, which as it evaporated left a bright ring around the darker colors.

The success of these works has nothing to do with any resemblance to the local landscape. They are so suggestive of the mood of the swamp that they achieve a resonating quality of mystery and distance. At his best, as with the work illustrated here, where the recessional mood of the picture is enhanced by the soft light flashing down the remote, obscure stream of water, Drysdale is a master of the tonalist approach. Instead of depicting the individual features of the landscape of longing and desire, he captures its tone of shimmering elusiveness.

As we leave the swamps to contemplate the ruins of Southern culture, upon which the grotesque imagination is founded, it seems correct to ask if there really is a Southern landscape art. Richards' call for a generation of artists to arise and capture the "broad savannas" and "mystical lagunes"

ALEXANDER JOHN DRYSDALE (1870–1934), *Moonlight over the Bayou,* oil on canvas, 19½ x 32½ inches, 1926, Roger Houston Ogden Collection, New Orleans, Louisiana. Drysdale's most inspired work often departs from his more predictable formulas of moss-hung trees and receding streams of water. In this tonalist essay the play of light and shadow is merged with the eerie moonlight spilling down the ghostly bayou.

may not have been answered on the level of the Hudson River School. But artists of note and talent did emerge to essay the natural wonders at hand.

What they were seeking in those "arcades of cypress" where "fancy floats at will" is still a cause for speculation. The spirit of the Hudson River School was underwritten by the optimism of the transcendental faith in man's ability to develop intellectual capacities. It was also grounded in a profound love of nature, at peace with the world.

The Southern landscape artists may have had a hidden agenda. Richard Clague, in particular, is a complex figure whose landscape art may have been the vehicle he used for expressing a sense of sadness at the passing of a culture. True, once the landscape art of the swamp became little more than a handy means of attracting tourists to the studio, it lost its forceful presentation of the theme of nostalgia. But nostalgia is a central theme of Southern culture, and like much about the South which has taken on the encumbering burden of triteness, it endures. All Southerners are drawn home, and like the little reeds who sigh, in Sidney Lanier's poem "The Song of the Chattahoochee," they "abide, abide...."

V

RUIN AND REMEMBRANCE

There towered the twelve oaks, as they had stood since Indian days, but with their leaves brown from fire and the branches burned and scorched. Within their circle lay the ruins of John Wilkes' house, the charred remains of that once stately home which had crowned the hill in white-columned dignity. The deep pit which had been the cellar, the blackened field-stone foundations and two mighty chimneys marked the site. One long column, half-burned, had fallen across the lawn, crushing the cape jessamine bushes.

Scarlett sat down on the column, too sick at the sight to go on. This desolation went to her heart as nothing she had ever experienced.

MARGARET MITCHELL
Gone With The Wind

V

RUIN AND REMEMBRANCE

The dark night of Scarlett O'Hara's soul took place as she made a desperate journey from the burning ruins of Atlanta to Tara and then to the "charred remains of that once stately home" of John Wilkes, where she went to find food and some secure remnant of the romantic ideal she nurtured in her foolish heart. The desolation that went to her heart as nothing she had ever experienced as she sat upon that column in the half-darkness was a harbinger of far greater grief to come. She had discovered that her deeply cherished mother was dead and that Tara, her only real love, had been laid waste by the Yankee hordes which swept through Georgia like avenging angels of the Old Testament. Now Twelve Oaks lay in ruins and for one moment she knew despair before her famous vow to survive, spoken in a radish patch.

Nowhere else in the body of Southern literature and art does the symbolic interaction of reality and sentiment result in a work of imagination which personifies, and even clarifies, the most compelling aspects of Southern popular culture, as in Margaret Mitchell's novel, *Gone With The Wind*. In that novel, the realities of war and the sentimental longing for an ideal past are consolidated and given deeper meaning through the use of ongoing symbols and characters borrowed from the substance of Western thought.

While the film version of the novel is a truly remarkable achievement in

the cinematic art, its realization upon the screen is a part of another cultural movement outside the concerns of indigenous Southern culture. As a film, *Gone With The Wind* is the consummation of the technical genius of the first generation of Hollywood film makers working with sound, color, and the fury of vast sets and costumes. The film is a high-water mark for the projection of the basic types of the Southern saga into the larger national culture, a projection which ultimately and unfortunately debased those types into an endless stream of lesser film parodies and lesser pulp fictions which has eroded the true greatness of one of our finest novels.

This is to be expected. The true strength of any culture is witnessed most vividly in the ability of that culture to create enduring forms of art and literature which reflect a people's heroic dreams and act as a bright and shining mirror held up to the historical landscape. Insipid Scarletts and macho Rhetts can be seen in cheaper mirrors of inferior make, but they are still reflections, though dimmer, of those same elusive sentimental longings which we have seen throughout this volume.

Margaret Mitchell's characters, and the world they inhabit, offer highly exciting visual possibilities. Consider that John Wilkes' house stood in a circle of trees, like a Greek temple surrounded by a druidic ceremonial grove. The phrase "once stately" is deceiving. It brings to mind the concept of the "stately homes" of England, yet another cavalier association, and ties in with the objections to unrealistic aspects of Southern culture raised by W. J. Cash, and many others in subsequent generations. Yet, what it really refers to is not an actual building type, so much as a state of mind.

Dignity, permanence, and the ideal of an agrarian society are concepts of great substance which we have considered in the writings of the Nashville Fugitives. From the ruins of "the deep pit which had been the cellar" of Twelve Oaks will emerge a new structure. That structure will contain many features of the old one, but, as is to be expected from any ruin, grotesque Gothic creatures will also emerge. The grotesque is the perverse opposite of the romantic ideal, and in the writings of authors such as William Faulkner, Carson McCullers, and Flannery O'Connor, and in much of the visual art of the South of the twentieth century, the grotesque, as well as the sentimental, are projected onto the Southern soul.

Digging amid the ruins of the culture of the Old South is the best place

to begin a search for the beginnings of the grotesque in the contemporary South. Although frequent mention is made of the fact that the South is the only section of the country to have experienced a land war on site, with its accompanying devastation to property and human life, seldom is a serious connection made between that experience and the forms of visual art.

Remembering that the Currier & Ives print, *The Mississippi in Time of Peace,* was one of a pair of prints, we can examine *The Mississippi in Time of War* with an eye sufficiently informed so as to separate visual symbols which are purely melodramatic from those which have a greater reverberation down the long corridors of artistically-created light.

The Mississippi in time of war is not a pretty place. The sacred vessel of prosperity, the steamboat, is on fire and burning against the bank, sending flames high into the sacred grove of live oak and cypress. The light in this work is the light of the moon, not the nourishing natural light of the sun which leads the eye so deeply into the scene of peace. Dim, shadowy, ghostly white, this light reflects the worst disaster yet to befall the kingdom of agricultural harmony.

Black slaves are seen plunging from the burning boat and a plantation house across the river is on fire. As the old order collapses, the enslaved labor force flees. Again, it is interesting to note that a Northern artist, in the aftermath of the war, has chosen to represent abolition as a helter-skelter affair and not an ideal emancipation acted out with Biblical justice and clarity.

Formerly the great steamboats coursed up the river and down, patrolling the waters like giant, benign pleasure barges from the ancient world. Now we can see the dreaded Union gunboat reeking havoc on the levees. All jolly flatboatmen have disappeared and their flatboat lies sinking in the foreground drowning their folksy hilarity in the shallow waters near the shore.

By a curious irony, the image of the devastated cotton kingdom in the war print is much closer to the reality of the post-war South than the fantasy image of prosperity in the sentimental peacetime print. All wars result in enormous damage and upheaval, but the War Between the States created a psychological conflict imbued with radical racism which lasted for a hundred years.

Visual evidence of that devastation exists in two forms of the visual arts, the more traditional form of painting and what was then the new medium of photography. Much of the worst devastation occurred in the Valley Campaign in Virginia and in the course of General William T. Sherman's march to the sea across Georgia and South Carolina.

George N. Barnard, a photographer who accompanied Sherman on his march to the sea, has left an eerie account of that journey that has a quality of art photography composed in contemplation, rather than the aura of spontaneity one associates with the chaos of war. Barnard was restricted by the wet-plate process of making photographs and could hardly set up on site for battles or other important engagements. Instead, he would linger behind the lines in the rear guard of Sherman's forces, and set up his camera in the silence of the deserted streets of major Southern cities like Columbia and Charleston. The ruins of what was then the new South Carolina Statehouse, gutted by fire, roofless, have a spectacular sense of tragic grandeur, reminiscent of those ruins of Greek and Roman architecture which inspired the fantasies of neo-classical design. Looking at Barnard's photographs of the destruction of the Pinckney mansion and the churches of Charleston is a reminder that no one was spared the scorched earth policy, neither founding fathers nor God himself.

Wrecking the Southern countryside was certainly intended as an act of retribution for what the Northern establishment called the War of the Rebellion and the South referred to as the War of Northern Aggression. The extent of that destruction is apparent in the accounts of twentieth-century historians who drew upon contemporary reports composed in the field by the journalists who accompanied the Union forces as they proceeded from Atlanta to the sea.

South Carolina, in particular, seems to have been singled out for punishment. Albert Kirwan quotes General Hallam's remarks to Sherman, that "I hope that by some accident the place may be destroyed and if a little salt should be sown upon its site, it may prevent the growth of future crops of nullification and secession." Sherman's response leaves little doubt as to the intention of his soldiers, who were "burning with an insatiable desire to wreck great vengeance upon South Carolina."

Vengeance is a titillating ingredient for melodrama of the highest order,

FANNY PALMER (1812–1876), Currier & Ives, *The Mississippi in Time of War,* hand-colored lithograph, 18¼ x 27¾ inches, 1865, courtesy of the Museum of the City of New York, Harry T. Peters Collection. Palmer's pendant to her peacetime vision has been a much less enduring image in the popular imagination, perhaps because the graphic photographs of Mathew Brady and others guaranteed a more frighteningly realistic vision. Peters notes that "Palmer frequently colored the models that were followed by the colorists, and that she also worked with Charles Currier in the development and manufacture of his famous lithographic crayons." (Peters, p. 28.)

and ruins provide exquisite backdrops for such indulgence. They also provide, through the quality of the picturesque, ample subject matter for dramatic canvases. Barnard is known to have heightened the dramatic effects of his photographs by introducing skies from a second negative during the printing process. White high-flying clouds enhance the perspectival depth of these scenes, bringing to mind the effects created by the luminist landscape artists. Barnard sets an interesting trend, one which will be followed with far more surreal effect by the photographer Clarence John Laughlin.

After the war a few Southern artists used these ruins to create somber, precisely-composed paintings. William Aiken Walker, whom we have previously encountered as a painter of black genre scenes, was a soldier in the Confederate army during the war, most often stationed in his native Charleston. He was on site when Charleston was bombed in 1861, and after the war he painted the ruins of St. Finbar's Cathedral which had been destroyed in the Charleston Fire of 1861. Churches were seldom spared. Pohick Church in Virginia, George Washington's parish church near Mount Vernon, was used to stable horses, and all over the South various churches were either burned to the ground or left in ruins.

A Walker biographer, Roulhac Toledano, has praised the artist's painting of the ruins of St. Finbar's as an example of his "distinct approach to the landscape" of devastation. Almost as if to fulfill some Gothic revival fantasy of the romantic era, the ruins of the magnificent church have a solidity and stark sense of purpose that transcend literal destruction to become a hauntingly realistic symbol.

Toledano's observation that the "sophisticated execution surpasses much of the rest of Walker's work" rings true. For once, Walker, responding with emotion and technical skill, actually captures a scene of crucial cultural importance, an importance of far greater merit than his rather ambiguous pictures of black field hands. The giant church, towering over the tiny citizens of Charleston, is in the proper spirit of an event which overshadowed the lives of a people and left them possessed with the useless, though powerfully present, remains of a civilization in eclipse and searching for a new self-concept.

Sharp contrasts in Walker's work, a surreal sense of nature embodied by the deep blue of the sky in sharp contrast to the earth tones of the scene, and

WILLIAM AIKEN WALKER (1838–1921), *St. Finbar's Roman Catholic Cathedral,* oil on paper mounted to masonite, 11¾ x 18¾ inches, 1868, Gibbes Museum of Art/Carolina Art Association, Charleston, South Carolina. St. Finbar's Cathedral was designed by P.C. Keely of Brooklyn, New York and built between 1850 and 1854. It burned in the Charleston Fire of 1861. St. Finbar's seems to have been named through the influence of Bishop John England who came from Cork, Ireland where both Catholic and Protestant cathedrals are named after this saint. The site of St. Finbar's is now occupied by the Cathedral of St. John the Baptist.

the heightened contrasts of scale are rather fascinating harbingers of contemporary Southern art. Walker's intention was undoubtedly documentary, devoid of the biting satire and self-conscious folk quality of contemporary Southern fantastic realism. Subtleties of an unsettling and symbolic reality were almost surely beyond him...else we should have to give a far more critical and threatening reading to his genre works.

Edward Lamson Henry also seems to have had a documentary motive in recording the aftermath of the war and its ruin in the Virginia countryside. His well-known work, *The Old Westover Mansion,* is a picture of intense historical episode and dispassionate observation. Westover Plantation was occupied during the fierce fighting at Malvern Hill, one of the bloodiest engagements in the war. In this work, the full story of occupation and loss can be seen in the burnt-out wing, the pitched tents on the lawn, the shattered fence posts, and the sympathetic trees, wilting and leafless in the yard like the scorched veterans at Twelve Oaks.

Consider, however, that from a formal standpoint, the inherent strength

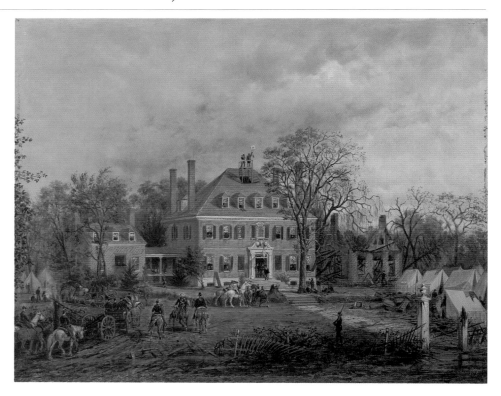

EDWARD LAMSON HENRY (1841–1919), *The Old Westover Mansion,* oil on panel, 11¼ x 14⅝ inches, 1869, in the collection of The Corcoran Gallery of Art, Gift of the American Art Association. Westover was built by William Byrd II between 1730 and 1734 on the north shore of the James River in present-day Charles City County.

in the mass of the building remains. The visual focal point of the work stands in the central block of the house with its forthright provincial Georgian lines, softened and given an earnest sophistication by the massive Palladian overdoor. Though assaulted and humbled, the house still stands; indeed, it continues to be one of the most visited homes on the James River plantation tour.

The endurance of the Southern plantation house, whether grand columnar or provincial vernacular and whether in ruins or restored to some amusement park level of preservation, has become the most important symbol of the Southern imagination. It is given even greater substance if read, in accord with the theories of the psychological philosopher Carl Jung, as a representation of the active mind, the organizing force for chaotic mental energy. Ruined mansions in the Southern imagination came to be identified with the very nature of the Southern sense of being...proud, remote, decayed, possessed of an elusive grandeur.

Even a relatively modest work like George David Coulon's painting of a Louisiana plantation house has an evocative shimmering quality. Like the waves of heat rising from the humid landscape of the River Road, the terrain

GEORGE DAVID COULON (1822–1904), *Ruins of a Louisiana Plantation*, oil on canvas, 25½ x 29½ inches, c. 1885, the collection of Jay P. Altmayer.

and house in this work seem to waver before the eye like an imaginary and futile oasis in the desert of despair. Coulon is rarely this inventive, and the appealing minimal use of color from an otherwise florid palette makes the work one of alluring comment.

The recurring image and theme of the ruined Southern house is both disturbing and instructive as it is encountered in Southern art and literature. At its most elementary level, ruin and the remembrance of things past becomes a rallying point for survival. When used as a dramatic prop, the ruined house becomes the setting through which the interwoven fates of race, culture, and human life in conflict can course, blown through shattered windows like a tattered diaphanous curtain.

The destruction of Twelve Oaks and the impoverishment of Tara spurred Scarlett to depart from the ways of the old order and seek a course that would lead to survival. *Gone With The Wind* is a very misread work unless the crucial theme of survival is grasped amid the passions of the capricious heroine. Scarlett is a survivor of the collapse of the old order. Rather than withdraw behind the lace curtains of genteel poverty like so many of her

neighbors, she becomes an entrepreneur. In this guise she defies her contemporaries and departs from the more shallow affectations of the Southern belle of sentimentality. She is a citizen of the New South of her fellow Georgian Henry Grady, although we may decide that she will ultimately pay too high a price for self-indulgence and willfulness as she watches Rhett leave for Charleston in the last moment of the novel.

Many of the characters in *Gone With The Wind* are more than simple stereotypes. Scarlett and Melanie both represent two important sides of the traditional Southern woman. Though far more shy, self-effacing, and saintly (to the point of irritation) than Scarlett, Melanie is no less a survivor. Her character is often slighted because of the film image of her as the cloying type played by Olivia de Havilland. It was Melanie, after all, who was ready to kill the Yankee soldier who invaded the house, endured the ride out to Tara, and survived the war to make a home in Atlanta that incorporated what she perceived to be the best of the old order in the midst of the new, which she accepts with far less reluctance than her husband.

Ashley and Rhett are manifestations of the archetypal Southern males as well, although they are drawn from more universal Western themes. As the man of action Rhett is an iconoclast who secretly loves what he seemingly despises as he reveals to Scarlett when he abandons her on the road to Tara in order to enlist in the Southern army, "because…of the betraying sentimentality that lurks in all of us Southerners."

But it may well be Ashley Wilkes who is betrayed by sentiment as he struggles to survive. Rhett refers to him as a "gentleman caught in a world he doesn't belong in, trying to make a poor best of it by the rules of the world that's gone." In this, Ashley precedes the existential heroes of the twentieth century, men of honor who do not survive because the rules keep changing so quickly and to such banal ends.

The basic types of character and the familiar setting of *Gone With The Wind* render it a novel from which the appreciating mind constantly strives to separate a truly insightful historical consciousness from the seductive romance of its central figures. That we are not altogether successful in this effort merely speaks well of the novelist as a raconteur and should reassure us that the survival of admirable individuals is surely more important than instructive social commentary.

William Faulkner's novels are much more ambiguous on the subject of Southern sentimentality and much more inventive in the creation of character types. His novel *Absalom, Absalom!* deals with the same epoch as *Gone With The Wind.* But where Margaret Mitchell combined ambition, ruin, recognition, and a tantalizingly uncertain ending, Faulkner tells a tale of dark proportions with sexual undercurrents of madness and revenge reaching into subsequent generations.

Thomas Sutpen's rise and fall in the Mississippi wilderness is a parable of the sins of the violators of the American frontier, whether Southern or not. While slyly suggesting that personal ambition is insufficient as a means of conquering nature and disturbing the natural order of things, it also creates a modern, surreal imagery highly compatible with the photography and film of the 1930s.

As befits an historical event about which float the several voices of fiction and fact, *Absalom, Absalom!* has no central narrator. It is a tale told by at least two people, Quentin Compson, a sensitive and confused young man, and Rosa Coldfield, an embittered spinster. Their relationship is a new type of great importance in the Southern creative mind. The idea of a young man who is a willing listener to the tales of the past, as told by an older woman who may or may not be an objective narrator, becomes one of the most important vehicles for the expression of the endurance of the Southern past into the Southern present. Often these young men are homosexuals, although there is no overt revelation of their sexual identity. (In this age of deconstruction it has been suggested that what Quentin is telling Shreve may actually be a pillow story, told as they prepare to sleep in the cold New England night...Quentin's suicide, as related in *The Sound and the Fury,* is hard to explain away on the grounds of an historical, or existential, identity crisis. Do people really take their lives because they find the past so oppressive or because they cannot reconcile the demands of a strictured past with an untraditional present?)

This hidden agenda, closeted away in the Southern mind, is one of the more curious aspects of Southern culture as it has evolved...the idea that sensitivity and a receptivity to the legends of the past are somehow linked to the ultimate level of male/male bonding. The effete young men of the Southern grotesque long for muscular vagrants like Joe Christmas in *Light in*

August rather than pale, phantom remnants of the Old South like Ashley Wilkes. This seeking after virility, if divorced from the sexual politics and social conventions of interpersonal relationships, is a persistent literary form. When imagined as a remembrance of the vitality of the colonial South, all those jolly flatboatmen for example, it becomes important as a symbol of the search for renewal rather than as proof of the perversions of a decayed ruling class.

From the outset of *Absalom, Absalom!* memory and tradition have the force of current event. The pall which hangs over the mood of the novel is a clear indication of the heavy hand of the past suppressing the present. Miss Coldfield sits in a "dim hot airless room with the blinds all closed and fastened" while Quentin listens to her version of the Sutpen saga, balancing it in the concurrent narrative of his own mind with what he has learned from his own family.

Light falls into the room through the shutters, and becomes "latticed with yellow slashes full of dust" like a photograph by Clarence John Laughlin. What Quentin hears is the story of Sutpen's children, legitimate and illegitimate, white and mulatto, and how they came to despair through unwittingly having danced up to the very edge of an incestuous marriage, a marriage only prevented by murder and dishonor. Like a tale of Old Testament revenge, the children of Sutpen are made to pay even unto the third generation until their lives are over and the house of Sutpen collapses in flames around them.

Sutpen's Hundred, an imposing mansion in the Southern high style, is both vehicle and setting for the novel. We encounter the house in three distinct incarnations. At first the house is known only as the manifestation of Sutpen's burning desire to found a dynasty in the Mississippi territory. He imports a French architect and lives in squalor with his dogs and slaves, working alongside them in a furious effort to finish the house.

Quentin's grandfather, General Compson, knew the young Sutpen and often visited him at the building site, watching "his mansion rise, carried plank by plank and brick by brick out of the swamp where the clay and timber waited...." Sutpen's house, a "dream of grim and castlelike magnificence" is brought into being upon land that has been stolen from the Indians and is being built by naked slave labor. The architect defies the nouveau

riche tastes of Sutpen to build a house which Quentin still finds magnificent, even in decay, or perhaps, especially in decay.

The house is experienced in its second incarnation as it departs the grim and windowless state and is filled with the goods of genteel respectability. When Sutpen has put his house into order he goes into town and acquires the storekeeper's daughter to be the chatelaine of his dynastic ambitions. Ellen Coldfield is the vessel of middle-class respectability. Although she provides him with heirs, she cannot prevent the inevitable tragedy.

Sutpen's drama is a parable of all Southern life as it might have been lived between the opening of the Mississippi territory and the end of Reconstruction. In his saga, all the elements of reality and sentiment are combined, for he is at once a ruthless opportunist with a glorious vision and a despicable amoral villain. His raw ambition and forthright determination are greatly admired by both General Compson and Quentin. His poor helpless sister-in-law, who is imparting Sutpen's tale to Quentin, despises him as a petty tyrant, a hate almost surely born from her suppressed sexual desire for him.

Faulkner does allow Sutpen to make one redeeming survivalist statement. In *The Unvanquished* Sutpen is again encountered, this time after the war. He refuses to join in the formation of a local Klan, on the grounds that he only wants to save his land. When asked if he is for or against the vigilantes, he replies, "I'm for my land. If every man of you would rehabilitate his own land, the country will take care of itself...."

In the third incarnation the house, in its decayed state, has returned to the same Gothic existence it had during the time of construction. Sutpen's Hundred becomes the site of the final collapse of the dynasty in the closing of the saga Quentin now tells his Canadian roommate, Shreve, who has already uttered the famous phrase: "tell about the South." A monolithic symbol of corruption, it is now the ironic home to the stealthy remains of Sutpen's clan.

As Quentin approaches the house for the final time, it "loomed, bulked, square and enormous, with jagged half-toppled chimneys, its roofline sagging a little...." As he and Miss Rosa continue their search, they creep along the now-rotten floor of the veranda until they pry open a set of shutters and enter through a window frame devoid of glass.

Thus the transparent existence of the South is penetrated, and the cycle of building up and tearing down is complete, from the time when there was no glass because there was none to be had to a time when the glass has been shattered. In less than one hundred years the proud house of Sutpen has been leveled, burned to the ground by a vengeful remnant of the old order. As it goes up in flames it casts one last fiery light. As she gazes at what is in reality a funeral pyre for Henry Sutpen, Miss Rosa's face is "lit by one last wild crimson reflection as the house collapsed and roared away...." Only the demented Negro Jim Bond is left to howl around the ruins and he too soon disappears.

Fantastic visions of houses ruined and deserted are spread upon the fields of Southern creative imagery throughout the early part of the century and into the era following the Second World War. Carson McCullers' heroines stand at the windows of confining houses and gaze at the reflections in the golden eye of experience. Truman Capote's young hero watches as an aging transvestite, who hears other voices and occupies other rooms, appears at the windows of a house which seems to sink into the shimmering soil of a watery dream.

One of the most delicate house images is that of Eudora Welty's novel *Delta Wedding* where the different households are like the diverse manifestations of the Southern mind. At The Grove, the ancient aunts are curators of their grandparents' precious belongings, sustaining the cult of antique remembrance. Their nieces and nephews at Shellmound, the Fairchilds, live with raucous abandon, sometimes simply teasing, sometimes far crueler. Looming over all of them is the memory of Marmion, the house that was to have been the grandest of all and yet which never was, abandoned in the aftermath of a duel which claimed a life for "honor, honor, honor." Marmion seemed to be like "an undulant tower with white wings at each side, like a hypnotized swamp butterfly, spread and dreaming where it alights."

Light and the imagined life of the South often blend and merge in the harmonious rhythms of the art and writings of that generation of Southerners who are now almost as remote to us as that generation was to the war itself. Of that generation of visual artists the most articulate and original was the photographer Clarence John Laughlin. From 1935 until his death, Laughlin worked to photograph the ruins of the Louisiana plantations, dedi-

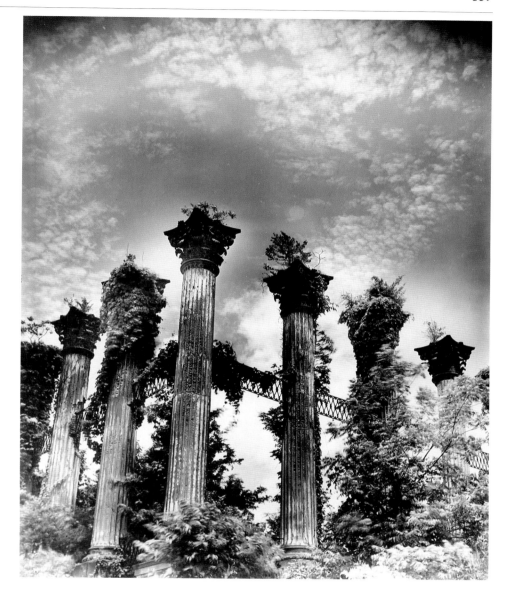

CLARENCE JOHN LAUGHLIN (1905–1985), *The Enigma,* gelatin silver print, 14 x 11 inches, 1941, The Historic New Orleans Collection, Museum/ Research Center, Acc. No. 1981.247.1.1659. "Windsor Plantation, near Port Gibson, Miss., was nearly burned during the course of the Civil War, but survived only to be destroyed by a fire of unknown origin in the 1890's. Here, the clouds hang like a question mark over the mystery of the ruins, whose tremendous plastered brick columns are crowned by huge cast-iron capitals. From the cores of the brick columns young trees sprout, the whole structure suggesting an incredible up-surge of Classical civilization, somehow completely lost in time and space." *The Personal Eye,* page 123. (Laughlin com-posed a series of extensive captions for each of his works, as published in *Clar-ence John Laughlin, The Personal Eye,* Phil-adelphia Museum of Art, 1973.)

cated to "the glory, the magic, the mystery of light." He wrote that the "mystery of time, the magic of light, the enigma of reality—and their inter-relationships—are my constant themes and preoccupations." These themes he set down in a series of photographs that use, in a surreal manner, the real ruins of Windsor, Shadowlawn, and the other houses passed by time and falling into the dust.

Laughlin's art is articulated by the series of captions he wrote for his works, all of which he assembled under various headings which have to do with their symbolic meaning. Many of his best works were published in the

volume *Ghosts Along The Mississippi*, a work which has now gone into multiple editions and continues in print. Laughlin's photographs of ruined houses, such as those of the columns of Windsor, stark against the sky, overgrown with lush vegetation, are the ultimate symbols of the lost order of the past, and strike an oddly nineteenth-century note.

His more surreal work, such as *The Mirror of Long Ago*, is more dramatic and unsettling. In that photograph an ante-bellum portrait by one of the French itinerants who visited New Orleans is superimposed upon the mirror hanging in the shabby genteel interior of a once-grand mansion. The fair subject, flowers in her hair, looks out from the picture plane in an attitude of pensive acceptance, gazing into a world that is fading, peeling, and cracked. No one seems to look back upon her.

It may be we who look back in envy upon that generation which had so many enticing remnants of the old order to seek out upon the hidden backroads of the Southern landscape. Maybe progress is so insured that the old ruins have either collapsed by now (after all, they were not marble, only wood, or at best handmade brick) or been removed for the new shopping mall down by the bypass.

But there are ruins to remember with fondness, and pockets of the Old South culture persist. If you get off the interstate at the last exit in Alabama before you cross the road into Mississippi on the road to Meridian, you will find the little towns of Cuba and York, once the residential centers for an expansive cotton economy.

There, the little houses sit beside the railroad track that divides the town neatly in two, and a proper and appropriate amount of decay persists among the renovated Victorian houses and columned cottages. This is the vernacular South, and it still exists in some form in every Southern state, offering the same wonderful possibilities for visual imagery Clarence John Laughlin discovered. In Cuba, one grand old Victorian house slides to one side, its heavily ornamented porch like the sagging veil of an oft worn hat cast aside from Sunday duty and forced into the market on Saturday mornings in the search of fresh greens.

Just down the road is Enterprise, Mississippi, which could have been the capital of the state, and was, briefly, in the aftermath of the burning of Jackson by Federal forces in 1864. But Enterprise declined to be the hub of

CLARENCE JOHN LAUGHLIN (1905–1985), *The Mirror of Long Ago*, gelatin silver print, 14 x 11 inches, 1946, The Historic New Orleans Collection, Museum/Research Center, Acc. No. 1981.247.1.2369. "Parlange Plantation was founded by Marquis Vincent de Ternant, fleeing the Revolution in France. This is a composite print from two negatives of the interior of the house, showing Julie de Ternant, the tragic granddaughter of the old Marquis, who is said to have gone mad on her wedding night. Here the phantom of the lovely and ill-fated Julie rises from the great mirror in the drawing room, surrounded by the symbols of magnificence." (*Ibid*, p. 122.)

the railroad empire pushing west from Alabama towards Texas and so it sleeps on, a perfect little treasure-trove of ante-bellum plain-style architecture in the Greek Revival mode. One two-story house is a grand mansion in miniature, complete with a small, but free-standing spiral staircase reaching into the spare and sunlit rooms above.

What do Southerners remember? Once, they remembered slashed portraits, stolen silver, divided families, and noble suffering. Now perhaps they remember hot summer nights cooled by the purring sound of an electric oscillating fan, a remembrance of how life was before air conditioning. Or

JOHN MCCRADY (1911–1968), *The Parade,* multi-stage on canvas, 20 x 43 inches, 1950, Roger Houston Ogden Collection, New Orleans, Louisiana.

else they remember the harsh bitter days of racial integration in the summer of 1964, when, while still teenagers, the realities of the democratic experiment intruded upon their lives and a black prophet took his place in the pantheon of Southern orators.

When Southerners remember, they recall with a divided mind. The creative mind of the South might look like John McCrady's painting of the parade at carnival season in New Orleans. Outside there is revelry in the streets as a wild carnival parade, preceeded by a float of a vast and repulsive watermelon, careens down the streets of the Vieux Carré. Inside the artist attempts to capture on canvas a nude posing beneath a naked light bulb. The frantic and decadent imagery without is contrasted with the quiet contemplation within. The search for reality is taking place in the glaring light of creative effort, while persistent, and decadent, sentiment again betrays the man in the street.

Entombed within the Southern consciousness is the cemetery of the Southern character with all its various components. Like the cemetery of Carroll Cloar's painting, there is a hierarchy of importance, though perhaps the imposing nature of some of the monuments may be deceiving. All are dead, and yet some call back from more modest graves, perhaps more befitting their true nature than others. With the passing of time, historical

CARROLL CLOAR (b. 1913), *The Last of the Wooldridges,* oil on board, 28 x 40 inches, 1982, Eugenia W. Weathersby. Most of Carroll Cloar's artistic life has been spent in Memphis, Tennessee, although he often reaches down into the nearby Mississippi Delta for subject matter. Though this work demonstrates the same somewhat flat, almost primitive quality of much of his work, it is drawn from a viewing of a cemetery in western Kentucky. Like many Southern artists, Cloar weaves a strong narrative implication and sense of place into much of his work.

events take on that solidity which only emerges when there are no longer living any survivors for whom an episode still strikes a hurtful note in a sensitive soul.

This passage makes possible a painting like Roger Brown's *Battle of Atlanta* where the soldiers are arranged in a flat space, stacked above each other like so many toys in a box. They fire their guns and some fall wounded, but the scene is one of pattern, and not of the dreadful carnage which marked the Civil War. Brown's painting is a two-dimensional cyclorama, lacking the drama of the work at Atlanta, or the great murals in the Virginia Historical Society's Battle Abbey. But it does offer a more appealing encapsulation of historical event, seen from a great distance, flattened into a minute hierarchy, blue barely distinguishable from gray, and quietly suggesting that the war itself has no longer a resonating significance.

Is this really true? Although it has now been more than one hundred years since the outbreak of hostilities at Charleston, memories of that conflict linger in the Southern mind. Perhaps they are no longer immediate, lacking even that quaint echo which marked the celebrations of the Civil War Centennial in 1961, when a few aged widows of Confederate veterans could still totter off to the festivities in Charleston, or Richmond, or Savannah.

Passing like gray ghosts the veterans and the widows shuffled out of the twentieth century with little note, a blurred and indistinct mass like the Larry Rivers painting of the last Confederate veteran. There he lies upon a rumpled bed, with the flags of both nations hanging above his head, a Pop Art reminder of ritual and defeat, defying in an age of defiance the ironic turns of public attention.

Now, though certain Southern patriotic organizations still exist in the form of Civil War Round Tables and sons and daughters of various things, the memory of the Old South is little more than a sentimental celluloid fantasy. We are often reminded that the South has changed, and even the New South is the New and Improved South. Like a fine soap powder marketed on the airwaves, the South has developed commercial appeal and is rapidly becoming the population center of this country. Influential in presidential elections, industrially-developed and prosperous, air-cooled, and seemingly freed from its old shackles of racial conflict, the South can

LARRY RIVERS (b. 1923), *The Last Civil War Veteran*, oil on canvas, 82½ x 64½ inches, 1961, David Anderson Gallery, Inc.

look back upon the last twenty-five years as the final victory in the long way back from the ruins of Twelve Oaks.

Throughout the long march back from Appomattox to the Toyota plant in Scott County, Kentucky, Southern historians and intellectuals have wrestled with the cohesion of Southern thought and history in an extended search for a central, unifying theme in what most assume is the least diluted of the colonial cultures which confiscated this continent in the name of progress.

Among cultural historians, the South, at least in the early years of this century, was disparaged as a "Sahara of the Beaux Arts," to use H. L.

Mencken's famous term. Almost as if to prove Mencken as wrong as Lee and Jackson proved Hooker to be at Chancellorsville, the Southern literary renascence exploded in the years between 1925 and 1965, giving the most profound body of literature in the national canon.

Nor are there signs that Southern literary creativity is abating. Like the English writers of this century, the Southern novelists continue to find themes of family and place which result in excellent works and attest to the vitality of the Southern literary imagination. Writers like Richard Ford, Reynolds Price, Gail Greene, and Peter Taylor have created works in a tradition which reaches all the way back to Ellen Glasgow's loving, yet critical assessments of rural Southern life.

And yet so much in contemporary Southern culture remains fixated upon the grotesque elements which continue to fascinate and absorb many creative minds. The social historians of this era delight in revisionism, and the facts of Southern history oblige them with deliciously wicked evidence.

Of late the social historian has had ample opportunity to delve into the archives of various Southern institutions and recover sufficient documentary material to re-create the total horrors of the slave epoch. Fawn Brodie has revealed to us that Thomas Jefferson had a black mistress by whom he may have had children. Bertram Wyatt-Brown has confirmed the fictive theories of Lance Horner and Kyle Onstott that there was more going on in the quarters than Joel Chandler Harris would lead us to believe.

Ably assisting the dedicated seekers of sensationalism are the remnants of the piney-woods brigades of Mississippi and the back-road warriors of Georgia who parade through the streets of Southern towns dressed in sheets with more polyester content than real cotton from the kingdom they profess to love. Waving the battle flag designed by Nicola Marschall and singing the old minstrel song "Dixie," these individuals have been far more successful in destroying the very substance of Southern tradition than all the Yankee invaders whose presence in Georgia Aunt Pittypat ever so piteously questioned.

In the midst of these revisions and reactions, it seems to me that we are seeing the same explosion of Southern visual energy that occurred during the Southern literary renascence. Southern artists are finding in Southern life and history material from which they can create a body of art which

WILLIAM CHRISTENBERRY (b. 1936), *Green Warehouse, Newbern, Alabama, 1978,* ektacolor print, 20 x 24 inches, 1978, courtesy of the artist and Middendorf Gallery, Washington, D.C. Trained as a painter, William Christenberry began to make photographs with two simple cameras he found in his parents' home in Hale County, Alabama. Always enchanted by the terrain of his native land, he started photographing the simple buildings there, being "deeply taken by the surfaces, textures, and colors of those buildings—the roofs, the way the corrugated tin rusts and ages." (See *William Christenberry, Southern Photographs,* introduction by R. H. Cravens, Millerton, New York: An Aperture Book, 1983.)

BIRNEY IMES (b. 1951), *Behind the Whispering Pines, Lowndes County, Mississippi*, type c print, 16 x 20 inches, 1987, collection of the author.

continues to explore the visual possibilities of the reality and sentiment of Southern life.

Southern photographers, in particular, have responded to the terrain and people of the South with an insight devoid of a patronizing agenda, while celebrating much that is strange and beautiful. William Christenberry's photographs of Hale County, Alabama have a still, distant quality which comes upon the little country churches with their peaky steeples and tin roofs like a loving native son returned home after a long absence. His response to the textures of rusty cotton gins and faded signage on the sides of vanishing country stores give depth to nostalgia and render the mundane a tactile remembrance.

Other photographers have found beauty in unexpected places. Birney Imes of Columbus, Mississippi has visited the road houses and juke joints of the Delta in an effort to capture an important aspect of culture which he feels may be vanishing, the haunts of the blues singers and the interiors composed by folk decorators. His travels have taken him to the Whispering Pines where the chicken feet are stacked up like trophies and the decay of the place is not a sad reminder but a triumphant endurance.

Nor has the grotesque been ignored. George Dureau has photographed the dwarves of New Orleans and the sadly deformed bodies of men, black and white, with a soft and caressing camera. Seen through his lens these figures are perhaps the ultimate reconciliation of reality and sentiment, for there is no sadness in what we see, only a curious distortion often presented in very heroic poses. Nor has Dureau limited himself to the deformed, for much of his photographic work is a celebration of the innate attractiveness of the backwoods Southern male or the towering black athlete who has perfected his musculature on the streets and in the city park basketball courts. His photographs of black and white men engaged in antique Greco-Roman wrestling poses have a quality of Victorian realism, Eakins gone South, or Muybridge camped out on the bayou.

Southern painters of this time have found the same challenge. Young artists like Don Cooper, Glennray Tutor, and Douglas Bourgeois have found the same humor and rich pattern of visual detail in certain parts of Southern life that we see in the works of the photographers. Cooper's paintings from his Stone Mountain series have a lurking mystical note emerging

GEORGE DUREAU (b. 1930), *Thompson/Brown,* silver gelatin print, 14 x 13 inches, 1982, collection of the author.

in the ghostly presence of Lee and Davis as they ride in place on the monolithic stone wall, surmounting a forest inhabited by angels and wildlife and the subliminal force of fantasy and sexuality.

Tutor's painting of the abandoned *Starvue* recalls the nostalgia for the 1950s when Elvis was the King of Rock and Roll and James Dean could be seen at the end of the hood, if the ornament didn't get in the way. Doug Bourgeois has seen a vision of Elvis in heaven, perhaps dispelling any notion that he is alive.

Longing for Elvis is the greatest proof that the central theme of Southern culture at this time is nostalgia. As we have considered throughout this volume, the primary concern of Southern life has always been the extent to which the past continues to exert an influence, for good or bad, upon the present. The colonial South longed to create a culture in the virgin wilderness of the tidewater plains and savannahs that would rival the English

DON COOPER (b. 1944), *The Adoration of Natural Wonders,* oil on canvas, 60 x 84 inches, 1984, collection of Trammell Crow and Ron Terwilliger. Don Cooper's training with Jim Herbert at the University of Georgia in the 1960s was certainly an adequate preparation for a career painting works that belong to what might be called the "fantastic realism" school of Southern art. He himself has said that he is "looking for something I've never seen before—something described by its difference...the mystery of the space between reality and the imagination."

(Cooper's comments are excerpted from the catalog of the *Awards in the Visual Arts 4,* published by The Southeastern Center for Contemporary Art, Winston-Salem, North Carolina, 1985.)

GLENNRAY TUTOR, *Starvue,* oil on linen, 30 x 42 inches, 1987, used with permission of the Alice Bingham Gallery, Memphis, Tennessee. Glennray Tutor has ignored the traditional path to artistic creativity which has dictated a move to New York, and instead continues to work in northern Mississippi. His love for the Delta and the hill country around Oxford is apparent in his works. He feels that "Mississippi has always been a magical place...filled with treasures. Over the years, my sense of wonder for it has never lessened." (Tutor's works were featured in a publication which accompanied the "Reveries and Mississippi Memories" exhibition at the Lauren Rogers Museum of Art in Laurel, Mississippi in 1986.)

DOUGLAS BOURGEOIS (b. 1953), *A New Place to Dwell,* oil on plywood, 14 x 18 inches, 1987, private collection. In the ultimate transformation, Elvis has become a prayerful, allegorical figure, clasping in his hand a small glowing guitar which has the aura of a sacred and enlightening relic. He kneels upon the rocky path of life, as though he were Dante, confronted with two roads diverging in a wood. His choices and his fate are clear. His mother looms on one side, and his wife on the other. Behind him, a bed bound by ropes of thorn suggests the tortured existence he may have led, while the glow of his guitar can only mean that ultimately he was redeemed by his music.

countryside.

The ante-bellum South longed for an isolation that would permit them to deal with the issue of slavery, the disposition of the land, and the negotiation of agricultural commodities to their own best interests. When that longing gave way to frustration, and war resulted, the South longed to win that war against overwhelming odds.

Once that war was over, the New South longed for the Old South, while simultaneously seeking renewed prosperity. It was at this time, as we have seen, that the cult of the Old South entered ideal realms both redemptive and destructive. The nostalgic yearnings of the generations who survived the war resulted in a literature of sentiment and grace, which is no less interesting because of the cynicism of our own age. Those desires also culminated in a rich landscape school of mystical proportions and seductive allure.

Meanwhile, as the South of the mid-twentieth century longed to hold back the black population, those Southerners (for the black is Southern as well, having lived upon the land and suffered in the same enriching tragedy, bound in the same relationship as the white) longed for freedom. That longing for freedom is what finally saved the South, for as time washes away the tensions between the races, Southern culture will continue and be all the deeper for those tensions with which it struggles.

What does the South long for now? Some Southerners wish that Elvis was still alive and singing that sad song about finding a new place to dwell down at the end of a lonely street. Others wonder if Rhett will come back (and soon someone will tell them whether they want to hear or not). Fictive cultural entities have come to have the communicating power of real people, the ultimate triumph of sentiment in a world which wanders from hyper-image to hyper-image.

When Shreve McCannon asked Quentin Compson why he hated the South, Quentin's response broke the cold night air of New England with a shrill cry denying any such thing. Far better to have asked why he loved the South. Probably it is because when he looked across the street where the gas station stands now, he— and we—could remember when somebody's great-aunt lived there and she told the most seductive stories of the old times as you sat out on the shady side of the porch with her on hot summer after-

DAVID BATES (b. 1952), *Caddo Lake*, oil on canvas, 84 x 64 inches, 1987, collection of Anne MacDonald Walker. Although David Bates' work is clearly in the most current idiom of the contemporary art world, he manages to combine an appreciation for the folk elements of Southern culture with certain ongoing pop trends, especially those of Red Grooms, an artist whom he is known to admire. Still, there is an echo of the Southern artist in search of place, especially when one considers such Bates comments as "My work in the past few years had been a process of allowing myself to paint subjects I really cared about—finding my own place that is special to me." His fascination with the moss-hung trees of Caddo Lake in his native East Texas demonstrate the same affinity with that exotic and sublime landscape that we have seen in the works of Clague and Smith and Buck. (See Marla Price, *David Bates, Forty Paintings*, Fort Worth: Modern Art Museum of Fort Worth, 1988.)

noons drinking cold bitter lemonade and watching the pickup trucks come in from the farm. What you didn't know then you might know now; it is always better to remember than to forget, not because you know so much more, but because you have so much more to tell.

For that is what we have come to in the South. We are constantly telling about the South, whether in love, or parody, or strong disapproval, for it holds the attention, and if at this juncture it is too dramatic to say that it is seductive, then perhaps we should simply call it evocative, drawing us back

MICHAEL PALUMBO (b. 1948), *Untitled photograph of funerary sculpture*, 35mm ektachrome, 1988, Louisiana State Museum. This unstaged photograph was taken in the Cabildo on May 12, 1988, the day after a fire destroyed much of the third floor of this National Historic Landmark in New Orleans.

into a world that still defies some aspects of the onslaught of rapid change.

Even now, when we look into a painting like David Bates' *Caddo Lake,* we can see the echo of the landscape where fancy floats at will. The contours and forms of that landscape are sharper and more spiky and the light has nothing to do with the natural observation of nature, but the seduction is there. Orange light still creeps around the disturbing shadows of a wilderness setting, and we can tremble a little to look through the frame and into the swamp where slaves have sought refuge, where Audubon stumbled upon his great discoveries, and where steamboats foundered.

Ruin and remembrance. When the Cabildo on New Orleans' Jackson Square, one of the oldest buildings in the South, caught fire and burned in the summer of 1988, the newsletter of the Friends of the Louisiana State Museum remarked that "the legends spawned by disasters tend to focus upon ironies." A chance photograph of a surviving marble funereal piece is even more ironic. Crouched by the open window of the fire-wrecked attic of the Cabildo, the allegorical maiden, embodiment of virtue, leans against the sill, her head resting upon a hand held up against the outside world. A single laurel wreath is held within the other hand, and about her feet are the charred remains of the roof timbers. As she was not sculpted with an attitude of regret, she lends the scene an air of ironic acceptance…a marble figure, slightly soiled by the passing of time, but crouching peacefully in the ruins of a structure almost sure to be rebuilt from the energies of those who love her.

Select Bibliography

Much of the writing in this volume is a distillation of various scholarly publications I have written over the past ten years. Without exception, those articles, or catalogs, or monographs, have had a very limited audience. In writing this series of essays it has been my intention to bring to a wider segment of the reading public many of these same thoughts, translated into a context devoid of intimidating footnotes and the small print that is the inevitable fate of academic journals.

Within the following bibliography I have included a list of my own writings among those titles which I feel would enrich the reader of this volume who desires to pursue the topic of Southern art and culture in greater depth. In many instances I have repeated specific passages or phrases which I felt were worth salvaging from dusty shelves, nestling them comfortably amid the splendors of full-color illustrations, good-sized type, and the nurturing security of a hard cover.

Two patterns of thought which flow through this volume existed in my thinking when I first began to pursue a career as an art historian and they continue to intrigue me. The first has to do with the technique of creating the visual impression of depth and perspective on the two-dimensional surface of the picture plane. From the Renaissance to the nineteenth century this was the most pressing formal problem in painting composition. To my

eye, the American landscape artists of the nineteenth century, whether they were working on the Hudson River or the Bayou Teche, solved those problems by combining a deeply felt appreciation for place with a superbly realized technique.

The other thought which has fascinated me as much as technical composition in landscape art has to do with cultural definition. Within the context of Southern studies we seem to return always to the central question: what is Southern about the South? To my mind, the larger question should concern the continuing resonance of the past into the present. While each effort we make to define Southern culture will only be overturned by the next generation, it is very important to keep interpreting the literature to give it greater currency, and to bring to public attention lost works of art. In the final analysis this is the joy of being an art historian, the sense of being an explorer who has found the city of gold and brought it home to an awaiting nation.

Audubon, John James. *Delineations of American Scenery and Character*. New York: G. A. Baker & Company, 1926.

Audubon, John James. *Journal of John James Audubon made during his trip to New Orleans in 1820–1821*. Boston: The Club of Odd Volumes, 1929.

Audubon, John James. *Ornithological Biography, or An Account of the Habits of the Birds of the United States*. Edinburgh: Adam and Charles Black, 1831–1849. repr. New York: Abbeville Press, 1985.

Brooks, Cleanth. *William Faulkner: The Yoknapatawpha Country*. New Haven: Yale University Press, 1963.

Chambers, Bruce W. *Art and Artists of the South: The Robert P. Coggins Collection*. Columbia: University of South Carolina Press, 1984.

Clark, Kenneth. *Landscape into Art*. Boston: Beacon Press, 1961.

Clark, Thomas D., and Albert D. Kirwan. *The South Since Appomattox*. New York: Oxford University Press, 1966.

Eaton, Clement. *The Growth of Southern Civilization: 1790–1860*. New York: Harper-Row, 1961.

_____. *Mind of the Old South*. Baton Rouge: Louisiana State University Press, 1967.

I'll Take My Stand: The South and the Agrarian Tradition. New York: Harper Torchbooks, 1962.

Mitchell, Margaret. *Gone With The Wind*. New York: Macmillan, 1936.

Painting in the South: 1564–1980. Richmond: Virginia Museum, 1983.

Pennington, Estill Curtis, "The Aesthetics of Everyday Life in Old Natchez," essay in *Natchez Before 1830*, Noel Polk, ed. Jackson: University Press of Mississippi, 1989.

_____. "Below the Line: design and identity in Southern art," essay in the catalog, *The South on Paper: Line, Color and Light*. Spartanburg, South Carolina: Robert M. Hicklin Jr., Inc., 1985.

_____. "The Climate of Taste in the Old South," *The Southern Quarterly*, XXIV, Nos. 1 and 2 (1985).

_____. "Kentucky-Mississippi Itinerancy: West, Jouett, Bush and Lambdin," *The Southern Quarterly*, XXV, No. 1 (1986).

_____. *The Last Meeting's Lost Cause*. Spartanburg: Robert M. Hicklin Jr., Inc., 1982.

_____. *Mississippi Portraiture*. National Society of the Colonial Dames of America in the State of Mississippi. Laurel, Mississippi: Lauren Rogers Museum of Art, 1987.

_____. *William Edward West, 1788–1857: Kentucky Painter*. City of Washington: National Portrait Gallery, Smithsonian Institution, 1985.

Rathbone, Perry T., ed. *Mississippi Panorama*. St. Louis: City Art Museum of St. Louis: 1950.

Rubin, Louis D., Jr., and Robert D. Jacobs, eds. *South: Modern Southern*

Literature in Its Cultural Setting. Garden City: Dolphin Books, 1961.

_____. *Southern Renascence: The Literature of the Modern South*. Baltimore: Johns Hopkins Press, 1953.

Trovaioli, August P. and Roulhac B. Toledano. *William Aiken Walker, Southern Genre Painter*. Baton Rouge: Louisiana State University Press, 1972.

Welty, Eudora. *Delta Wedding*. New York: Harcourt, Brace, 1945.

Whitley, Edna Talbott. *Kentucky Ante-bellum Portraiture*. National Society of the Colonial Dames of America in the Commonwealth of Kentucky, 1956.

Wyatt-Brown, Bertram. *Southern Honor: Ethics and Behavior in the Old South*. New York, Oxford University Press, 1982.

Acknowledgements

All the original research and writing for this volume occurred during the summer and fall of 1987 when it was commissioned by Rob Hicklin. I am most grateful to him for his support and encouragement of my work in the realm of Southern art. The entire process of assembling this volume has been made far easier by the assistance I have received from Kim Tuck, Claire Sasser, and Cynthia Siebels, members of his staff. Winnie Walsh, my editor at Saraland Press, has listened and tolerated my outbursts and most ably guided my prose.

Anne Jones, who has designed this volume as well as another of my publications, is a great genius and her sensitivity to my writing and visual ideas extends far beyond the normal bounds of professionalism.

I should also like to thank the staff of the Louisiana State Museum Library, the Historic New Orleans Collection, the New Orleans Museum of Art, and the Howard Tilton Memorial Library at Tulane University for sharing their excellent research facilities. The museums and collectors who have supplied transparencies are a disparate group, and yet all have cooperated most kindly. A special acknowledgement should be extended to Roger Houston Ogden who has shared with me his magnificent collection of Louisiana painting.

None of us who work in the world of art functions in a vacuum and I

have been most fortunate that a group of my colleagues has been willing to listen to me ramble on about the various ideas presented in this volume. My gratitude to Ellen Miles, Jessie Poesch, Bruce Chambers, Linda Simmons, Derita Coleman Williams, and Quentin Rankin also includes a warm feeling of thankfulness for their friendship.

Finally, I must thank my parents, Helen and Glen Wagner, and my dear friends, Gardiner and Bobbie Lou Green. I have not the slightest suspicion that they ever listen to a word I say, but they are so nourishing in that very comfortable Old South way and I love them for it.

Photography Credits

David Anderson Gallery, Inc., 171

Larry Cantrell, 20, 23, 96, 102, 141, 159

Ceren/Haire, 169

Helga Photo Studio, 46

Robert Linthout, 85

Owen Murphy, cover, 109, 123, 125, 126, 133, 134, 135, 136, 139, 140, 144, 147, 168

Michael McKelvey, 177

Blake Praytor, frontispiece, 10, 13, 14, 19, 27, 35, 36, 45, 48, 57, 58, 61, 86, 89, 93, 94, 98, 99, 103, 106, 107, 119, 121, 122, 138, 143, 146

Katherine Wetzel, 25

Index

A NOTE ON THE TYPE

The text of this volume was set by TypeArt of White Plains, New York using AGFA Compugraphic's version of Cloister Oldstyle. The face was designed by Morris Fuller Benton in 1913 for American Type Founders. It is based on a face designed by Nicolas Jenson in 1470 and is classified as a member of the "Venetian Oldstyle" family.